Norman Parkinson

STYLE

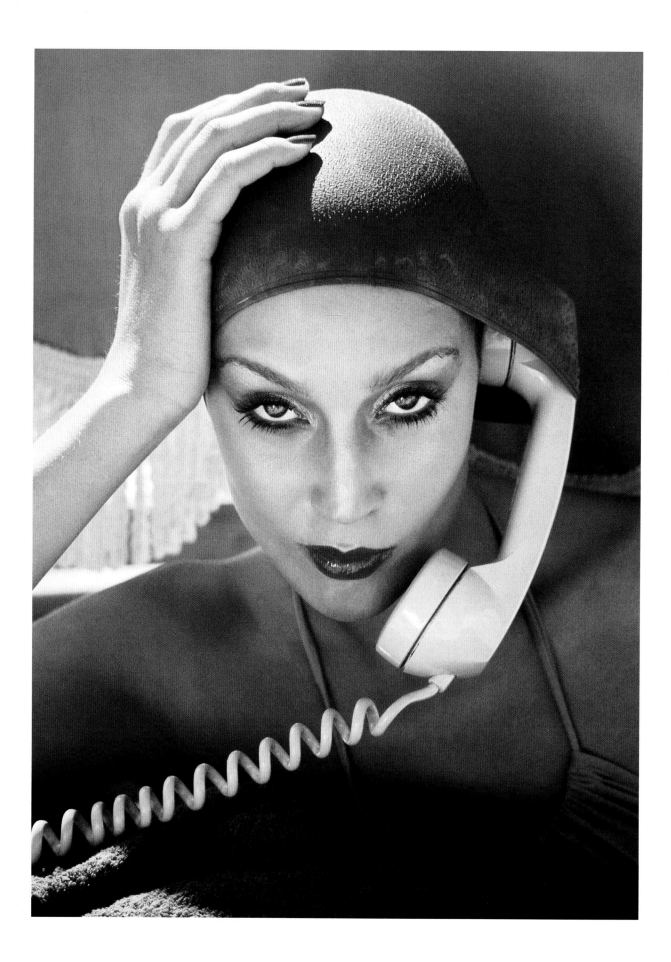

Norman Parkinson

STYLE
Photographs
For Vogue

Text by
Terence Pepper with Grace Lee

WELBECK

Contents

1930s

1940s

1950s

1960s

1970s

INTRODUCTION

This is the first book solely devoted to Norman Parkinson's stylish and beautiful contributions to *Vogue* magazine, from the 1930s to the end of his contract in the early 1980s. Previous books and exhibitions have celebrated Parkinson's anniversaries, such as his first major retrospective at the National Portrait Gallery in 1981. This exhibition, which I had the privilege to curate during my 40 years at the gallery, celebrated Parkinson's first 50 years as a professional photographer and was largely drawn from his work with *Vogue*.

The publication of this book in fact celebrates the anniversary of the creation of "Norman Parkinson", a name that originally began as a partnership of two photographers in 1934, and which was the name of the studio they opened at No 1, Dover Street with the acquisition of a lease at £400 per year.

The partners were Ronald William Parkinson Smith (known to his wife and on his passport as Ron or Ronald Smith) and a friend, Norman Kibblewhite. The two met when they both were working as apprentices at Speaight & Son Studio of Bond Street. Together, they took on the No 1 Dover Street studio.

At first, work was divided between them, but the partnership broke up and Ronald Parkinson Smith kept the new name and business. In the past, attempts to find out more about Kibblewhite stalled, but recently we came across a rare credit in a 1960s' magazine for a photographer of this name.

Ronald Parkinson Smith was born on 21 April 1913 to William Parkinson Smith, a barrister, the second of three children with his wife Louie (née Cobley). Parkinson's mother was half-Italian and a direct descendant of Luigi Lablache (1794–1858), the famous basso profundo and music teacher to Queen Victoria.

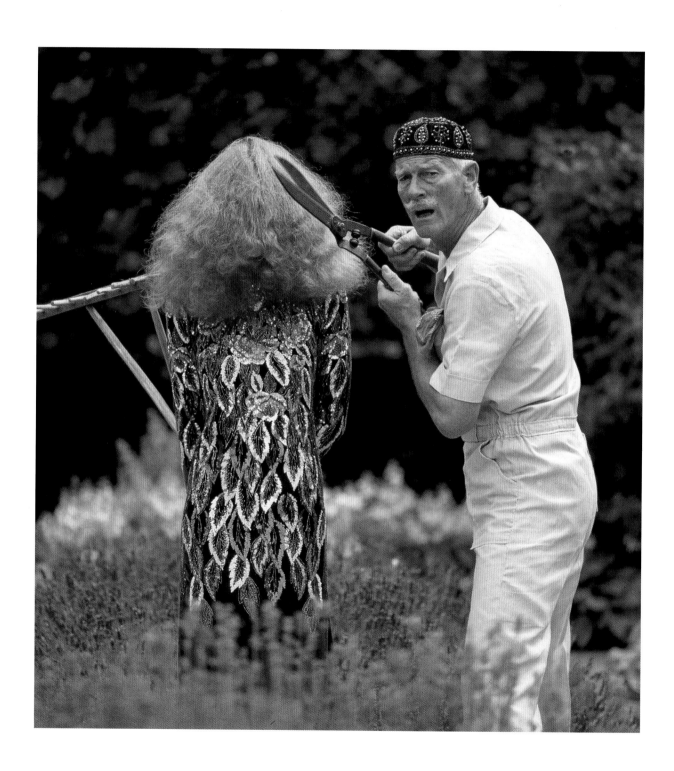

Parkinson's Dover Street Studio was well placed in Mayfair, opposite the Ritz Hotel off Piccadilly in a street where many other leading photographers of the time had studios. These establishments stayed open until 2 a.m. on the nights that débutantes were photographed for their presentation at Court (a custom which ended in the 1950s).

Parkinson's financial plan for the success of his studio depended on the income of print sales, which cost ten guineas for a dozen presented in special folders and mounts, while publication in quality periodicals was around £5 per page at that time. Parkinson set himself ten per day as the bar to keep afloat financially.

A chance visit by an art editor from *Harper's Bazaar* to visit another photographer at the same address, George Canons (trading as Canons of Hollywood), drew attention to Parkinson's work. His framed travel photographs hung on the staircase wall and on the basis of these he was recruited to work for *Vogue*'s rival, who was seeking new talent to match the skills of other *Bazaar* photographers such as Martin Munkácsi. Parkinson's success at *Bazaar* also led to commissions from leading fashion stores and designers, which appeared in several magazines including *Vogue*.

The majority of the images in this book have been selected from original vintage prints or new prints from negatives to show Parkinson's published *Vogue* images. However, in some cases only variant poses survive and these are indicated in the caption text.

Terence Pepper

Opposite: Norman Parkinson
photographed with Andrea Holterhof
by his American assistant Chuck
Zuretti for French *Vogue*, 1980.

1 9

30s

Parkinson began the 1930s as a schoolboy, then in his last year at Westminster School, followed by a two-year apprenticeship to the Bond Street royal and society photographer Richard N. Speaight. As Parkinson recalled in his autobiography *Lifework* (1983), Speaight wanted a £500 fee from his father to pay for his apprenticeship of three years, in return for which Parkinson would be paid £1 a week, but "my father drove a hard bargain and I was ushered in for £300".

As well as being present for the first photographs of Princess Margaret, Parkinson gained useful experience in taking studio photographs of the leading personalities and débutantes of the day. These would be his main photographic subjects when he opened his first portrait studio at No 1 Dover Street in 1934, aged 21.

Most of Parkinson's work was published in news and society magazines such as *The Tatler, The Bystander and The Sketch*, but as his reputation grew, leading advertisers commissioned work for their campaigns, and his advertising portraits for brands such as Imperial Airways, and fashion houses including Matita and Ann Talbot, saw his work also published in *Vogue*, as seen here.

It is likely that other advertising images by Parkinson also ran, but at present we only know of those credited in the magazines at the time. One of his most prestigious clients was Matita whose logo "Goddess of Sport" joined their copy line "Matita, London... of Paris... New York." A glamorous advert which ran in several magazines at the time read, "Australia sends us lovely Margaret Vyner to grace both the English scene and screen. In the heart of the country she wears a top coat of novelty diamond weave in greys, beautifully tailored: a dove grey jersey suit both by Matita." (Margaret Vyner [1914–1993] was a model.)

Thelma Woolley (neé Garwood Blay), who is shown in another Matita fashion photograph with a pet tortoise, was also one of Parkinson's preferred fashion models, and modelled for him from the late 1930s up until their marriage in 1942. Afterwards, they would live together in Tewkesbury in Gloucestershire. The advertisement for one of a long series of Ann Talbot fashion pieces shows the sister of actor Michael Rennie in a studio pose and is also an early example of Parkinson's interest in double exposure techniques, which he used throughout his career.

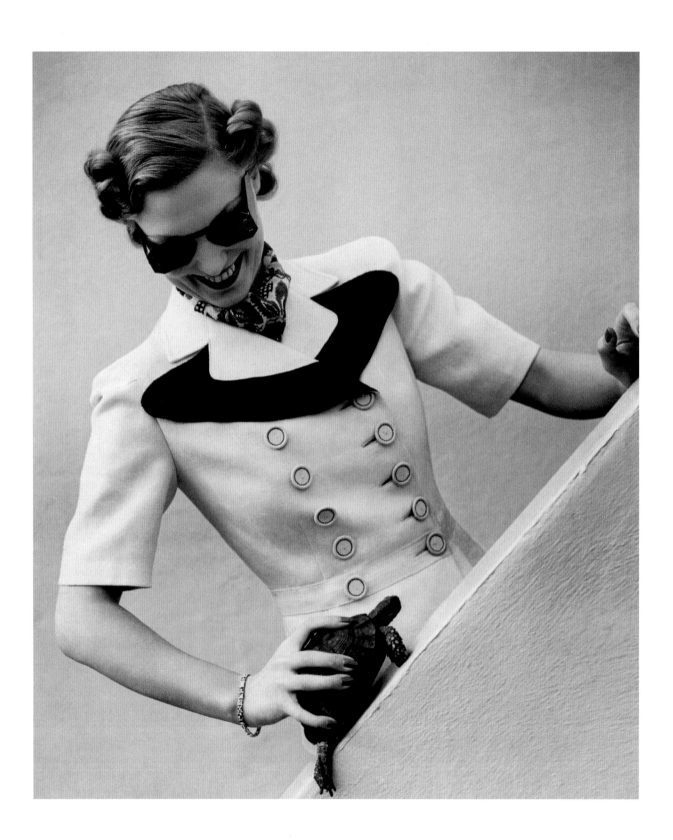

Above: Thelma Woolley and a tortoise in a Matita "Goddess of Sport" advertisement. British *Vogue*, 27 April 1938.

Opposite: Feeding the birds: fashion advertisement for Dorville's tweed suits. British *Vogue*, 30 November 1938.

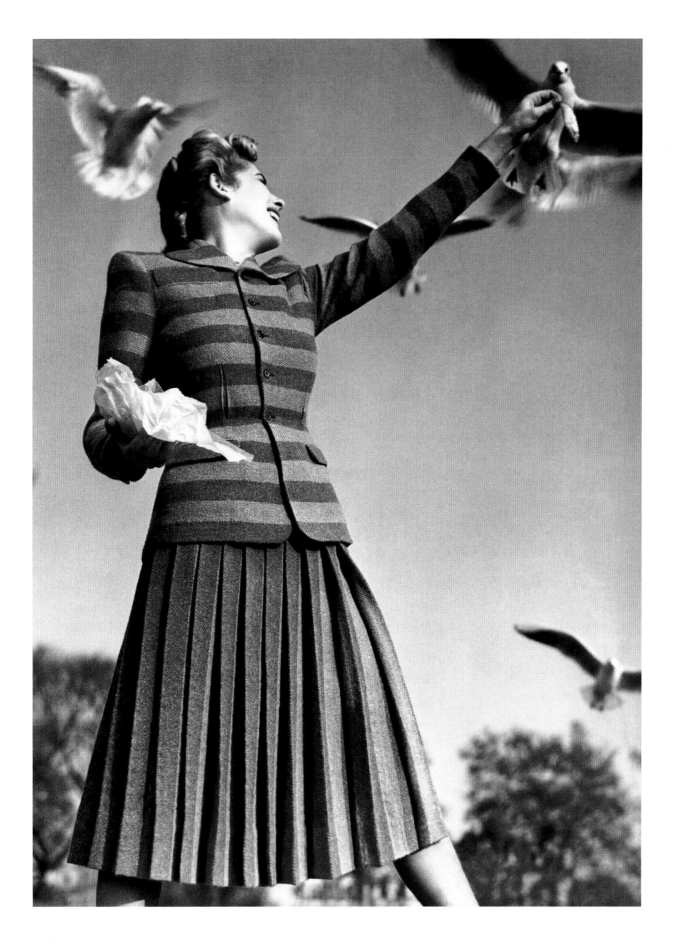

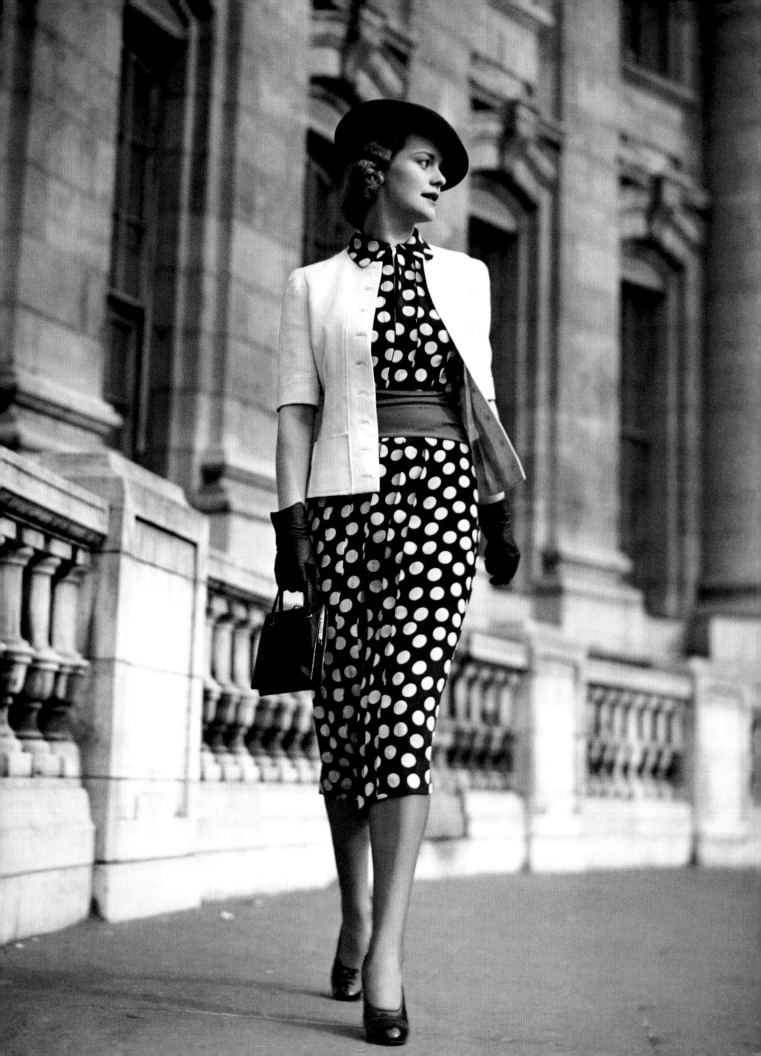

Posing at Admiralty Arch by
Trafalgar Square: advertisement
for Matita "Goddess of Sport".
British *Vogue*, 13 April 1938.

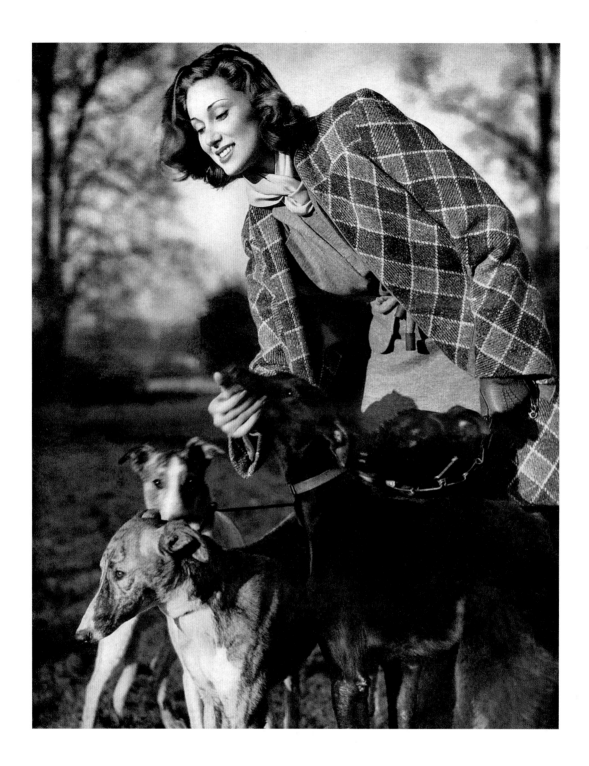

Above: Margaret Vyner with four dogs in an advertisement for Matita. British *Vogue*, 22 February 1939.

Opposite: Anne Paget, a cousin of the Paget Twins and a 1959 débutante. Photographed with her pet pug for a Matita advertisement. British *Vogue*, 11 January 1939.

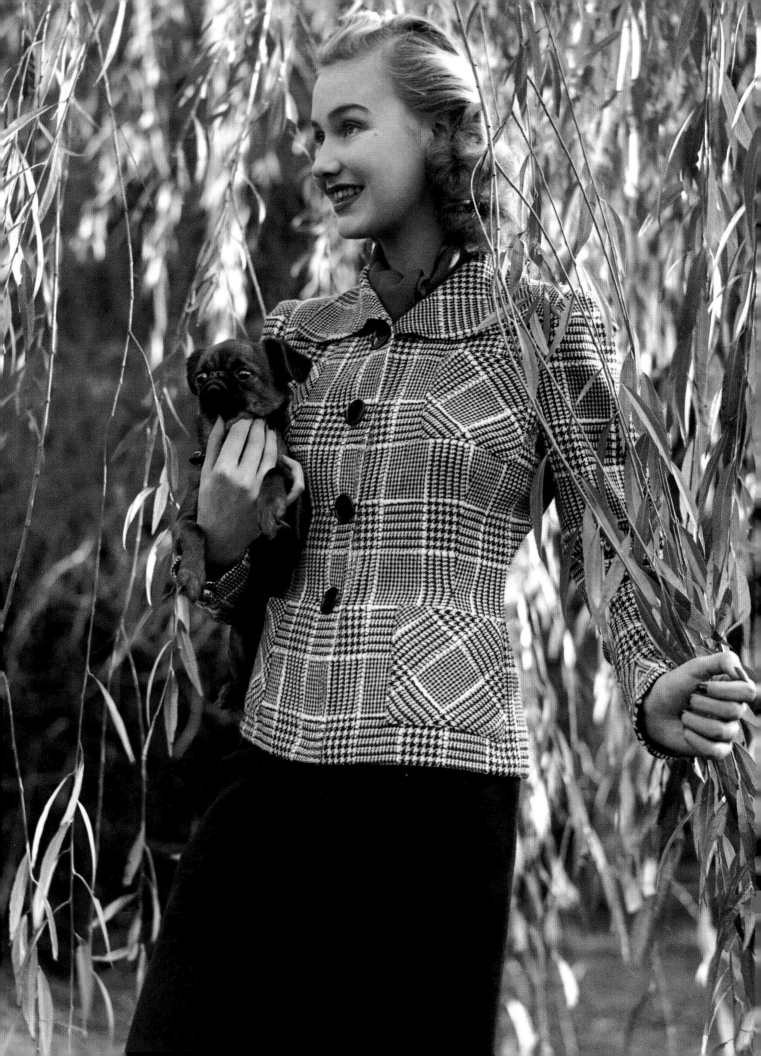

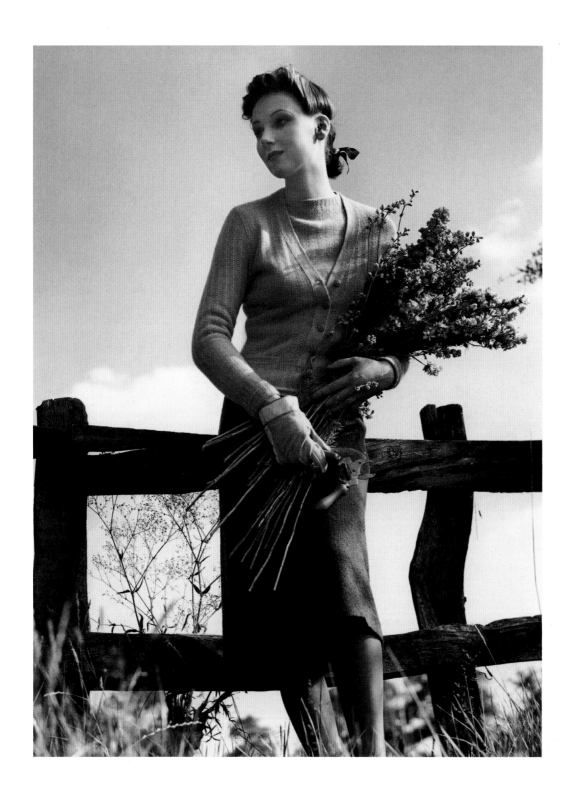

Above: Advertisement for Braemar knitwear. The caption described the twinset as simple and classic, in the true Braemar tradition. British *Vogue*, 5 October 1938.

Opposite: Ann Talbot's mid-season collection advertisement featuring the sister of the actor Michael Rennie. Double exposure photograph for British *Vogue*, 27 April 1938.

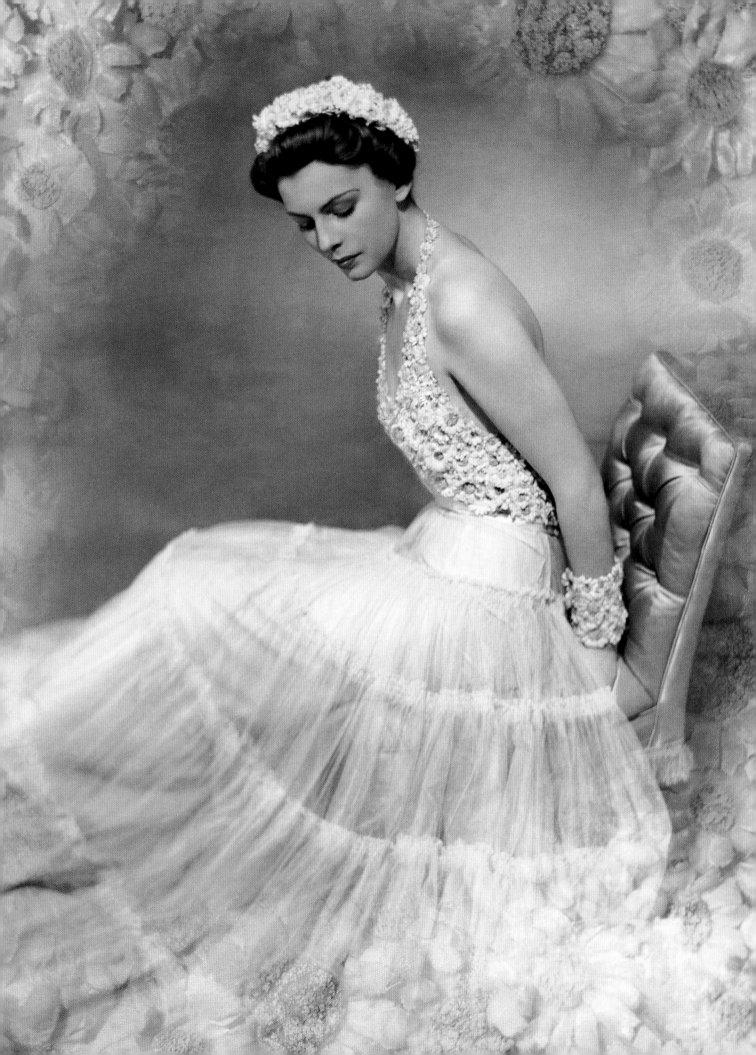

1 9

40s

Parkinson's first editorial photographs for British *Vogue* appeared inside the July 1941 issue. Eight years later, one of his stunning photographs would appear both on the cover of British and American *Vogue*, further catapulting his artistic fame.

Previously, Parkinson's main fashion editorial work was connected to the British edition of *Harper's Bazaar*, but with the outbreak of war he closed his studio at No 1, Dover Street off Piccadilly and his fashion editorial stories for *Bazaar* were taken on by the photographer Nancy Sandys Walker, who had been his assistant both on location and in the studio.

Parkinson lived in the British countryside and was registered as a labourer in the national census. He worked only a day or so a week for *Vogue* until the end of the Second World War, focusing on morale-raising work on the Home Front and photographic reports of the war effort.

Cecil Beaton and Norman Parkinson were the two most important British *Vogue* photographers during the 1940s, but with Beaton absent overseas, commissioned to cover the war for the Ministry of Information, Parkinson shared domestic coverage with the American-born photographer Lee Miller in several of *Vogue*'s wartime issues.

Parkinson's fashion photograph of Diana Nadin (1917–1996) shows one of a number of models who also worked in intelligence and other wartime activities such as Bletchley Park. Many special images of such 1940s fashion models survive in the Norman Parkinson Archive and provide us with a fascinating wartime fashion history.

An early European travel story in the February 1947 issue of *Vogue*, titled "Weekend in Brussels", set the template for many future Parkinson fashion and travel stories – most dramatically, his first trip to New York in 1949 at the invitation of Alexander Lieberman of American *Vogue*, who requested that Parkinson photograph there for periods of six months each year onwards. It was in New York that Parkinson first met the young model Carmen Dell'Orefice, and he would continue to capture her up until the 1980s.

Parkinson would work with many renowned *Vogue* editors, from Audrey Withers to Beatrix Miller; and art directors including John Parsons, whose love of narrative fashion stories and settings became a particular feature in the magazine. An example of this is Parkinson's "The Woman in White" portfolio, published in the July 1947 issue and photographed at Raglan Castle and Tintern Abbey, with accompanying text written by Lettice Cooper inspired by the Victorian novelist Wilkie Collins.

Perhaps the most important moment for Parkinson in the 1940s was a photo shoot for travel clothes, for the story "Boat, Train and Plane". It was on this shoot at *Vogue* Studios that he was introduced to his most inspirational and cherished muse, the young actress Wenda Rogerson. He would marry her in 1951 and collaborate with for the rest of her life, first as model and then as *Vogue* travel writer under the name of Wenda Parkinson.

Other important *Vogue* models such as Anne Chambers, Della Oake and Barbara Goalen made their first entrances into the world of fashion with Parkinson's stunning photographs, and their careers continued into the 1950s.

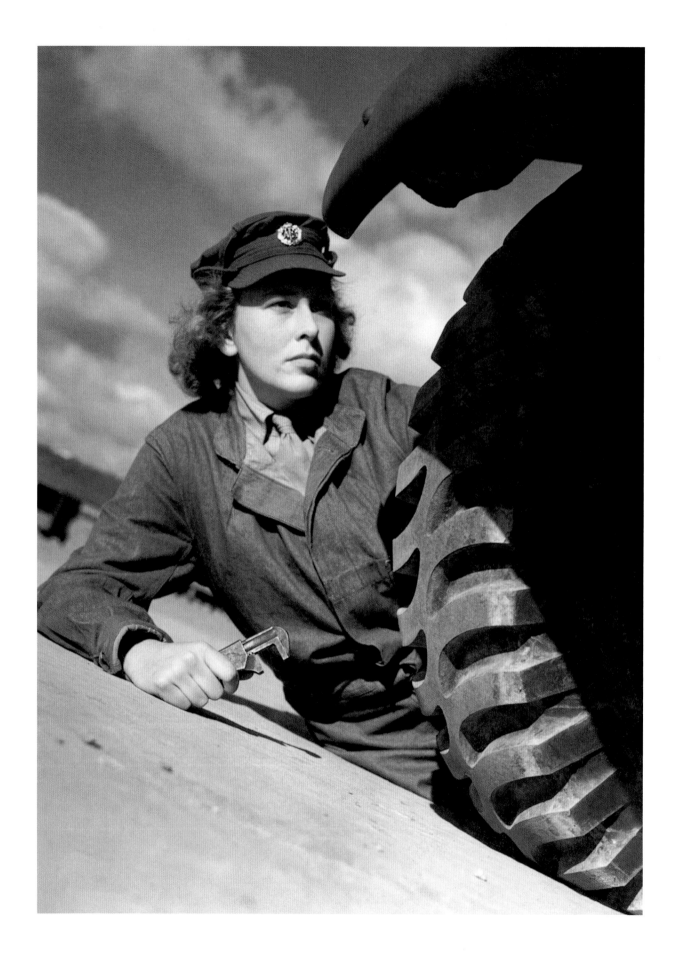

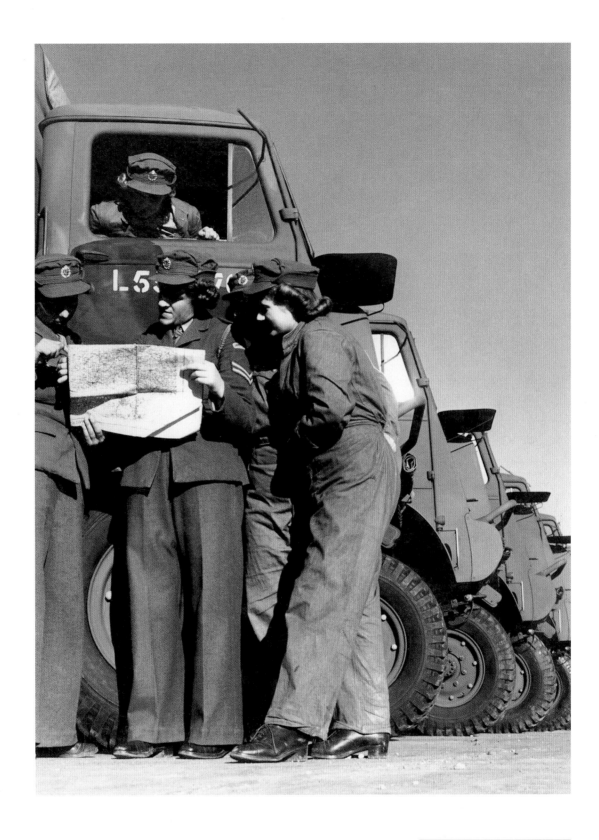

Women during the Second World
War: repairing a car, and lorry
convoy drivers of the ATS (Auxiliary
Territorial Service) studying their
route. British *Vogue*, January 1942.

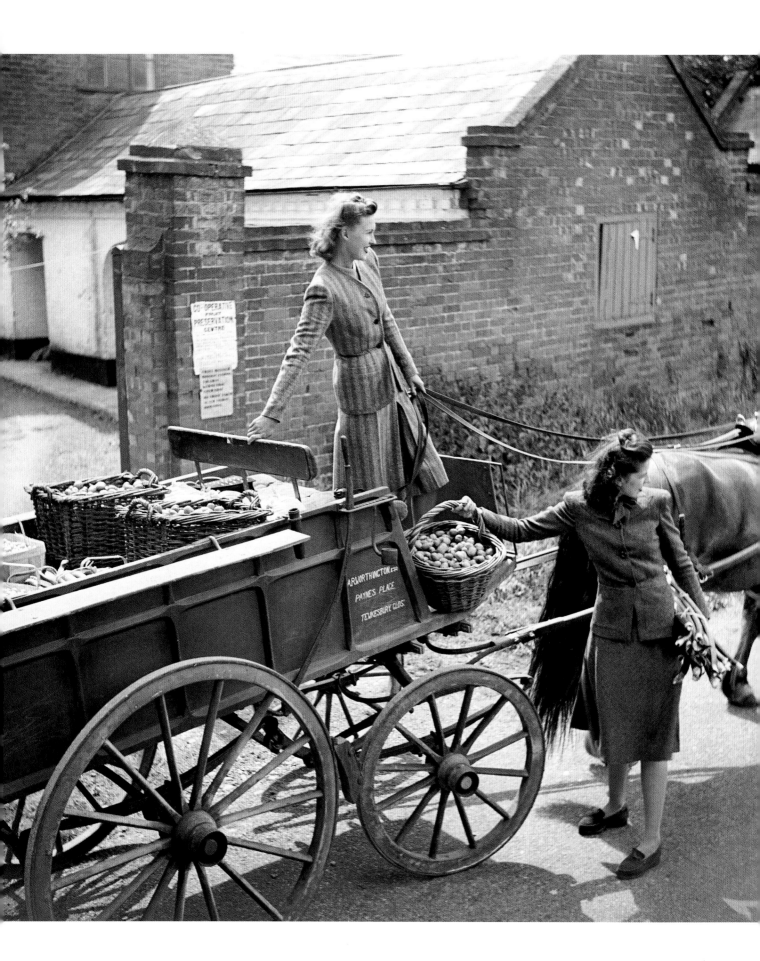

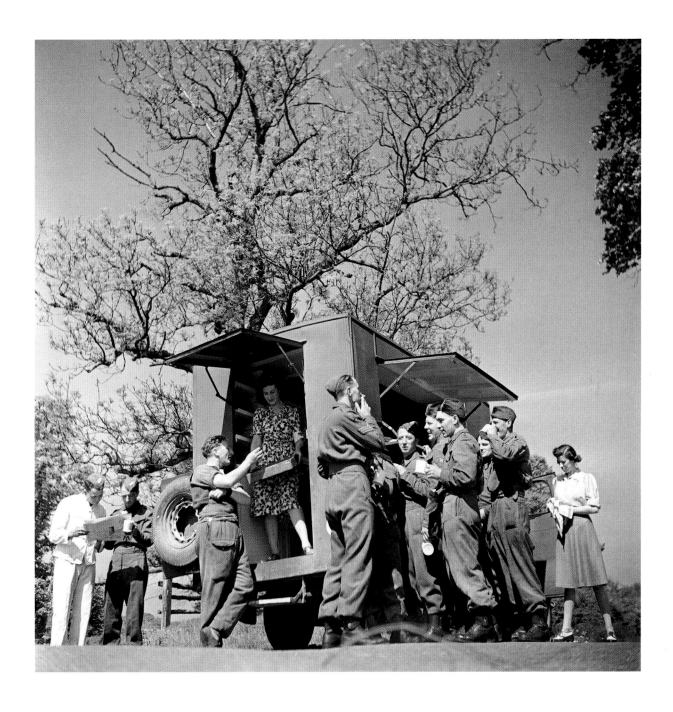

Opposite: Delivering fruit to the Preserving Centre, where members of the Women's Institute and WVS (Women's Voluntary Service) will turn it into jam. The woman on the cart wears a beige and brown tweed cardigan suit from Dorville at John Lewis and the woman on the ground wears a beige and black herringbone suit with a red crêpe blouse from Lillywhites. British *Vogue*, September 1942.

Above: Country women playing their part in the village war effort, visiting men in camp with their mobile YMCA canteen. Woman inside wearing an "Island Story" printed cotton dress from Cresta, the other wearing a silk shirt and a grey skirt, both from Simpsons. Variant photograph published in British *Vogue*, July 1943 in the feature "Country Ways – Community Life".

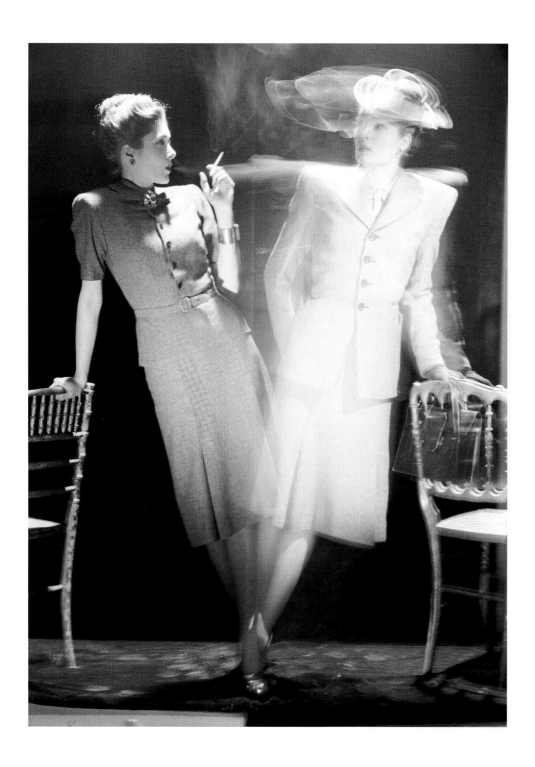

Above: Fashion designer Lachasse experimenting with fabrics despite the coupon shortage. Model (left) wearing a tailored jumper with a matching skirt and (right) a mustard and brown tweed suit with a crêpe shirt. Double exposure published in British *Vogue*, April 1944.

Opposite: Mirrored portrait of a model wearing bright striped tailored shorts and a square-cut jacket from Simpsons. British *Vogue*, June 1946. Originally, this was published in the middle of a double-paged *Vogue* spread so that the mirrored image cleverly folded in half.

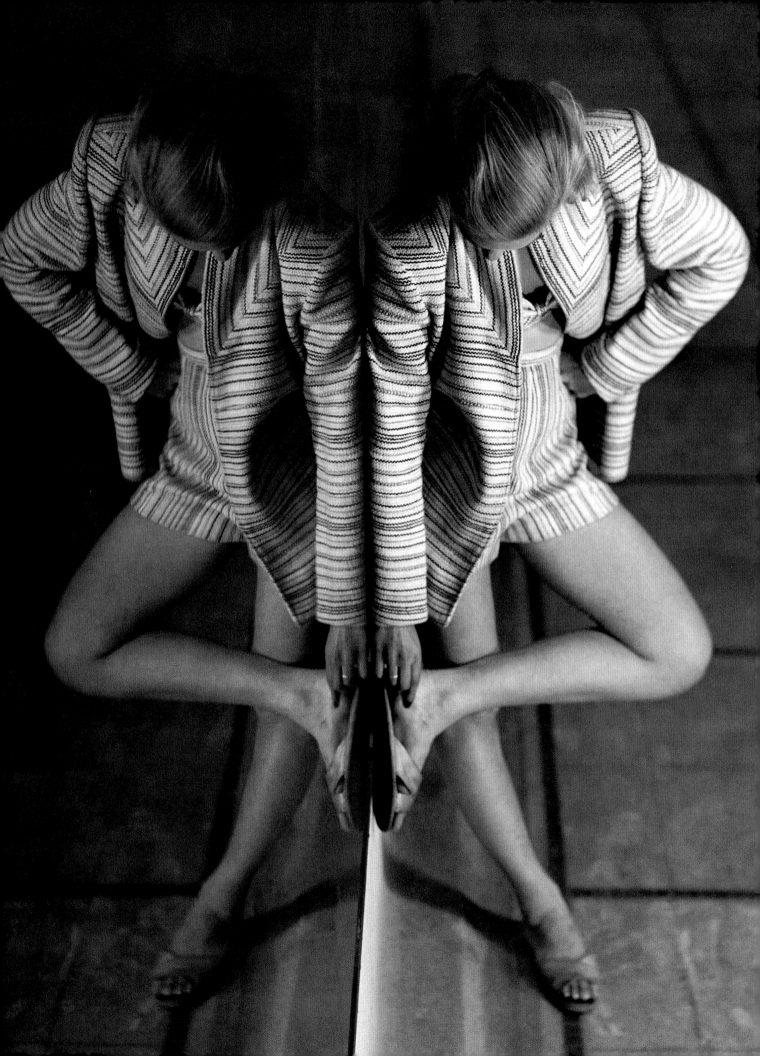

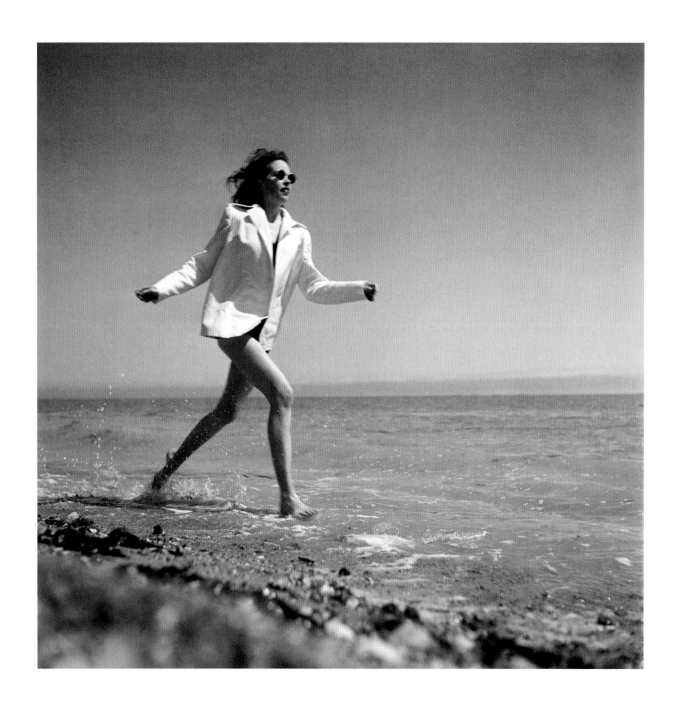

Above: Diana Nadin (1917–1996) photographed at the beach wearing a white waffled piqué jacket over a swimsuit from Fortnum & Mason for a "Blue Days at Sea" feature in British *Vogue*, July 1945.

Opposite: Tree-climbing in brown Bedford cord slacks and a fine wool shirt by Jaeger. Published in British *Vogue*, July 1945 in the feature "Green Days in Forests".

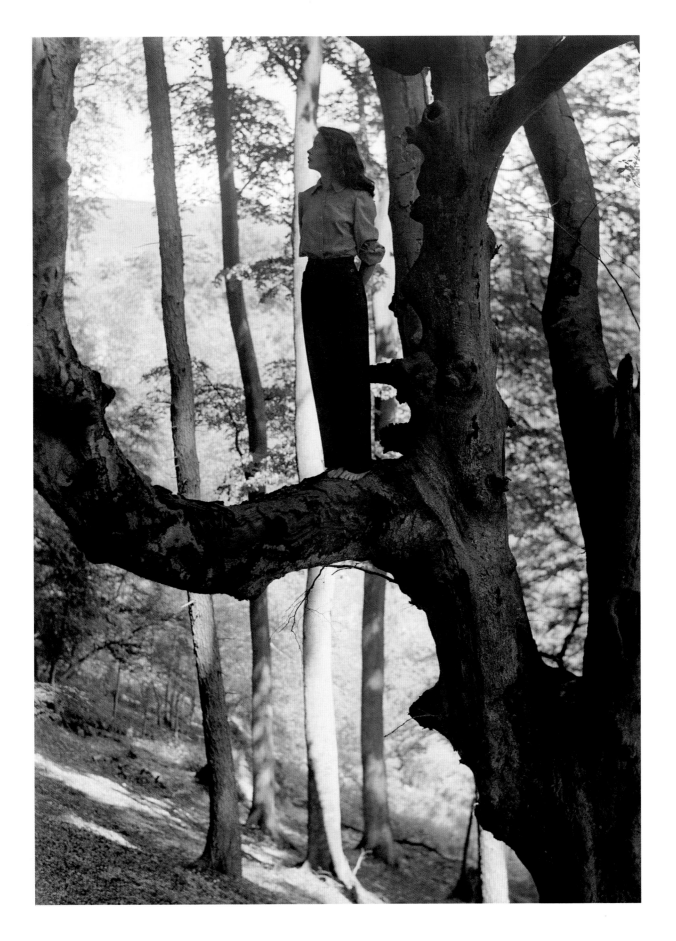

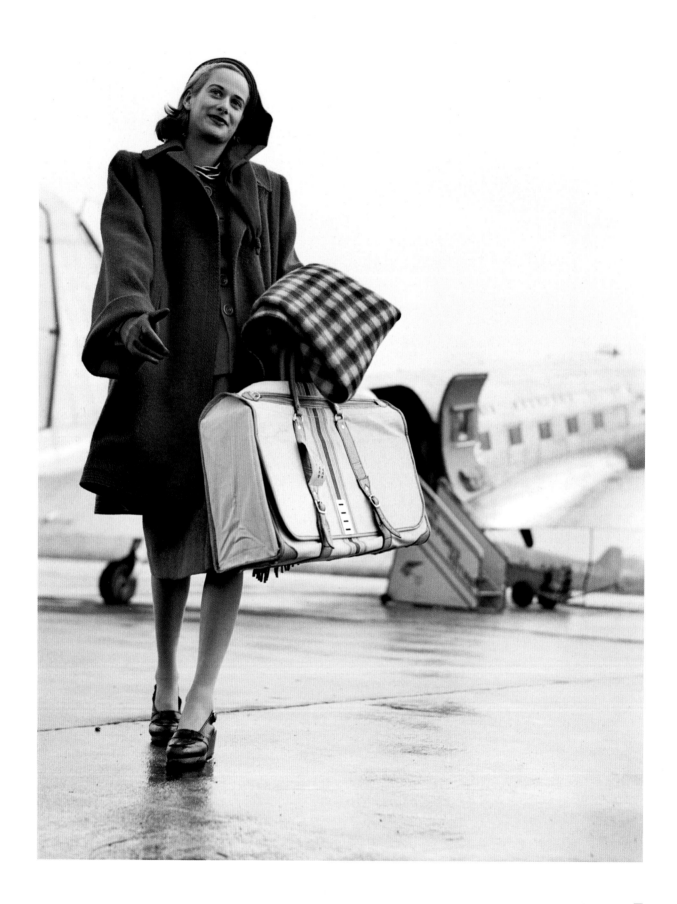

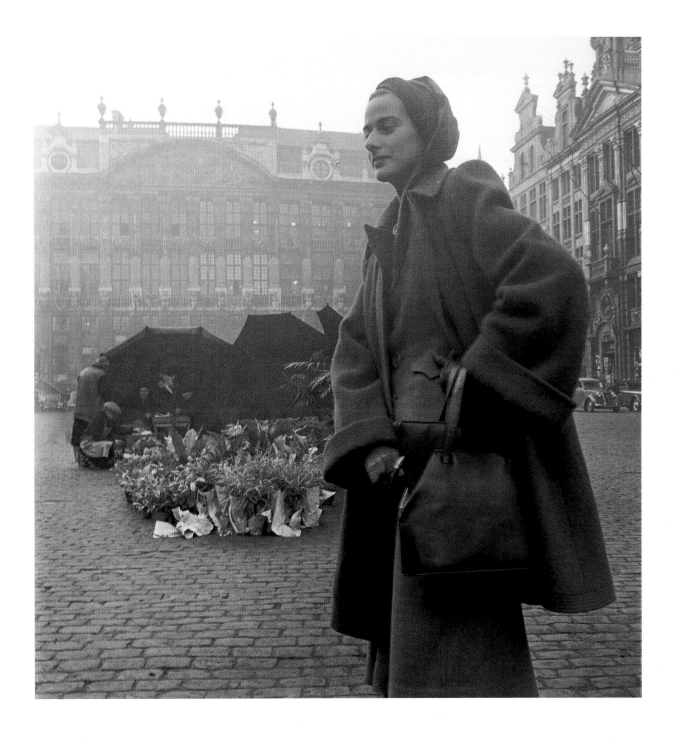

"Week-end in Brussels" – Norman Parkinson's first overseas assignment for *Vogue*. April Hunt is all set for take-off in a red coat, cinnamon stocking cap, a checked rug for the flight and a canvas suitcase all from Debenham & Freebody. Variant pose published in British *Vogue*, February 1947.

At the Grand Place in Brussels wearing a honey tweed suit, cinnamon cap, red coat, gloves and a large handbag, all from Debenham & Freebody.

Wenda Parkinson

British *Vogue*, May 1947

This was the *Vogue* shoot where actress and model Wenda Rogerson met her future husband, Norman Parkinson.

The shoot took place at Vogue Studios in Rathbone Place in March 1947. Wenda was one of four models that day. As she emerged from the dressing room in a tweed coat and large hat, Parkinson said to her, "So, what's under the hat? Oh, it's you."

This 1947 photoshoot would be the start of four decades of creative collaboration, with Wenda as Parkinson's most important muse and inspiration. Launching Wenda's career as an iconic model of the mid-twentieth century, it would also begin their forty-year love story, which continued until her death in 1987.

Wenda married Norman Parkinson in 1951. Born on 17 May 1923, Wenda first trained as an actress at the Royal Academy of Dramatic Art, combining it with occasional fashion modelling. She was recommended to Norman Parkinson by fellow photographer Cecil Beaton, who was immensely impressed by her acting at the Arts Theatre Club in 1946.

She made a lasting impression. In his 1983 autobiography written four years before she died, Norman Parkinson wrote: "Irving Penn had Lisa Fonssagrives, Richard Avedon his Suzy Parker, David Bailey had Shrimpton; and Norman Parkinson had Wenda."

Wenda Parkinson (née Rogerson) modelling fashion from Wallace and Vernier. British *Vogue*, May 1947 – the first *Vogue* shoot for Wenda, where she met her future husband, Norman Parkinson.

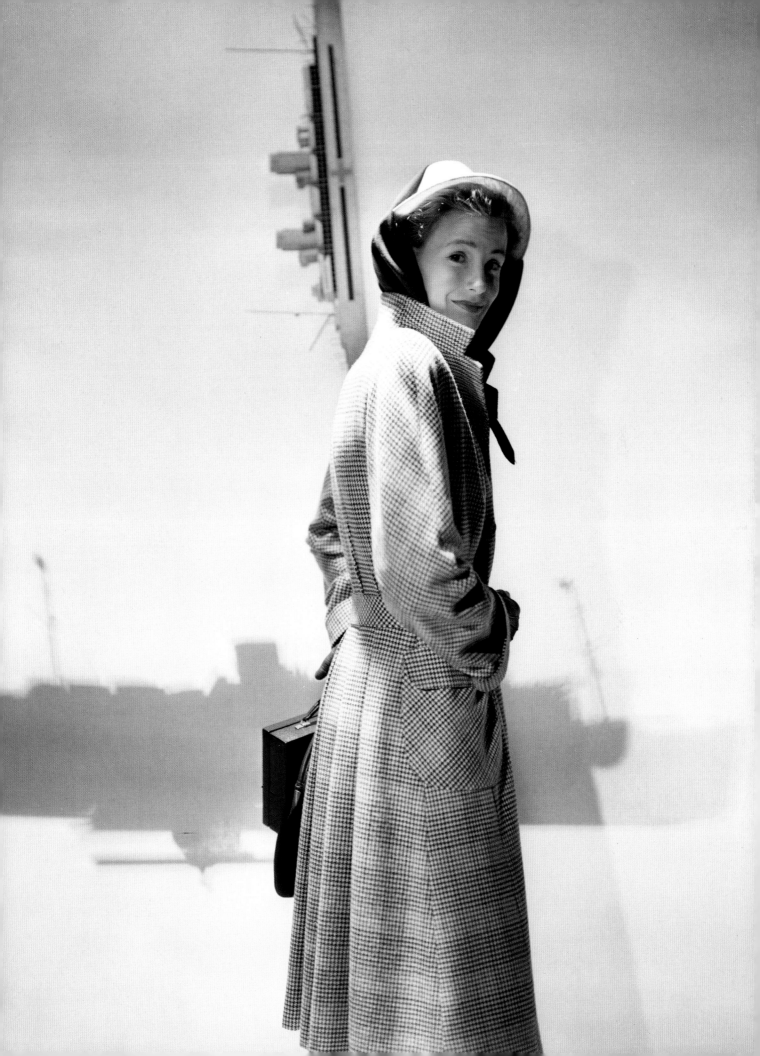

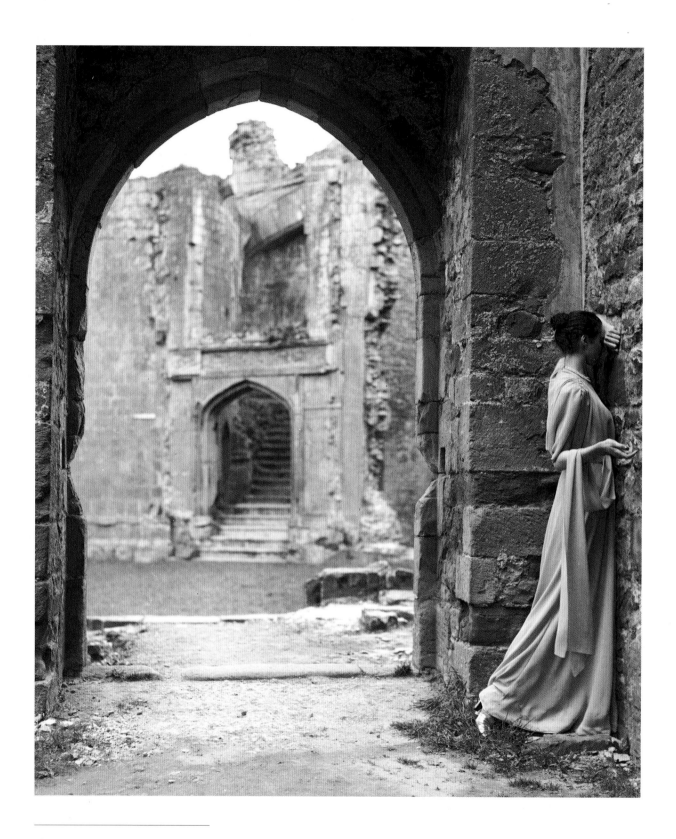

Above: "Woman in White" photostory at Raglan Castle with fashion by Luke at Jays. British *Vogue*, July 1947.

Opposite: "Woman in White" photostory at Tintern Abbey with fashion by Kitty Foster at Ships. British *Vogue*, July 1947.

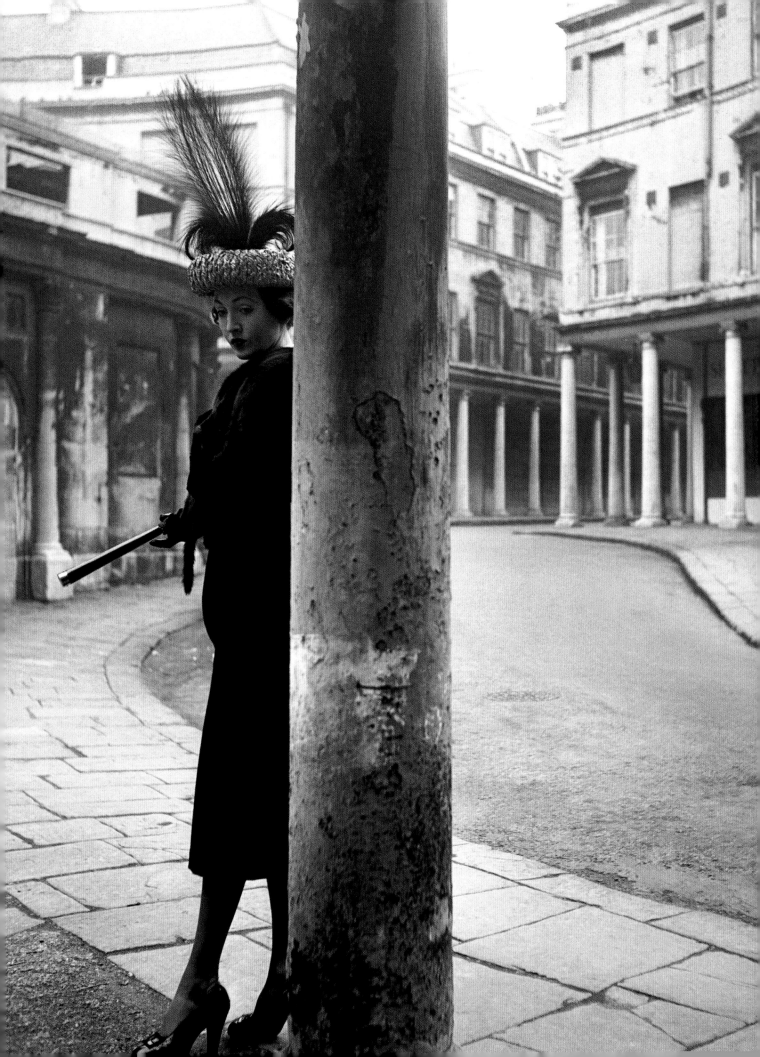

"Spring Hats in Bath" shows model
Anne Chambers photographed in a
Bath street with an elegant hat by
Pissot & Pavy and umbrella from
Galeries Lafayette. British *Vogue*,
February 1948.

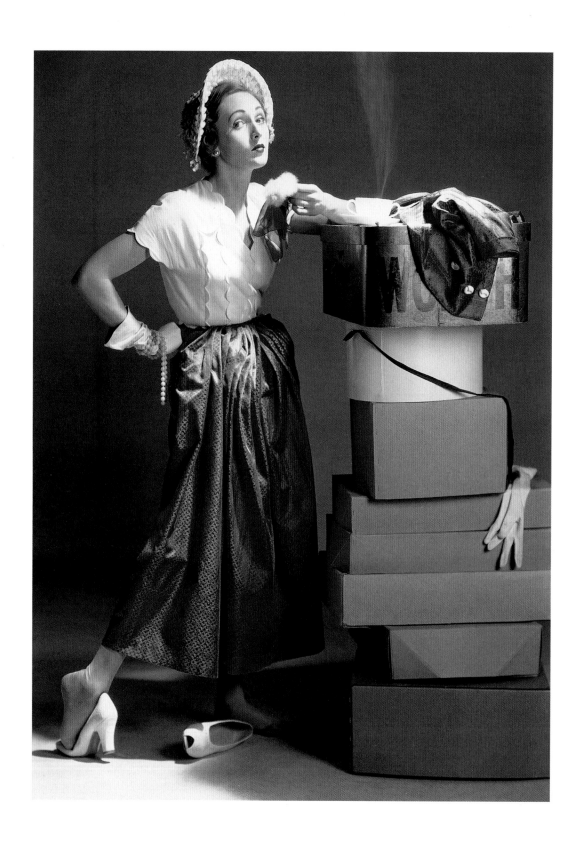

Anne Chambers wearing a brocade skirt suit and scalloped blouse by Worth. British *Vogue*, March 1948.

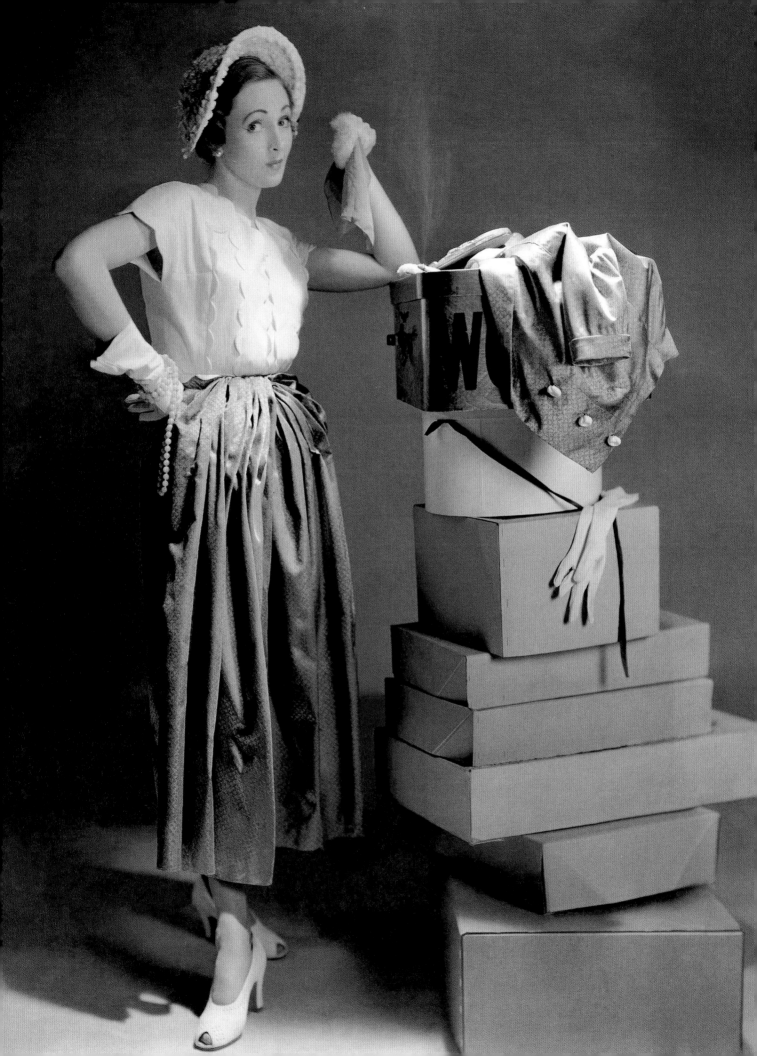

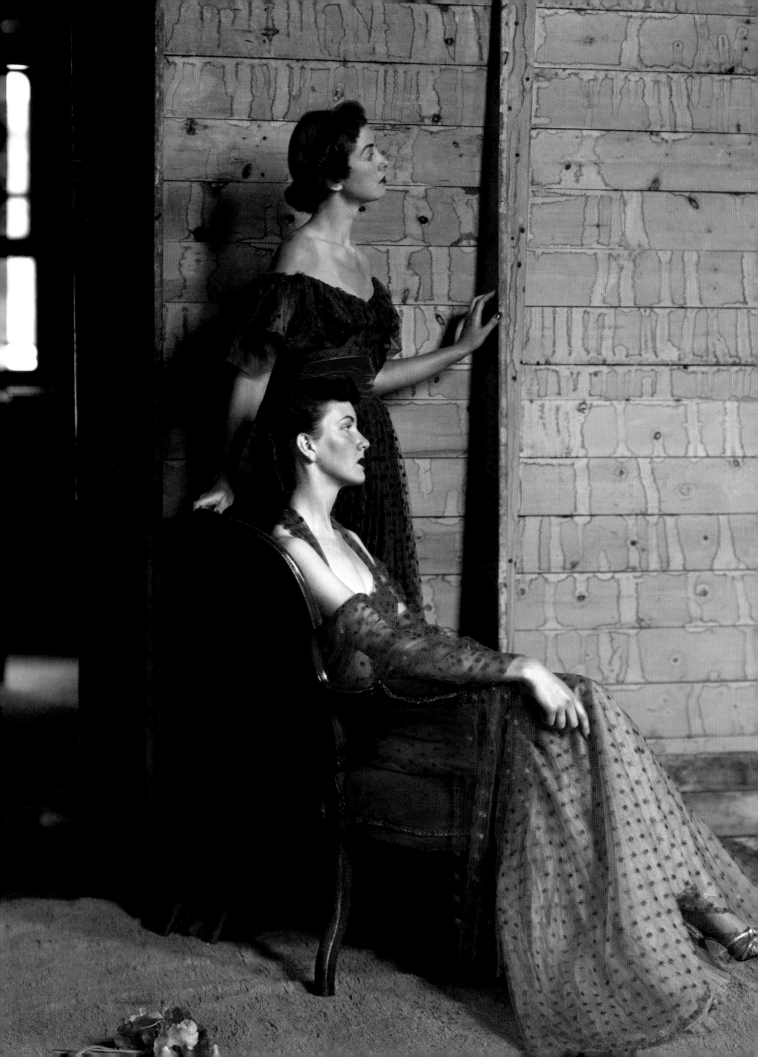

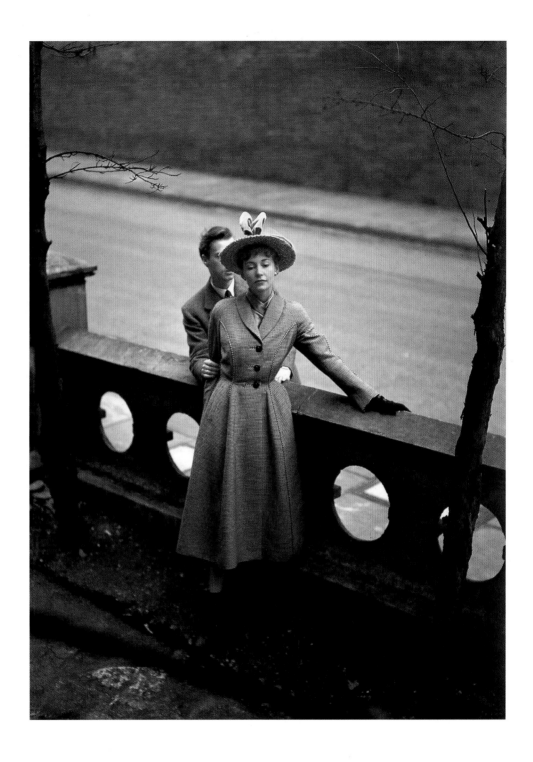

Opposite: Orange star-dotted net dress from Fortnum & Mason by Angele Delanghe and a teal blue off-the-shoulder strapless dress by Mattli. British *Vogue*, October 1948.

Above: John Parsons, Art Editor of British *Vogue* from 1940 to 1965, and a model wearing a striped fitted jacket by Digby Morton made from wool by Dormeuil Frères and a hat from Vernier. British *Vogue*, May 1948.

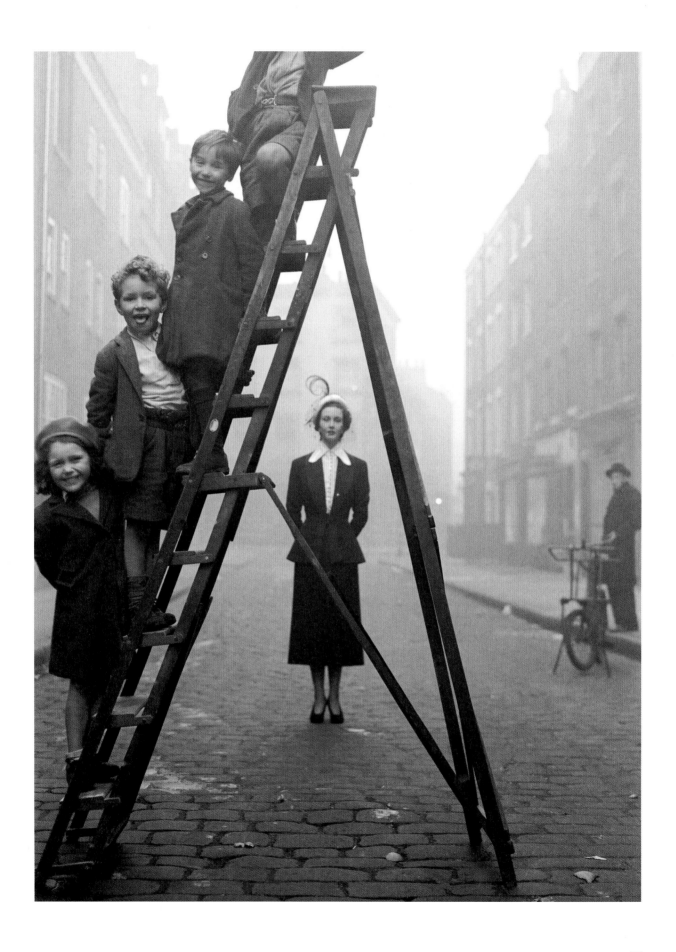

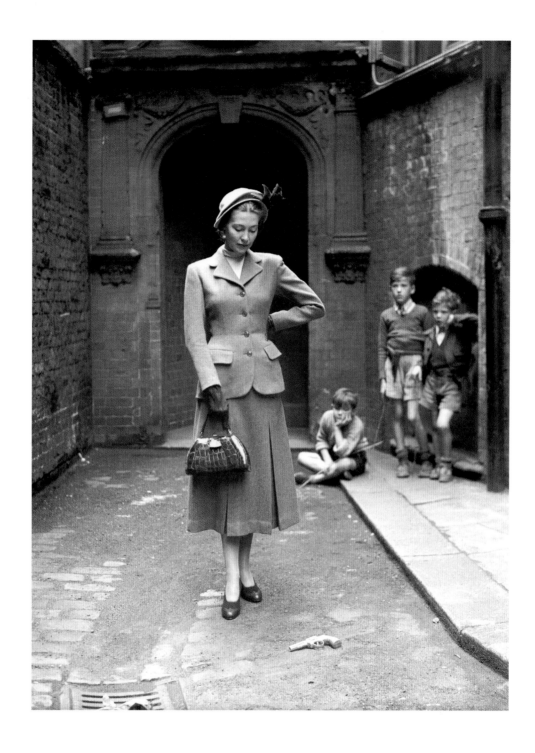

Opposite: Anne Chambers posing behind children climbing a ladder on the streets of post-war London wearing fashion from Jaeger Utility. British *Vogue*, October 1948.

Above: A group of street children's game with a gun forms the background to Norman Parkinson's fashion shoot. Anne Chambers wears a Jaeger two-piece with gloves and bag by Lederer. British *Vogue*, October 1948.

Wenda Parkinson wearing a Hardy
Amies coat. A variant pose was
used for the cover of British *Vogue*,
March 1949.

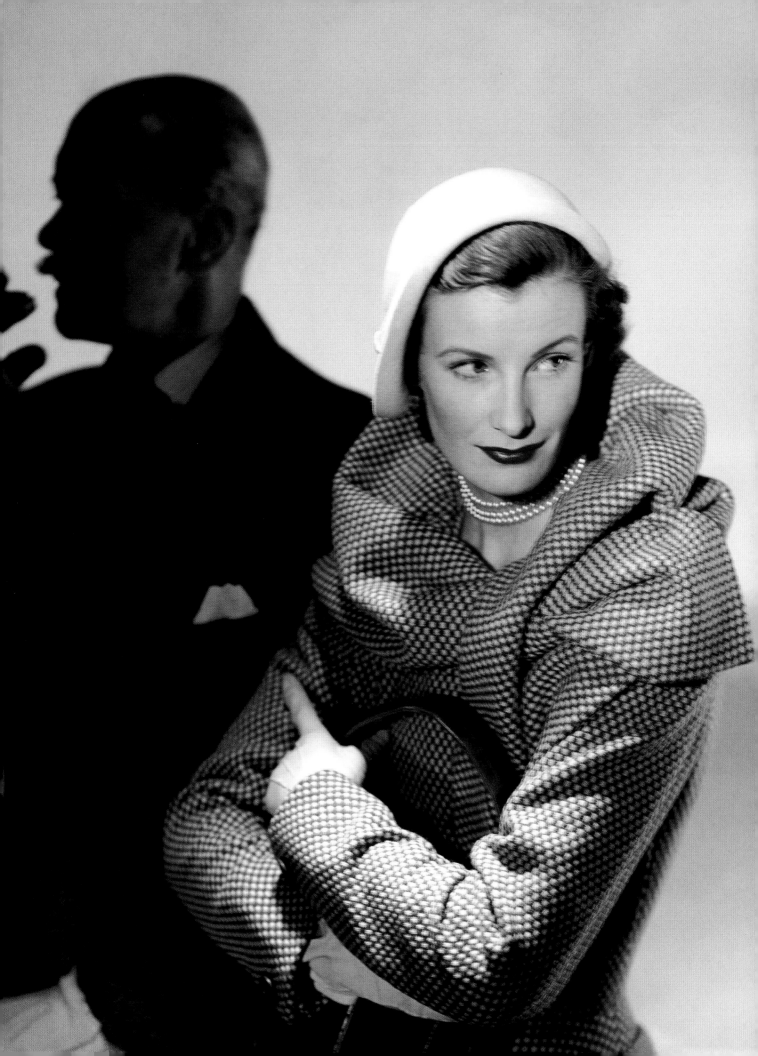

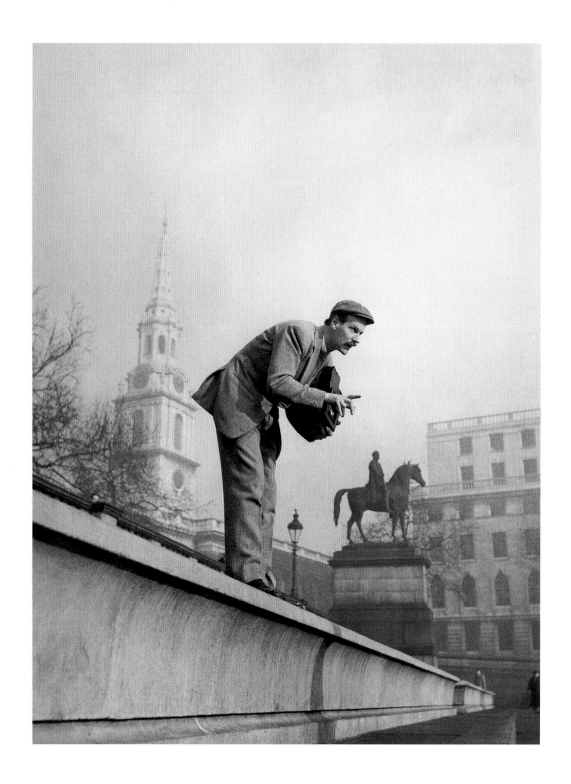

Above: Norman Parkinson capturing the London Collections for British *Vogue* at Trafalgar Square. Photograph by *Vogue* studio manager and colleague Patrick Matthews, 1949.

Opposite: Wenda Parkinson and Barbara Goalen wearing Hardy Amies and Molyneux coats outside the National Gallery on a misty day in Trafalgar Square, London. British *Vogue*, March 1949.

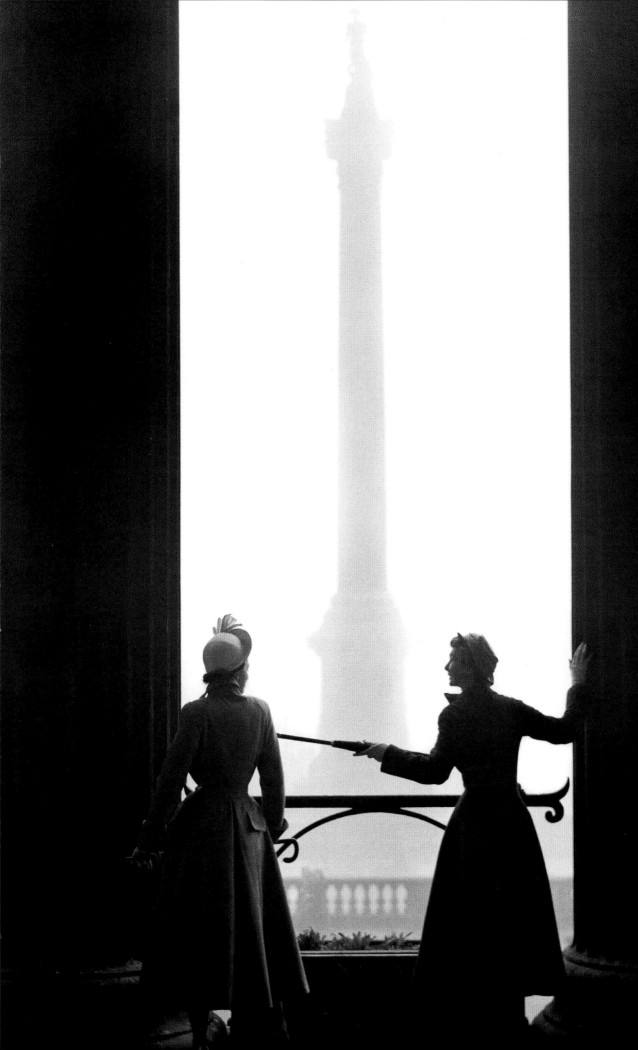

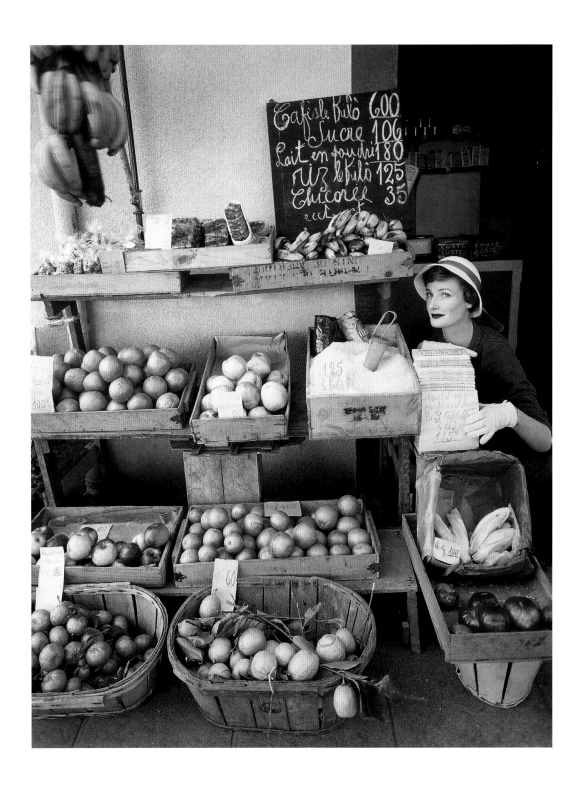

Above: Wenda Parkinson poses at a fruit stall in the south of France. Unpublished out-take for British *Vogue*, May 1950.

Opposite: Wenda Parkinson wearing a grey cotton dress by Spectator Sports at Harrods. Photographed at Cannes Harbour in the south of France. British *Vogue*, May 1950.

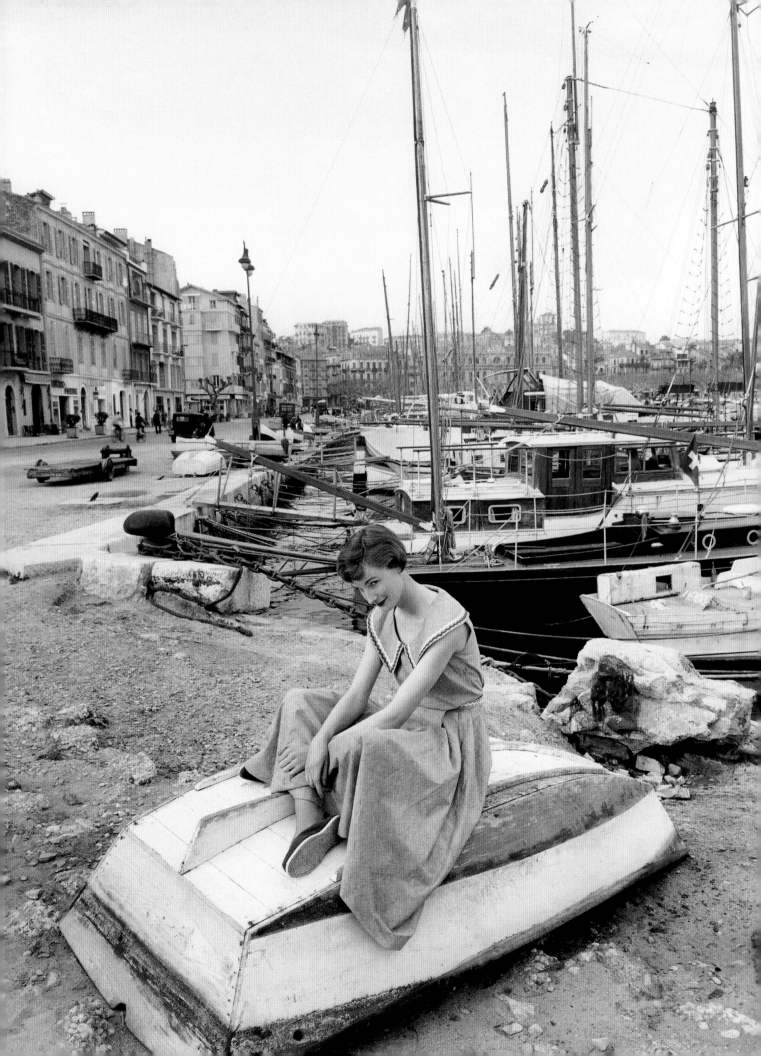

Carmen Dell'Orefice

American *Vogue*, October 1949

Carmen began her professional modelling career aged 15 in 1946 to support herself and her mother financially, having grown up in the boroughs of Manhattan during the Depression. Her first *Vogue* cover at this age was taken by Erwin Blumenfeld, and she was paid $7.50 per hour.

Norman Parkinson first photographed Carmen for American *Vogue* in 1949, which she vividly and fondly recalled in a BBC interview 70 years later: "It was very romantic and full of imagination. I was 17 years old and here I am, all dressed up on the balcony of the Plaza Hotel. I'm in the ideal strapless grey taffeta dress. I felt I was in perfect condition, in the perfect setting — this man must fall in love with me. I mean, that's the mentality of the time, and what a staggering presence Mr Parkinson, né Ronald Smith, had. The shoot went perfectly, it was an unspoken dance."

Parkinson and Carmen collaborated on many more editorial, advertising and cover shoots throughout the 1950s to the 1980s and enjoyed a close friendship. As Parkinson remarked of the iconic model, "In 1945 Carmen had potential and promise but in intervening years she has acquired an inimitable elegant maturity which I hope I have captured."

He later wrote in 1983, "Carmen has been my best friend for over thirty years. She is a double female, hilariously funny but wise, electrically charged with the ability to reject the absurdity of the rat race circuit, always ready to lift those expressive, recently European eyes to question the pompous or over-sycophantic."

Carmen Dell'Orefice wearing a Ceil Chapman gown at the Sherry Netherland Hotel in New York. American *Vogue*, 1 October 1949. This was Carmen's first time photographed by Norman Parkinson in *Vogue*.

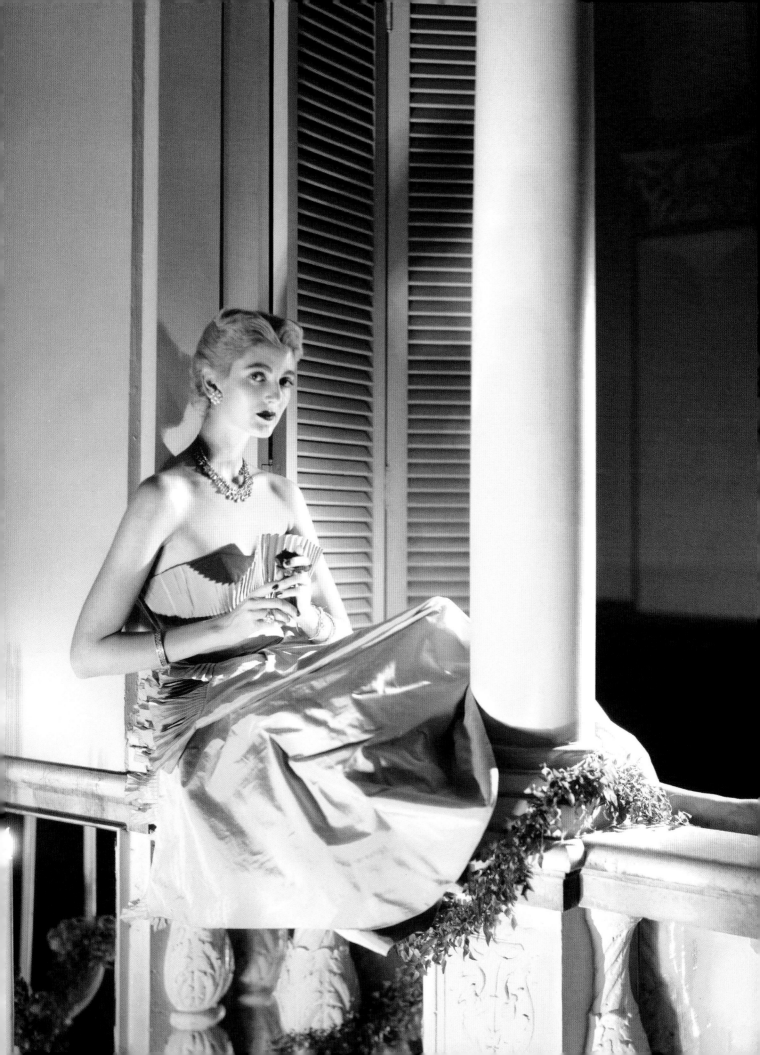

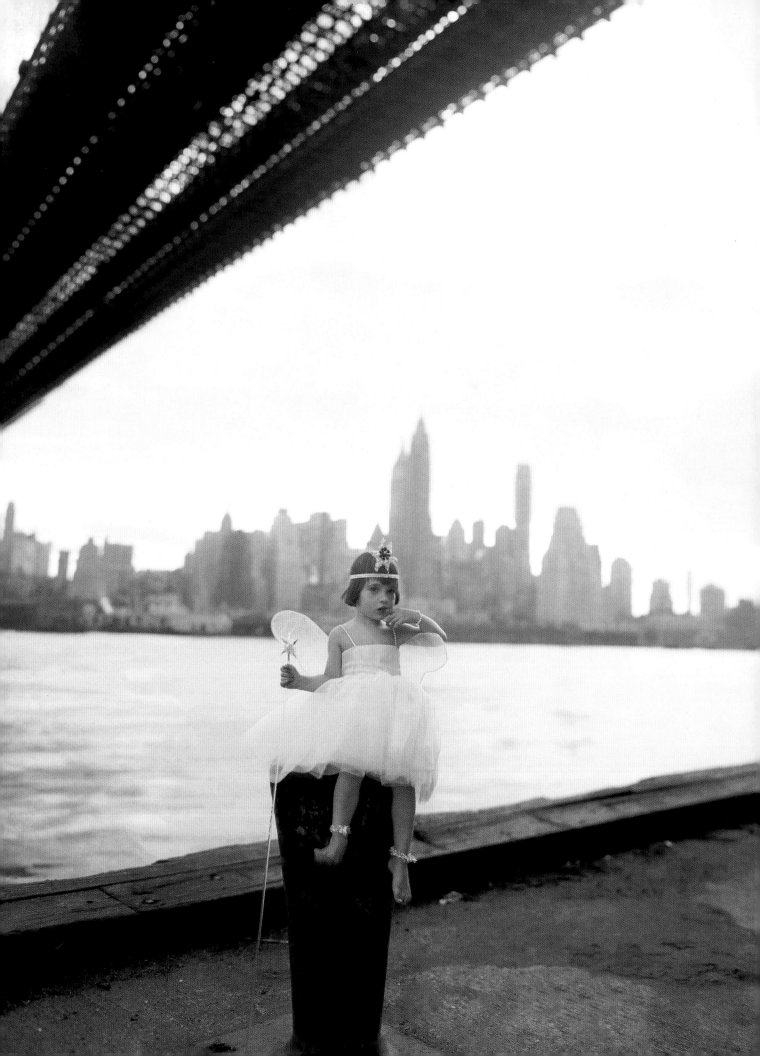

"Baba" Hope Hatch as the Christmas
Fairy, photographed during Norman
Parkinson's first contract with American
Vogue, 1 December 1949. The contract
allowed him to spend a few months each
year in New York, where he created some
of his most memorable works.

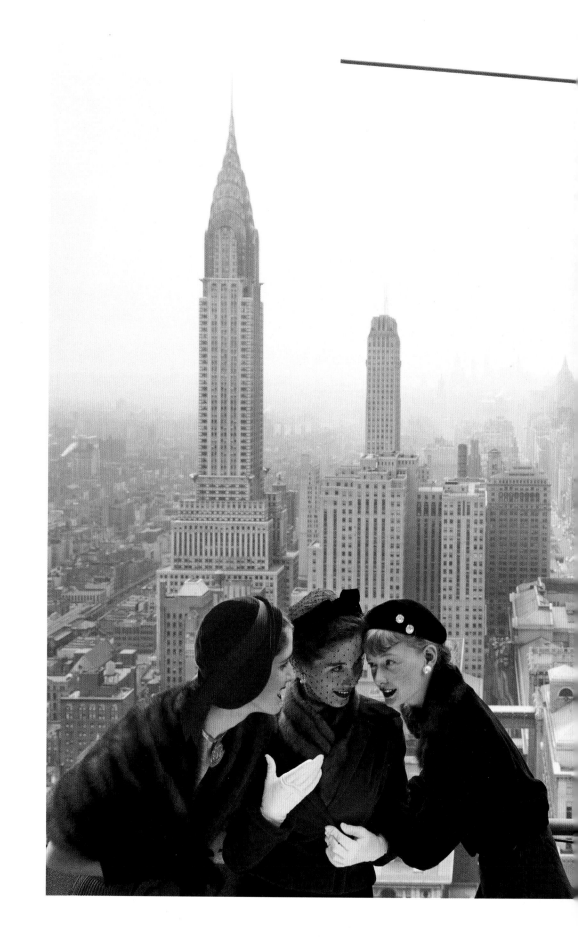

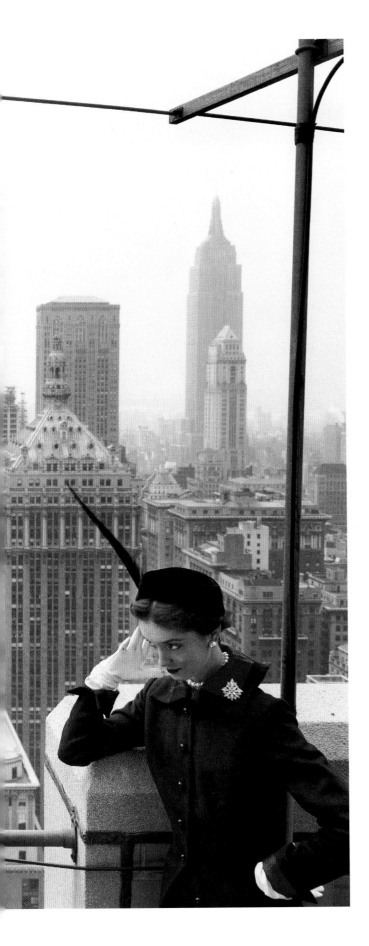

Fashion models including Rian
Taggart and Maggie McNamara
wear a variety of hats on the roof
of the Condé Nast building on
Lexington Avenue, New York City.
American *Vogue*, 15 October 1949.

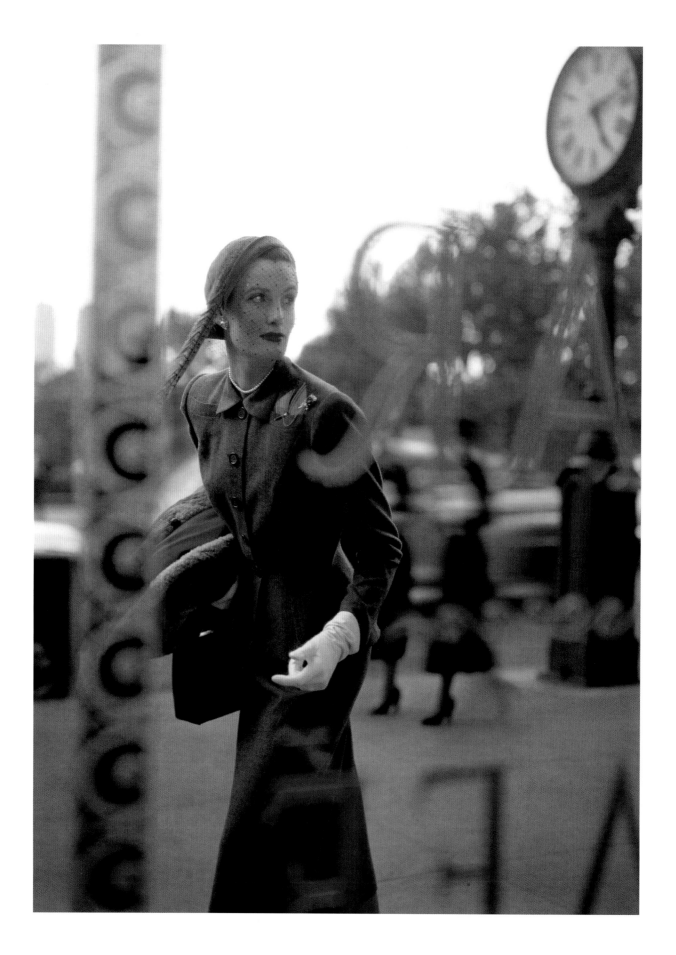

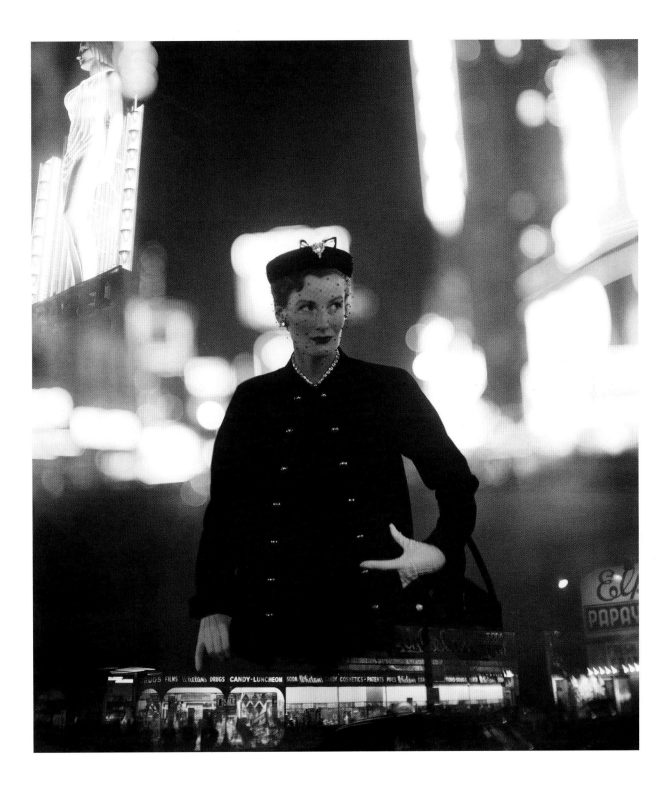

Opposite: Wenda Parkinson wearing a Fortnum & Mason suit in front of the Sherry Netherland Hotel in New York. Cover of American *Vogue*, 1 October 1949.

Above: Wenda Parkinson wearing a suit by Kraus in Times Square, New York. American *Vogue*, 1 September 1949.

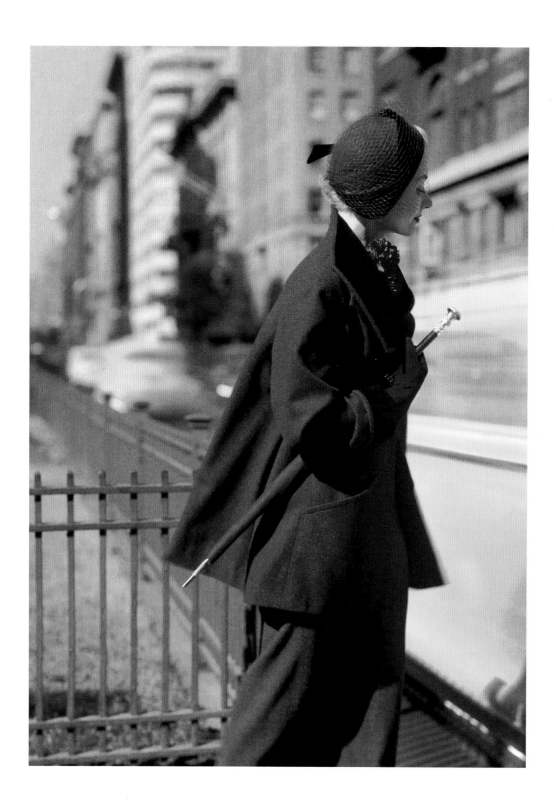

Lisa Fonssagrives photographed on Park Avenue,
New York wearing an Oxford flannel fingertip
coat by Hattie Carnegie. American *Vogue*,
1 September 1949.

Kathy Dennis wearing a Schiaparelli-inspired
coat. Cover of American *Vogue*, 1 November 1949.

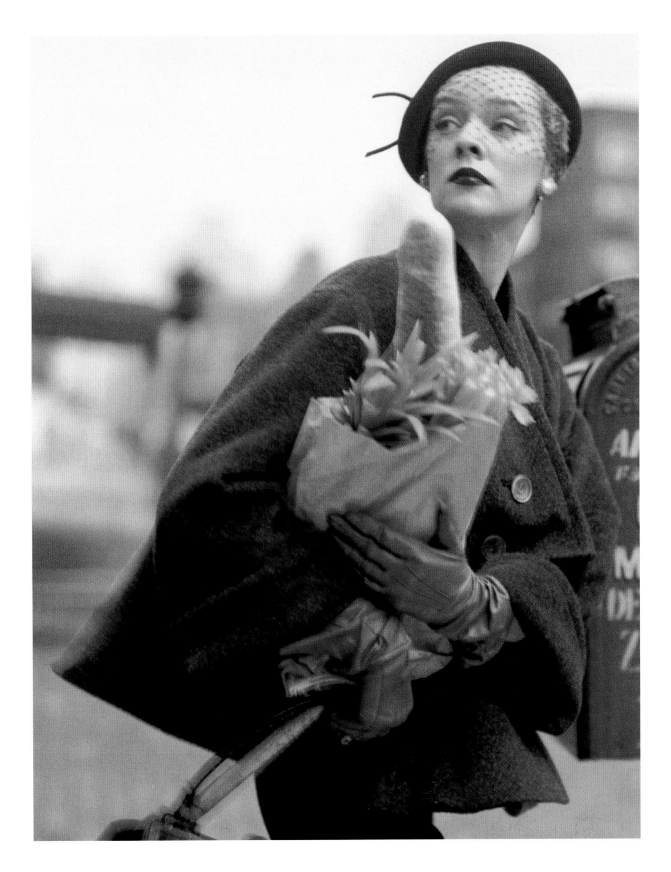

1 9

5　　　0s

The 1950s began with commissions from British and American *Vogue* to photograph the Paris collections in colour, in an extended photograph series in Paris and New York, during which Parkinson created some of his most memorable images of haute couture. His models included Jean Patchett in an evening dress by Jean Dessès and Maxime de la Falaise in Dior's "Mozart" dress in the music room of Madame Georges Menier, and Regine Debrise striking dramatic poses in New York.

Images of Wenda Parkinson in the early 1950s – during the years just before and after their marriage in 1951 – have become timeless records of their perfect collaborations as photographer and muse. When Wenda and Parkinson first met in Vogue Studios in 1947, both were married and the intervening years were spent overcoming different problems to be free to marry each other when their respective divorces became final. Parkinson's photograph of Wenda modelling a Hardy Amies dress with her 1920s Pierrot doll is shown here in a variant pose, rather than the decapitated version chosen for British *Vogue*'s March 1950 cover.

Parkinson was also making great images with fashion models who had contrasting but equally eye-catching looks, such as Enid Boulting who had come to England from South Africa aged 18, to find a brighter future than she could hope to achieve as an actress back home. Her first daughter would later be a major fashion icon of the 1970s named Ingrid Boulting, to be seen later in this book.

Vogue's modelling contest, in which Parkinson was an active jury member, launched the careers of many new names, including Judy Dent and Grace Coddington in the year of 1959. Perhaps Parkinson's greatest success of the 1950s was seeing the potential of Nena von Schlebrügge for the 1955 Scandinavia issue. Two years later he launched her career with two stories in *Vogue* at the Brussels International Fair and a wonderful journey by car through Italy as well as in London locations.

When Parkinson first joined *Vogue* in July 1941, over ninety per cent of his first few years of work were fashion photographs, but as the decades progressed more, he took many important portraits. First, he captured the young emerging stars such as singer Petula Clark, photographing her twice in 1947. In June 1948 he shot an early iconic study of Britain's best-known sculptor Henry Moore at the Battersea Park Open-Air Sculpture Exhibition, in front of his *Three Standing Figures*. A year later, Parkinson began a long collaboration with *Vogue* Features Editor Siriol Hugh Jones, who would introduce Parkinson to many of the most important artists, writers, intellectuals, theatre and music personalities throughout the 1950s, often accompanied by her texts.

Parkinson would become a leading *Vogue* portraitist in the 1950s to rival others such as Cecil Beaton and Irving Penn. Shown in this chapter are some of Parkinson's most important images of the decade: stage and film star Audrey Hepburn, photographed on stage in New York (the first image of the star published in *Vogue*); American stars at the height of their fame, including Montgomery Clift during the filming of *I Confess* and Katharine Hepburn while appearing on the London stage in *The Millionairess*. Other images show Marlene Dietrich during her performance at the Café de Paris; bombshell star Anita Ekberg at the time of *War and Peace*; and Jean Seberg, star of Otto Preminger's film *Saint Joan* on the roof of the Dorchester Hotel.

One of Parkinson's best society portraits shows Deborah (née Mitford), Duchess of Devonshire at Chatsworth House in front of Holbein's painting of Henry VIII.

In London, he photographed a number of film directors, such as Alfred Hitchcock. Important to mention are his documentation of John Huston's compelling pose on the set of *Moby Dick* and later images of Joseph Losey and Vittorio De Sica.

Wenda Parkinson in a Hardy Amies short evening dress. This image was an out-take for British *Vogue*'s March 1950 cover, which was cropped dramatically so you could not see her face.

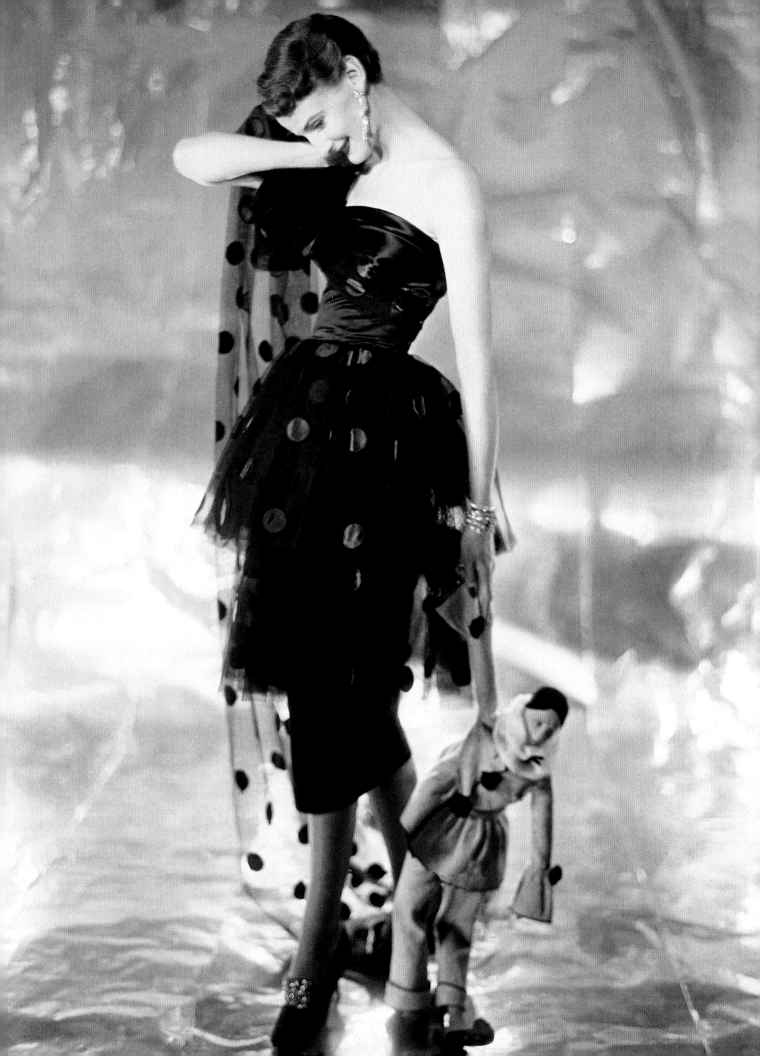

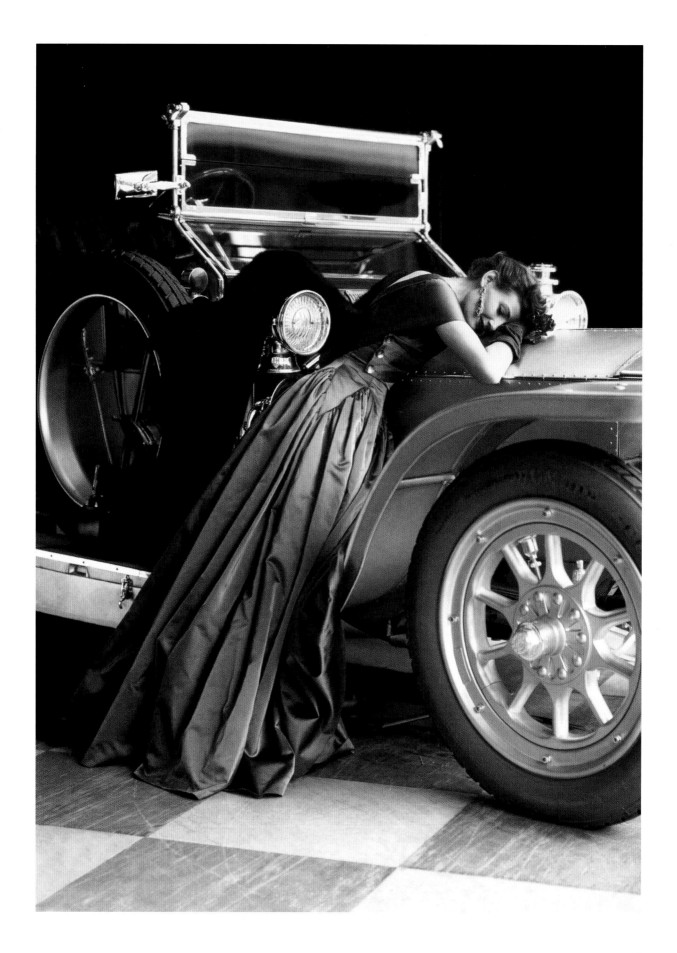

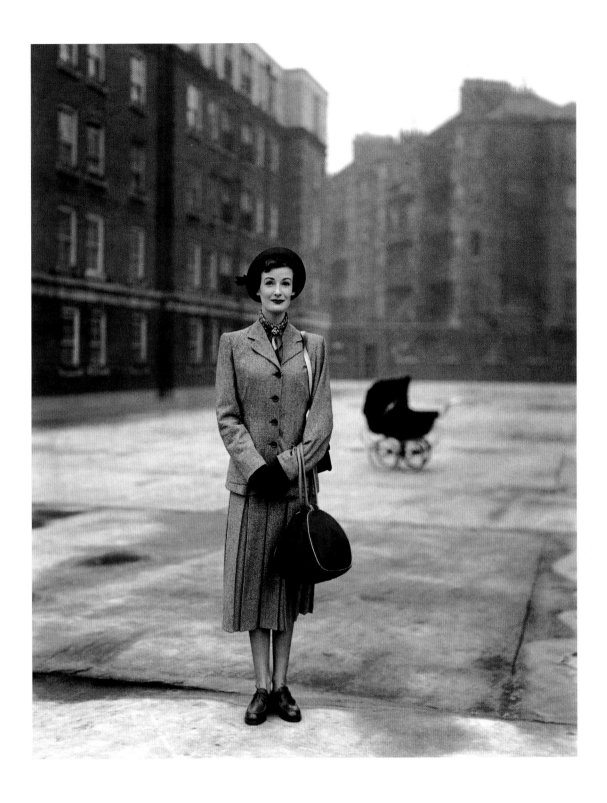

Opposite: Wenda Parkinson modelling a
Molyneux satin evening dress, with a 1907 Rolls-
Royce Silver Ghost. British *Vogue*, April 1950.

Above: Wenda Parkinson wearing a Simpsons
suit at the Peabody Trust Buildings on Fulham
Road in London. British *Vogue*, February 1950.

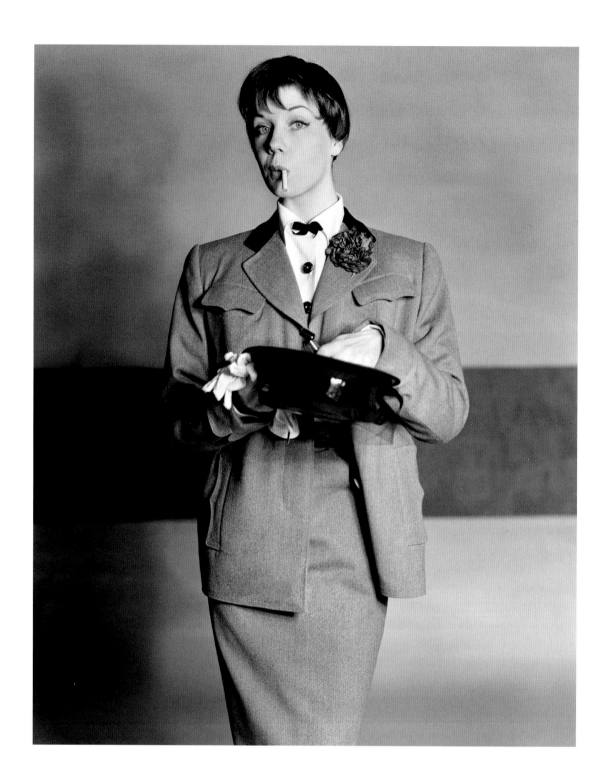

Above: Photostory titled "Impertinence": Enid Boulting wearing a Helena Geffers suit. British *Vogue*, March 1950.

Opposite: Enid Boulting wearing Charles Creed's "Florentine" black and bronze brocade plunge neck dress and Tabu perfume by Dana. Photograph taken at Barry Craig's studio for British *Vogue*, April 1950.

Above: Régine Debrise photographed at the Carlyle Hotel in New York wearing a taffeta Balenciaga gown. American *Vogue*, 15 October 1950.

Opposite: Maxime de la Falaise wearing Christian Dior's "Mozart" dress. Photographed in the music room of Madame Georges Menier for American *Vogue*, 1 April 1950.

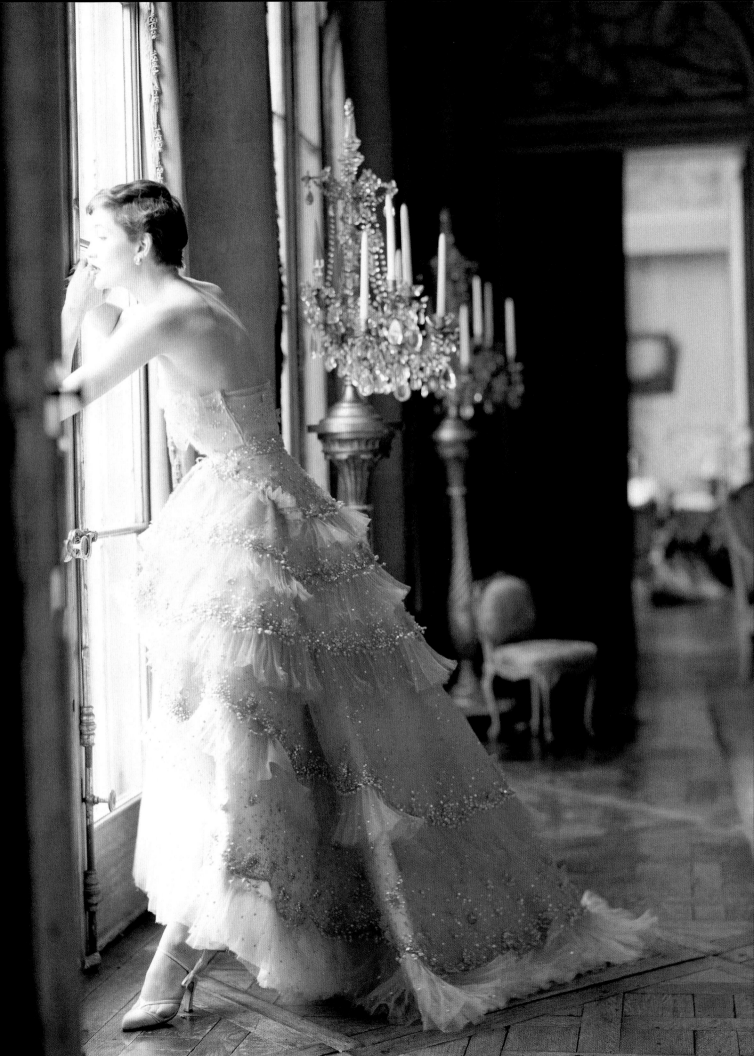

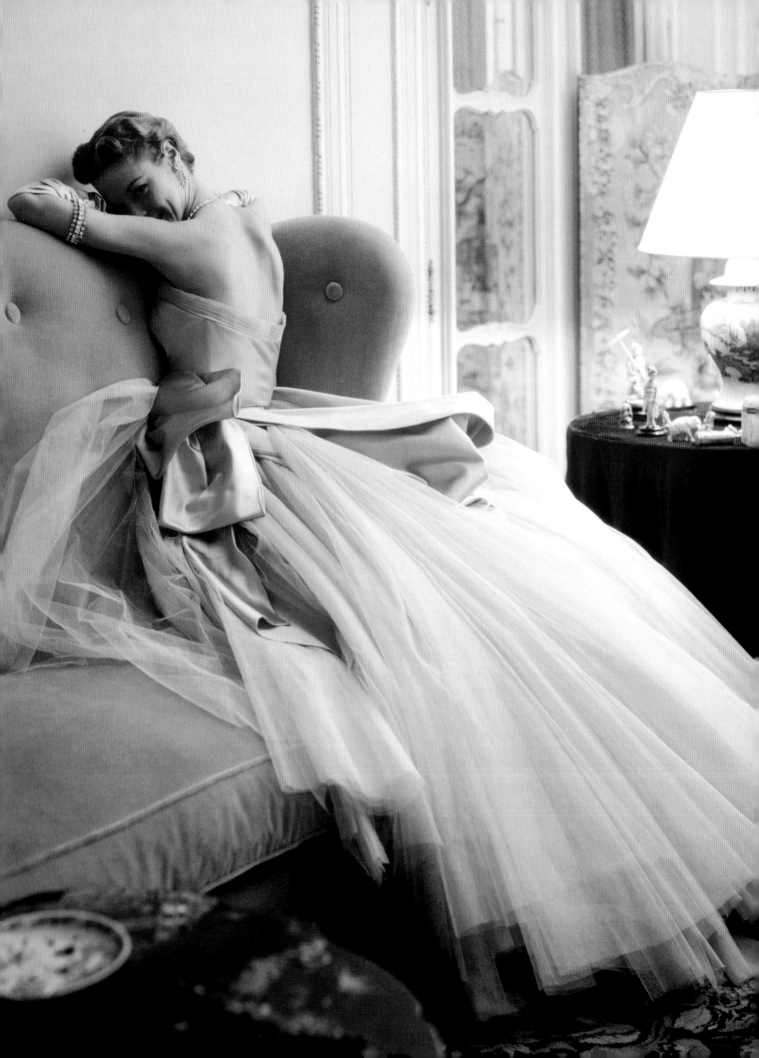

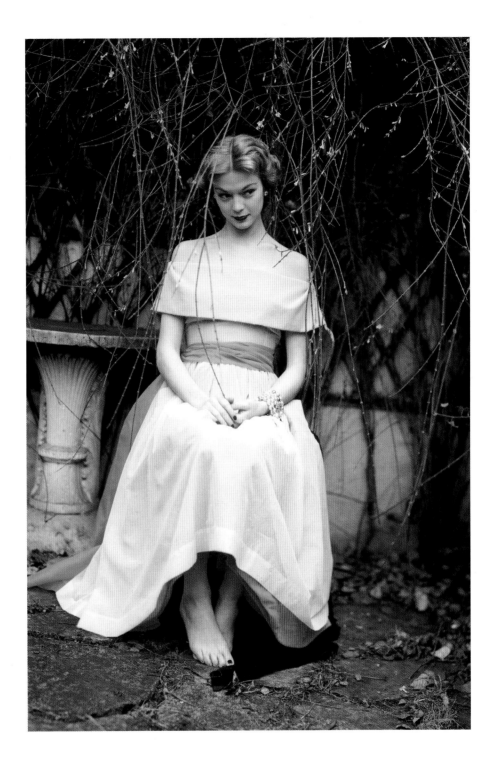

Opposite: Jean Patchett wearing a Jean Dessès evening gown in the designer's Parisian apartment. American *Vogue*, 1 April 1950.

Above: Out-take photograph of Jean Patchett for American *Vogue*, 15 March 1950.

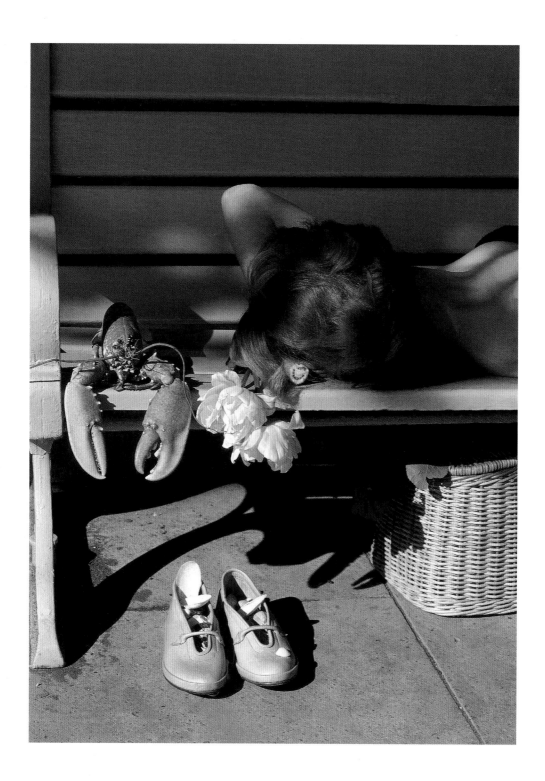

Above: Georgina Morris with a Harvey Nichols' fisherman's creel basket and shoes by Brevitt at Pines. Photographed in Brighton for the cover of British *Vogue*, July 1949.

Opposite: Della Oake wearing jewelled glasses by C. Lloyd Harding, antique paste ornaments from Cameo Corner and copper red lipstick from Yardley. Cover of British *Vogue*, May 1950.

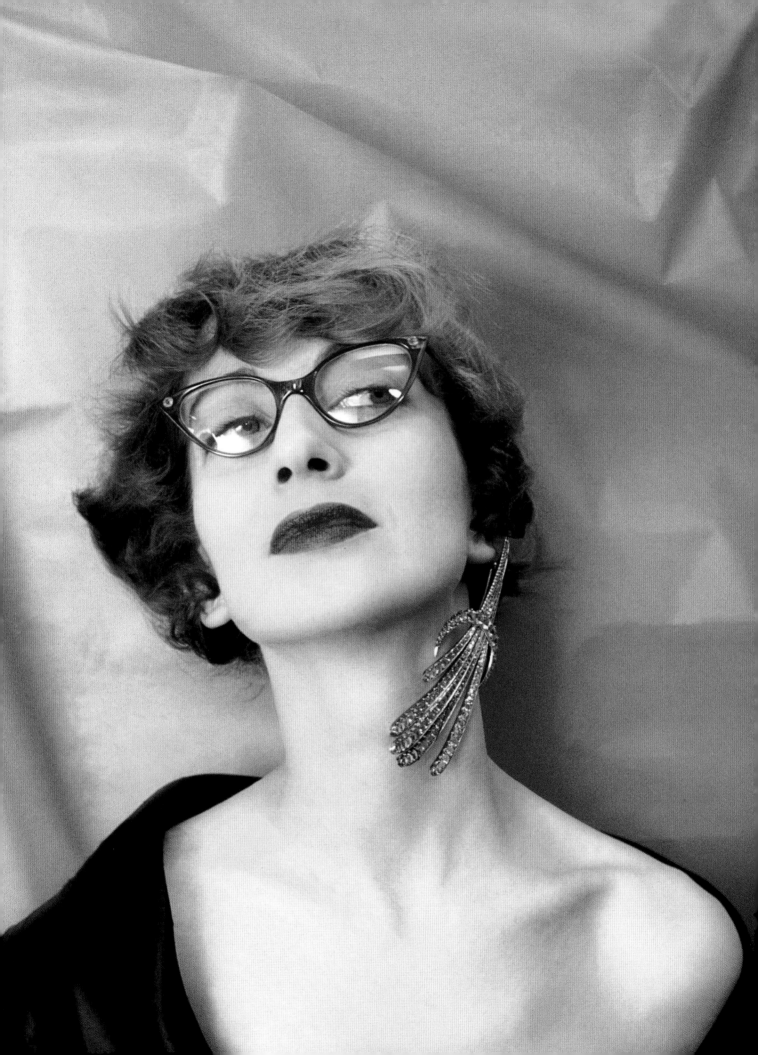

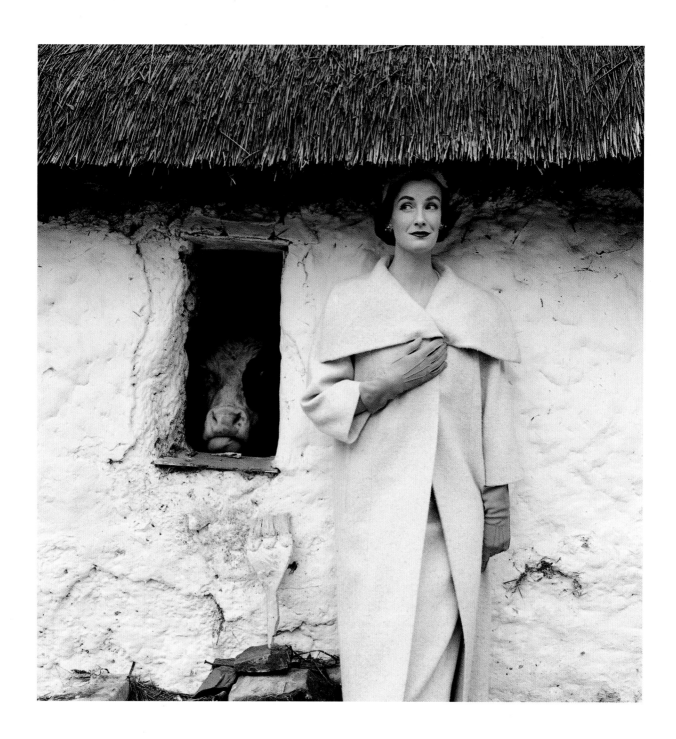

Above: Wenda Parkinson photographed in Ireland wearing a Sybil Connolly tweed coat. American *Vogue*, 15 March 1954.

Opposite: Wenda Parkinson wearing a tweed suit by Hardy Amies with a Swayne umbrella. Photographed near Rotten Row at Hyde Park Corner in London for British *Vogue*, February 1951.

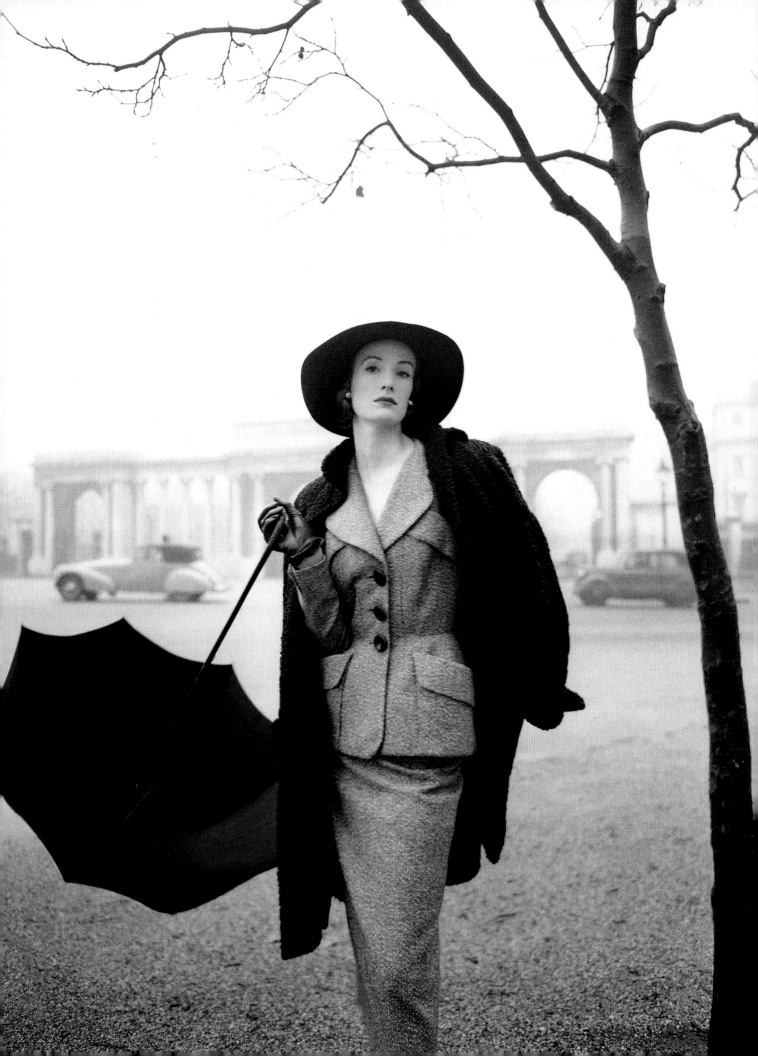

Right: (top) Wenda Parkinson wears a Burberry coat with matching rain hat, Lilley & Skinner boots and Faust gloves. Feature entitled "Deep-Country Quality" for British *Vogue*, February 1951.

(bottom) Summer picnic with Wenda and her niece Caroline Owen; Mary Robertson and son Simon Parkinson. British *Vogue*, July 1951.

Opposite: Wenda Parkinson wearing a Scottish tweed skirt-suit by Surmise. British *Vogue*, September 1951.

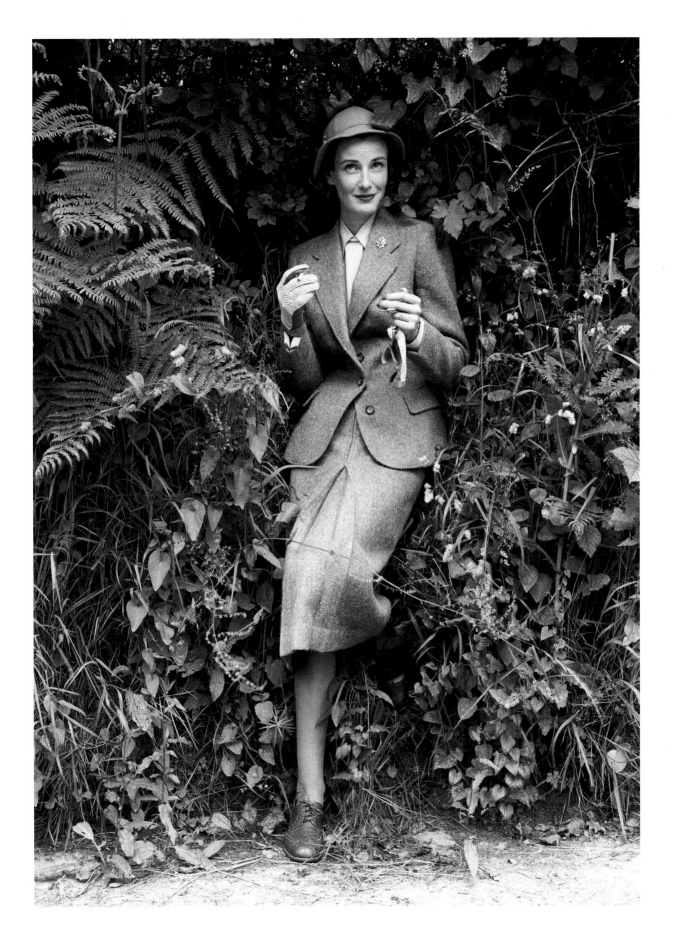

Wenda Parkinson wearing
a grey gabardine dress by
Dorville at George Airfield
in Nairobi, Kenya, next to a
Hermes aeroplane. British
Vogue, May 1951.

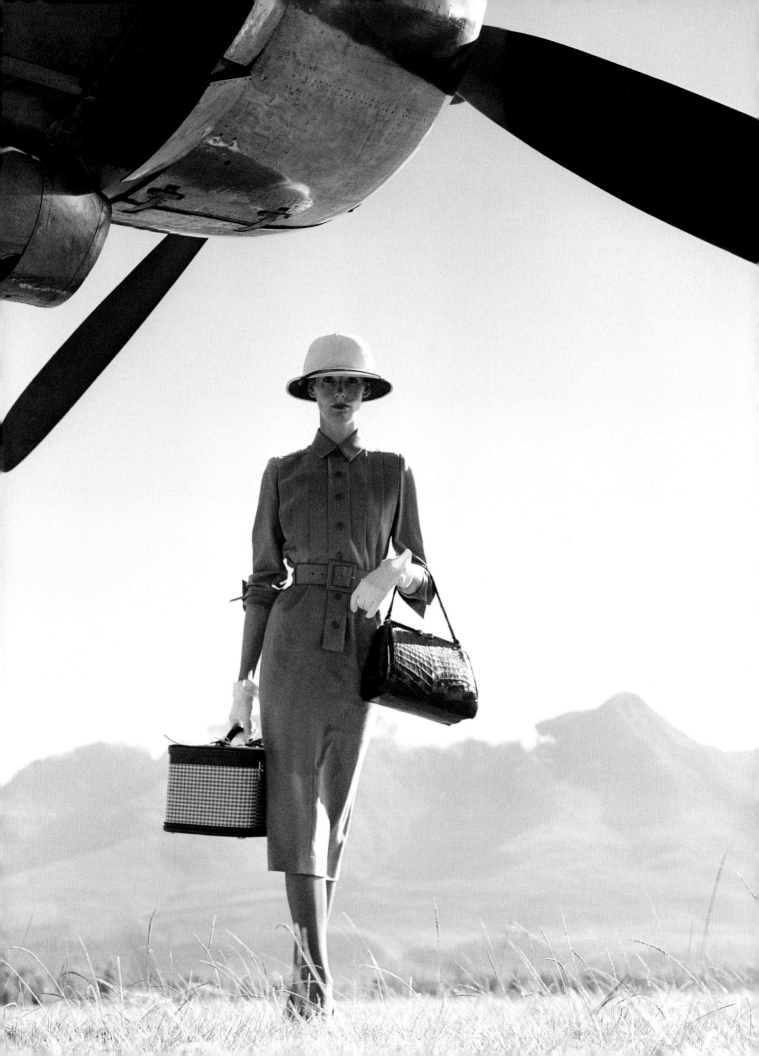

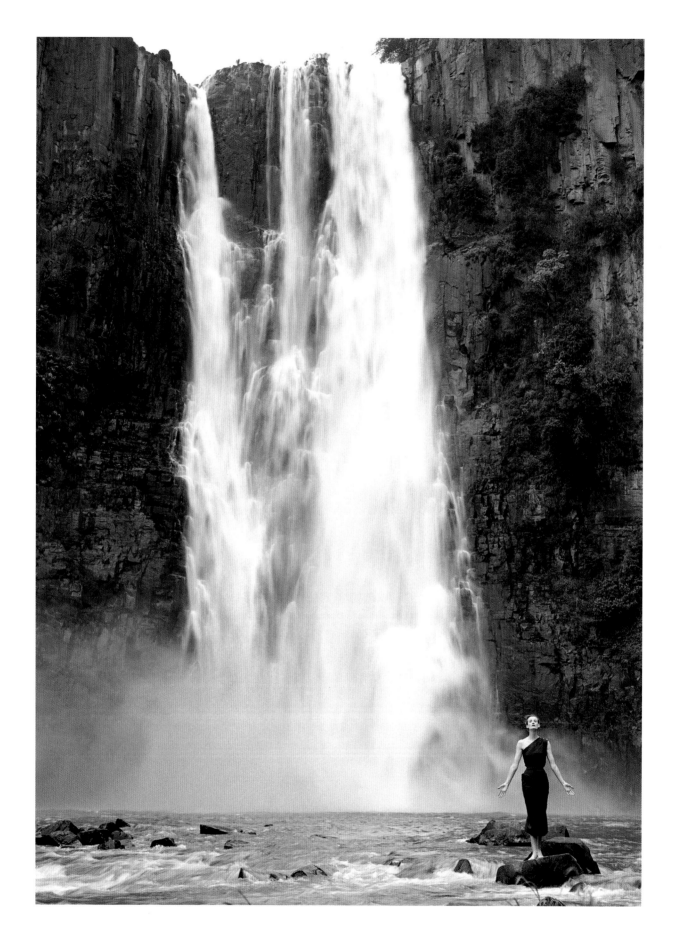

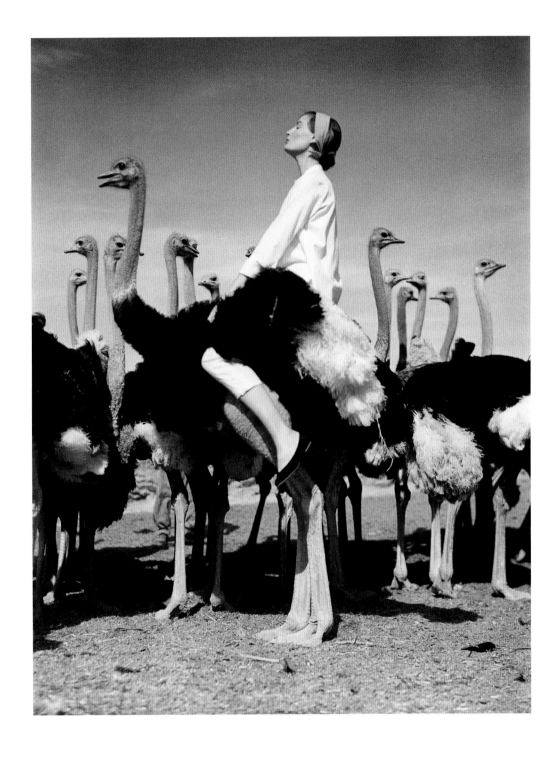

Opposite: Wenda Parkinson at Howick Falls wearing a dress by Spectator Sports. Underneath the sheer drop of 94 m (310 ft) in KwaZulu-Natal Province, South Africa. British *Vogue*, May 1951.

Above: Wenda Parkinson wearing Capri jeans and a heavy white cotton shirt by Spectator Sports. An alternative frame was originally part of a 16-page feature on holiday clothes photographed in Oudtshoorn, South Africa. British *Vogue*, May 1951.

Susan
Abraham

Cover of British *Vogue*, June 1951

Fashion model Susan Abraham was born in 1930 in Burma, spending her childhood in Dublin and Connecticut. She moved to London to pursue her modelling career and swiftly became one of Norman Parkinson's frequent models in the early 1950s, with photoshoots in the British countryside and at the beach.

Some of her most notable photographs by Parkinson were taken on location in Scotland, against the Edinburgh skyline. Abraham gave up modelling when she married in 1955, with fellow model and friend Anne Gunning as her bridesmaid. Living until the age of 90, Abraham died on 20th July 2020. Her legacy lives on in many of Parkinson's very best images of the 1950s.

Susan Abraham wearing a mimosa hat by Rudolf with a matching yellow taffeta dress by Digby Morton and Coty's red lipstick. Cover of British *Vogue*, June 1951.

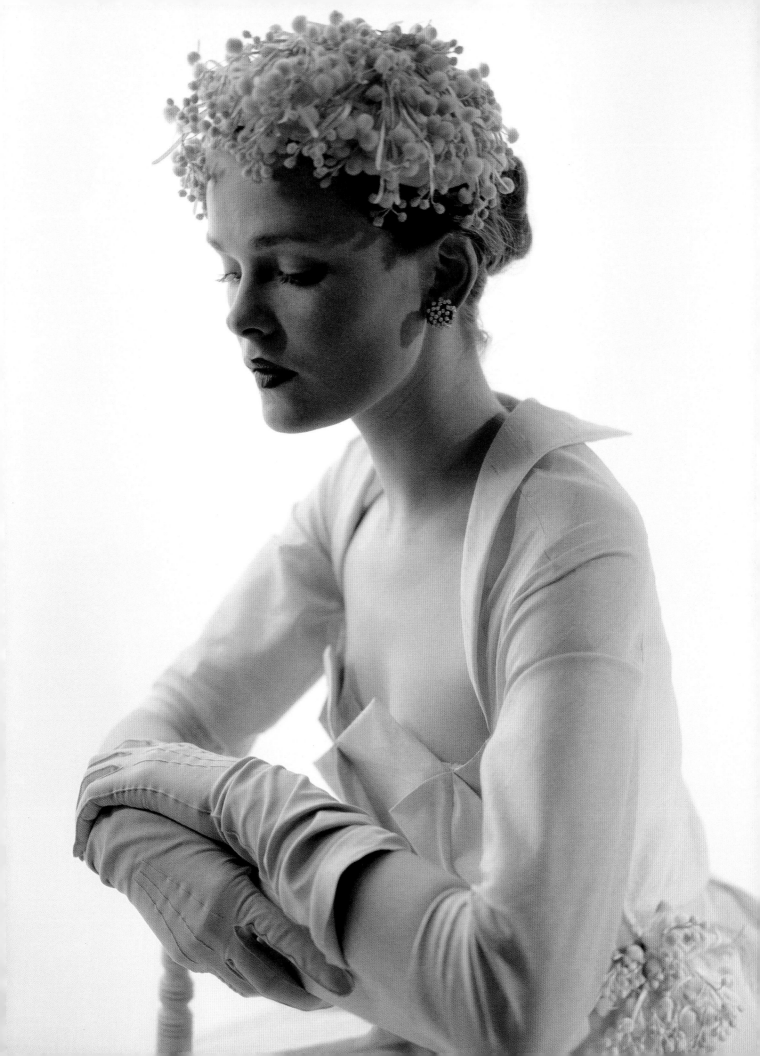

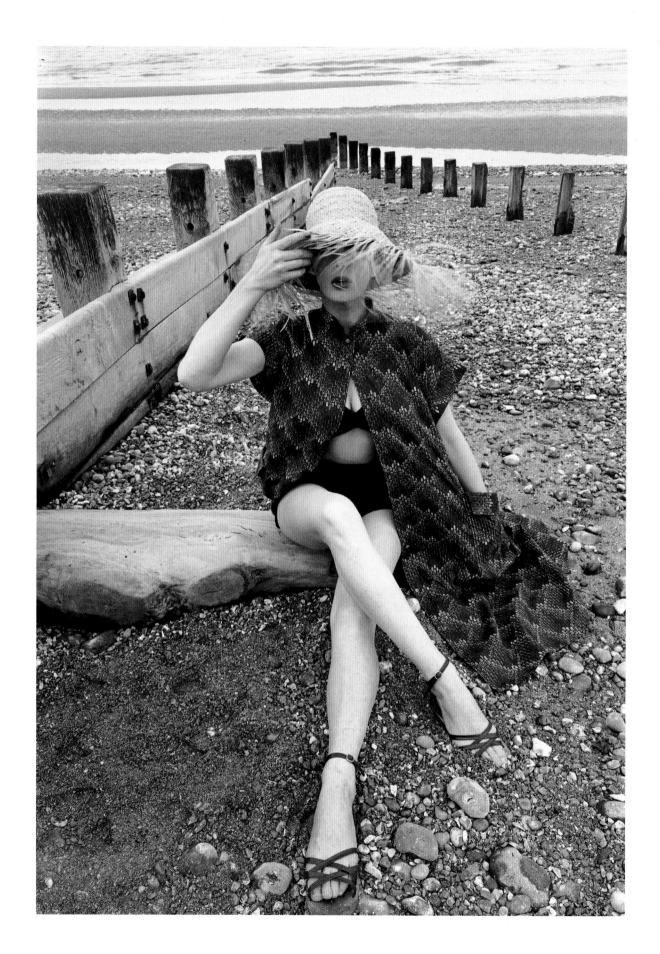

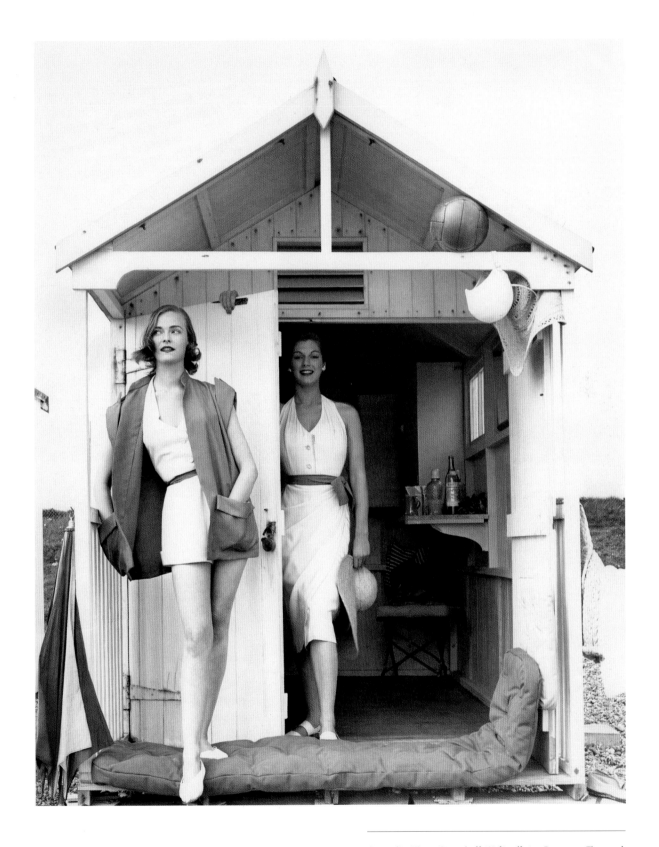

Opposite: Fiona Campbell-Walter (later Baroness Thyssen) on an English beach wearing an Estrava coat with a raffia hat from Eaton. British *Vogue*, July 1951.

Above: Susan Abraham and Fiona Campbell-Walter wearing fashion by Roecliff & Chapman. British *Vogue*, July 1951.

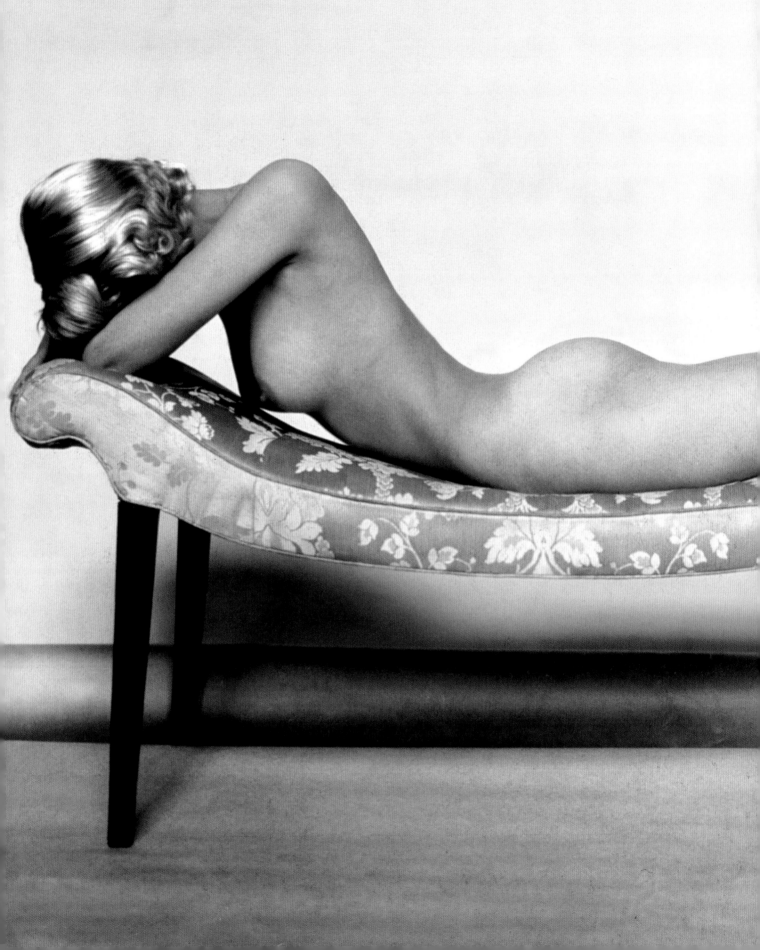

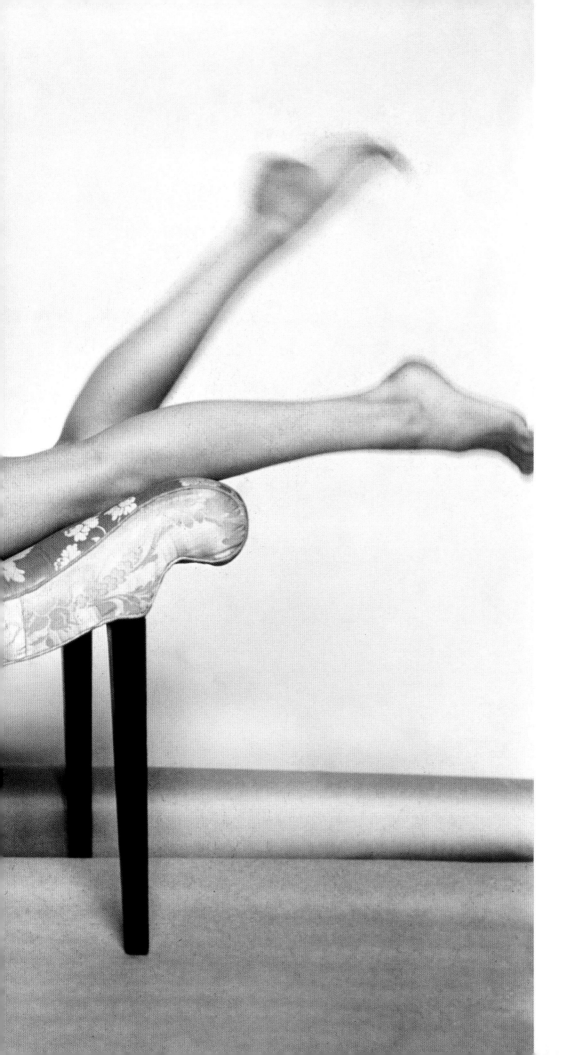

Parkinson's first nude
in colour, published
in British *Vogue*'s
Beauty Book No. 5
in 1951 as part of a
feature "Beauty is all
Embracing" and in
Alexander Liberman's
1951 book *The Art and
Technique of Color
Photography.*

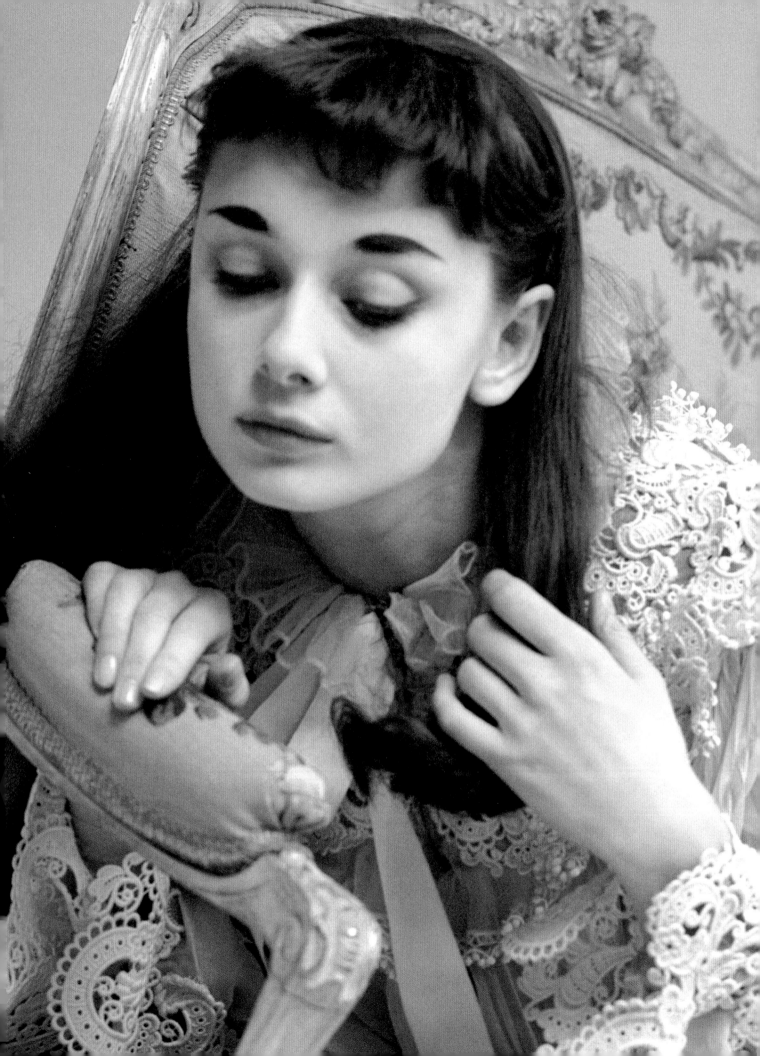

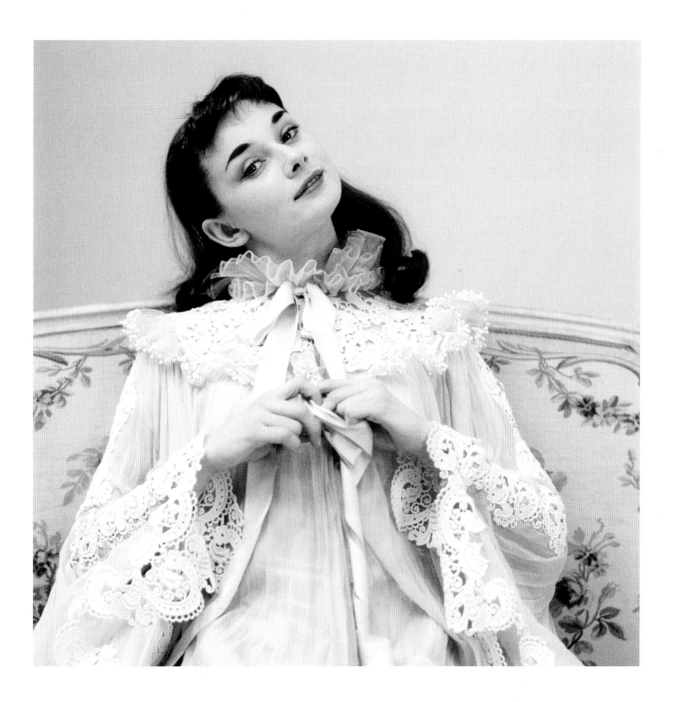

Audrey Hepburn in costume for her
Broadway debut in the play *Gigi*
written by Colette and Anita Loos.
Photographed in New York for her
first appearance in British *Vogue*,
January 1952.

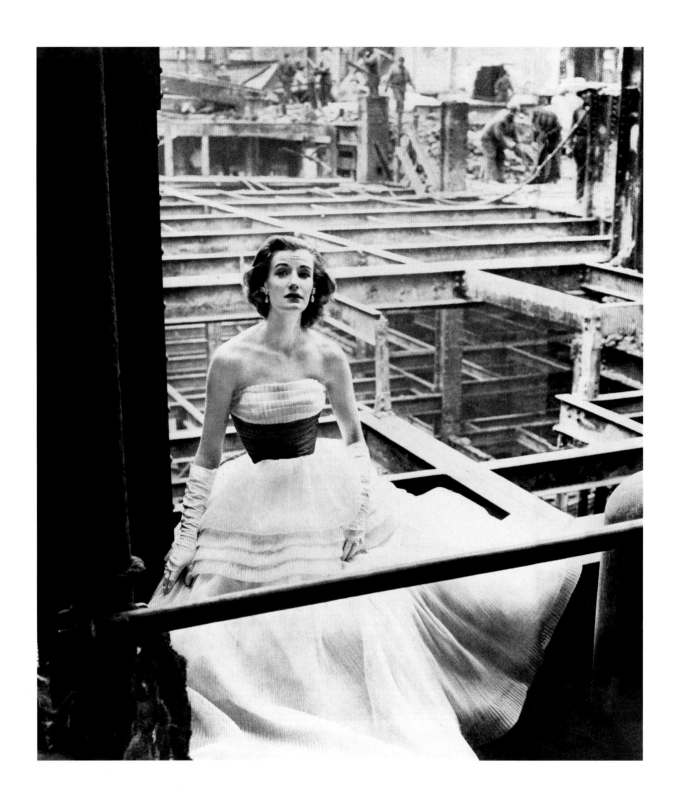

Above: Wenda Parkinson in the Oval Room of The Ritz, modelling a Cecil Chapman dress. American *Vogue*, 1 February 1952.

Opposite: Wenda Parkinson at Waterloo Place in London wearing a coat by Travella with a Rudolf hat. British *Vogue*, April 1952.

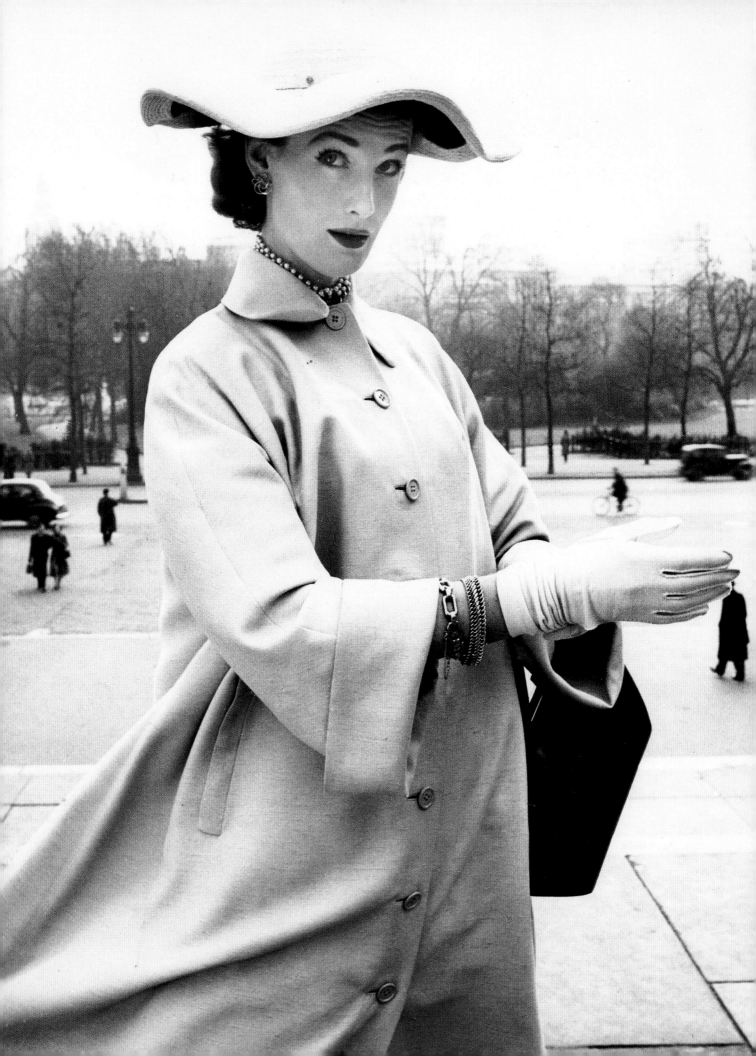

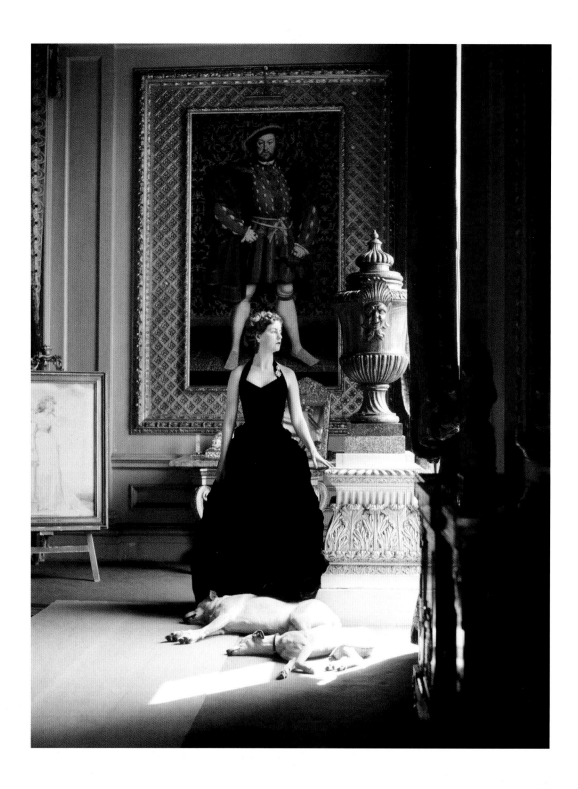

Above: Deborah Cavendish (née Freeman-Mitford), the Duchess of Devonshire, in the Gold Drawing Room at Chatsworth House beneath a portrait of Henry VIII after Holbein. British *Vogue*, August 1952.

Opposite: Mary Drage in front of John Singer Sargent's 1899 portrait of the Wyndham Sisters at the Metropolitan Museum of Art. American *Vogue*, 1 December 1950.

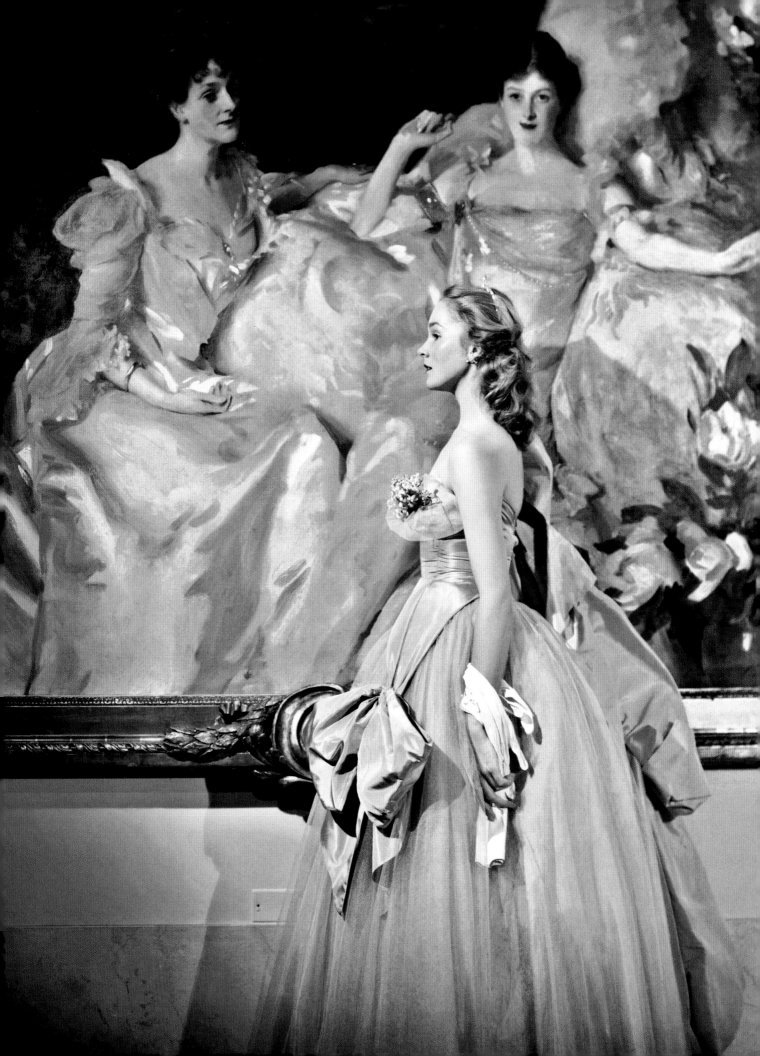

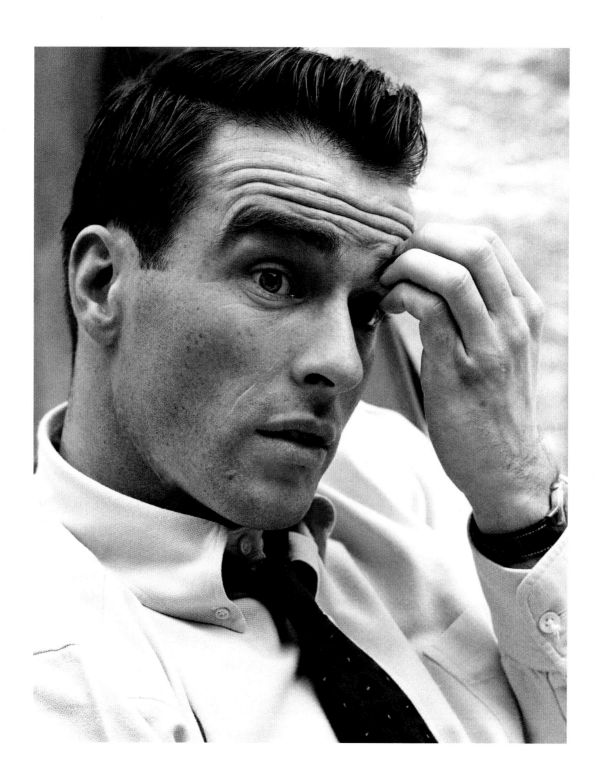

Above: American actor Montgomery Clift photographed in New York at the time of filming Hitchock's *I Confess*. British *Vogue*, November 1952.

Opposite: Katharine Hepburn photographed in London while appearing in George Bernard Shaw's play *The Millionairess*. British *Vogue*, June 1952.

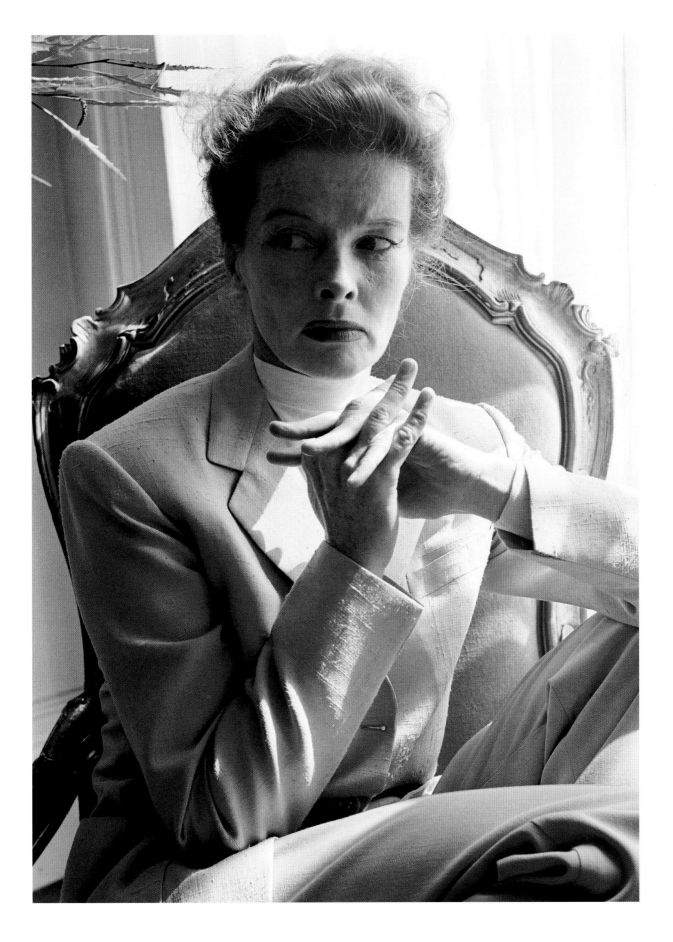

London's leading fashion designers

British *Vogue*, March 1953

In 1953, British *Vogue* published an infamous photo-article on the top fashion designers of the time.

The feature celebrated couture creators for high society and royalty alike. This included Hardy Amies, John Cavanagh, Norman Hartnell, Frank Stiebel, Peter Russell, Elspeth Champcommunal, Michael Sherard, Digby Morton and Charles Creed.

The opening *Vogue* text described how the magazine's usual report on the London Spring Collections would, in that Coronation year, shine a light on their leading couturiers, all members of the Incorporated Society of London Fashion Designers. The text went on to explain that each of them was shown photographed by Parkinson together with models who seemed to best embody the soul of their collection.

British *Vogue*, March 1953 Incorporated Society of London Fashion Designers:

Clockwise, from top left:
Elspeth Champcommunal (1888–1976) from Worth, at the time the only woman member of the Incorporated Society of London Fashion Designers; with June Clarke and Fiona, Baroness Thyssen wearing her designs.

Charles Creed (1906–1966) with a model wearing his tweed skirt-suit design with a cashmere sweater and Vernier brimmed hat.

Hardy Amies (1909–2003) with June Clarke and Fiona, Baroness Thyssen.

Norman Hartnell (1901–1979), then Chairman of the Incorporated Society of London Fashion Designers, seen with his Coronation ball dresses. One of the models is Myrtle Crawford.

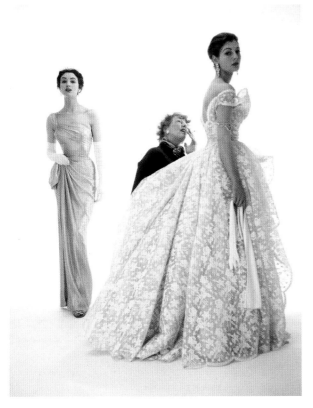

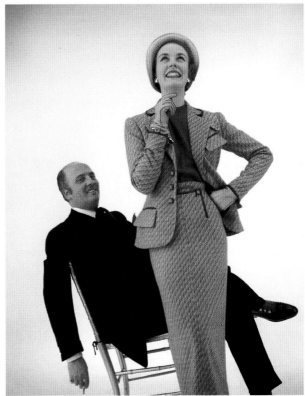

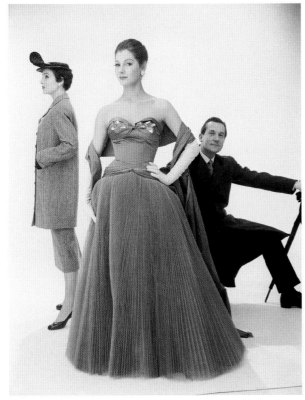

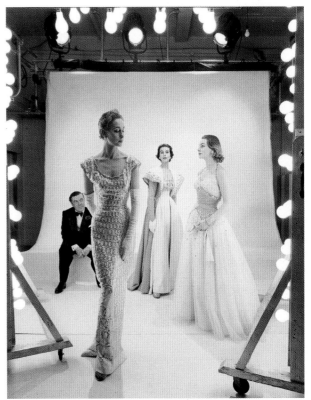

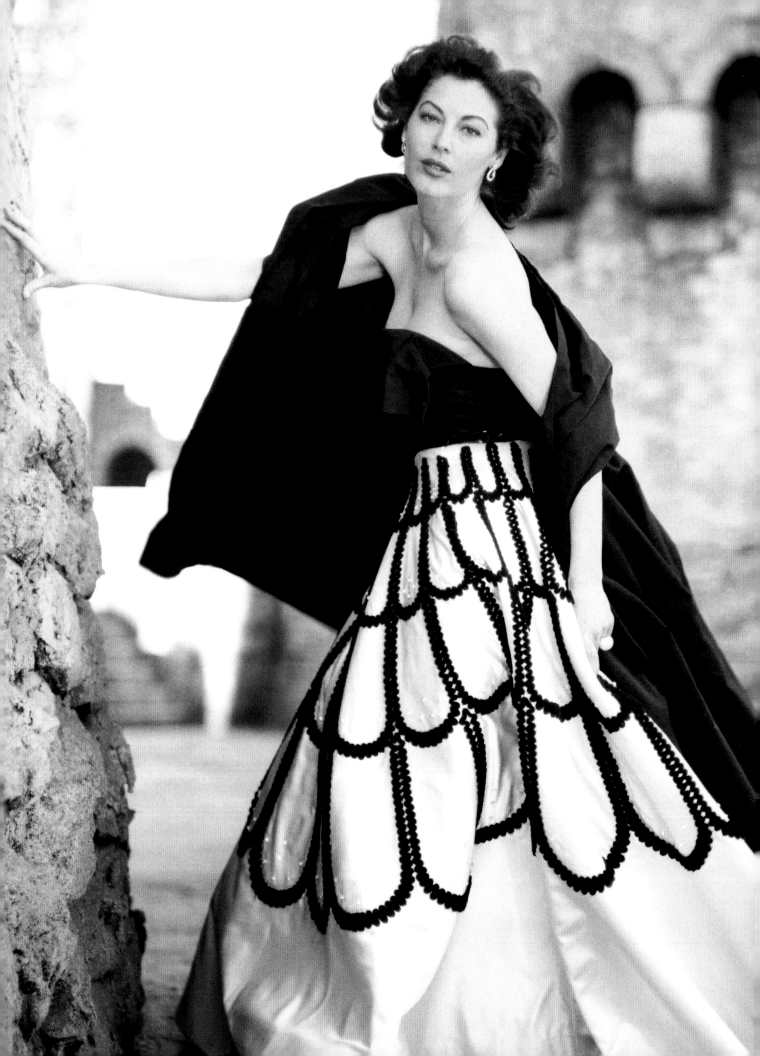

Ava Gardner photographed at
Borehamwood Studio in England during
a break from filming her role as Queen
Guinevere in the 1953 film *Knights of
the Round Table*. This photograph was
taken for British *Vogue*, December 1953,
showing a contemporary dress design by
Victor Stiebel.

Susan Abraham wearing a green
shirt and hat by Simone Mirman
with gloves by Holman and
Elizabeth Arden's lipstick. Cover
of British *Vogue*, February 1955.

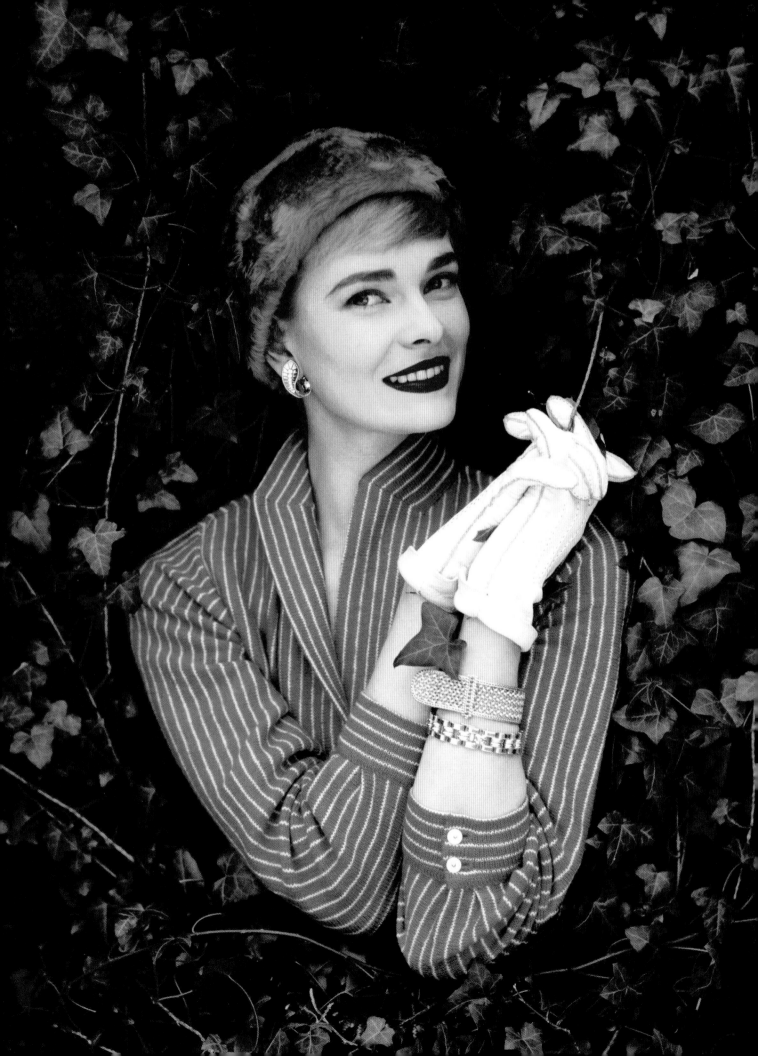

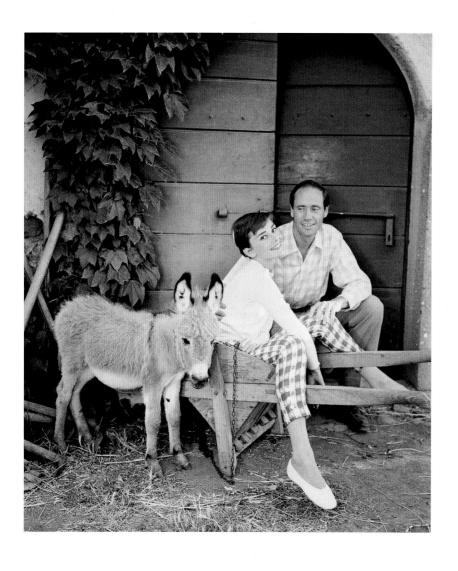

Audrey Hepburn with a pet donkey
named Bimba and her then husband,
the American actor Mel Ferrer. They
were renting a farmhouse at Villa Rolli
in Cecchina, Italy during the six-month
filming of King Vidor's *War and Peace*.
Photographed on 23 June 1955 for that
year's September issue of British *Vogue*.

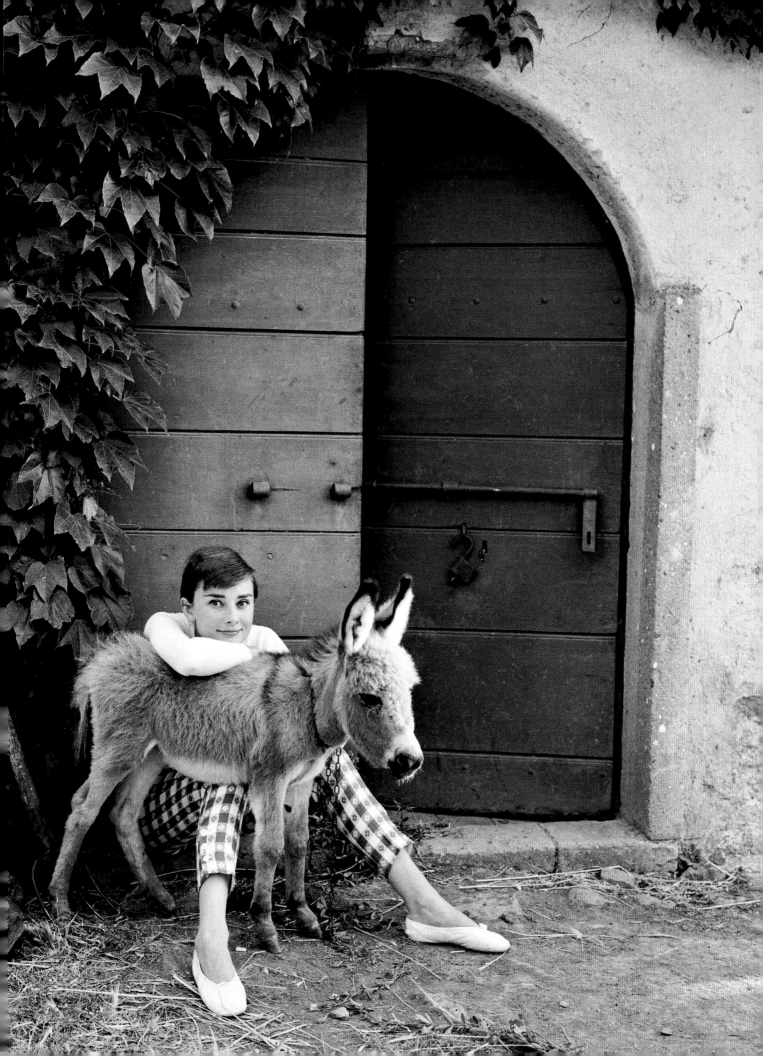

Barbara Mullen

Cover of British *Vogue*, August 1956

Born on 3 June 1927, Barbara was 18 years old when she began modelling as an in-house department store mannequin for Bergdorf Goodman's in New York City. Two years later in 1947, *Vogue* needed to photograph a Bergdorf dress that had been tailored to suit only Barbara's body. She was so slim that it would not fit any other models, so Barbara found herself transported to Vogue Studios to be photographed in the dress.

Barbara, and those around her, realized she had what was then a popular New Look for modelling. As *Vogue* editor Jessica Davies said, "Barbara Mullen was the first of these to be accepted as a top mannequin. Her eyes were slightly too prominent; the proportions of her face were not those of classic beauty. But the proportions of her body were made for modern clothes. Her tiny head, long neck and delicately elongated torso were the essence of the new elements."

A year before this photograph was taken, in 1955, *Photography* magazine put Barbara Mullen on its cover in a group shot with other top models of the time – Jean Patchett, Evelyn Tripp and Dovima – and the headline "Meet the most expensive models in the world". At this time, Barbara was earning 20 times the American annual average wage of $3,000.

Parkinson took notable images of Barbara Mullen on the streets of New York in the early 1950s, and most notably in India in 1956 with Anne Gunning. Mullen lived in semi-retirement up until her death aged 96 in September 2023, working on her biography with fashion historian John Michael O'Sullivan.

Barbara Mullen wearing a dress and jacket by Susan Small with an Otto Lucas hat and Lancôme lipstick. Cover of British *Vogue*, August 1956.

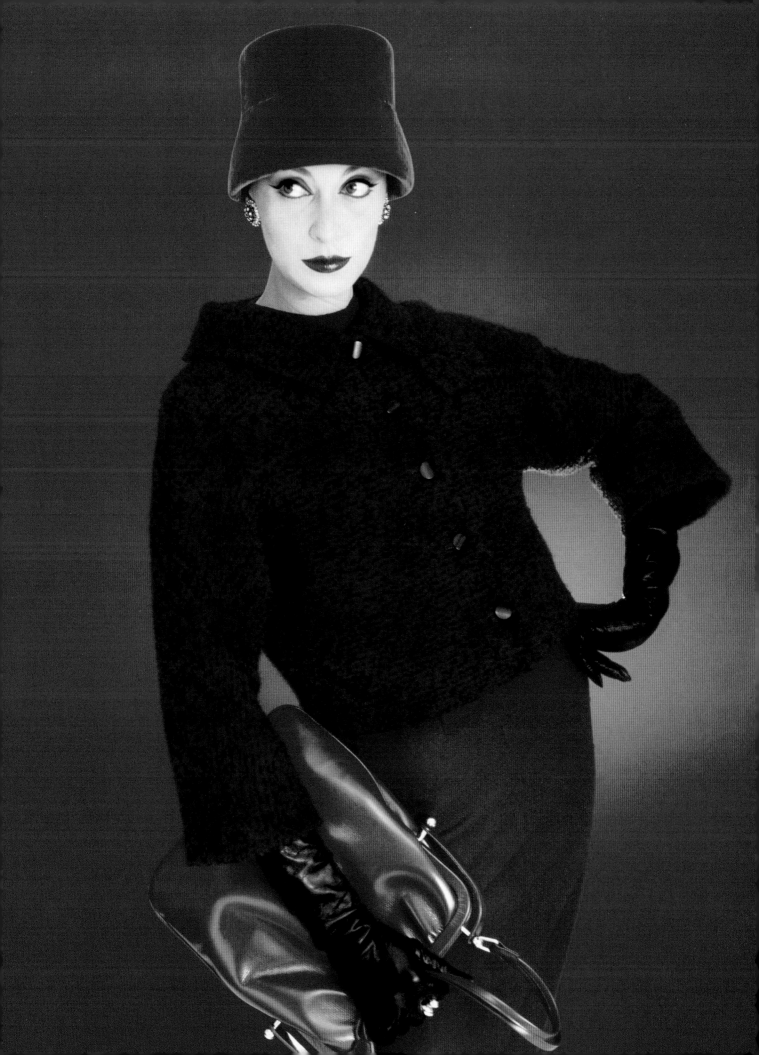

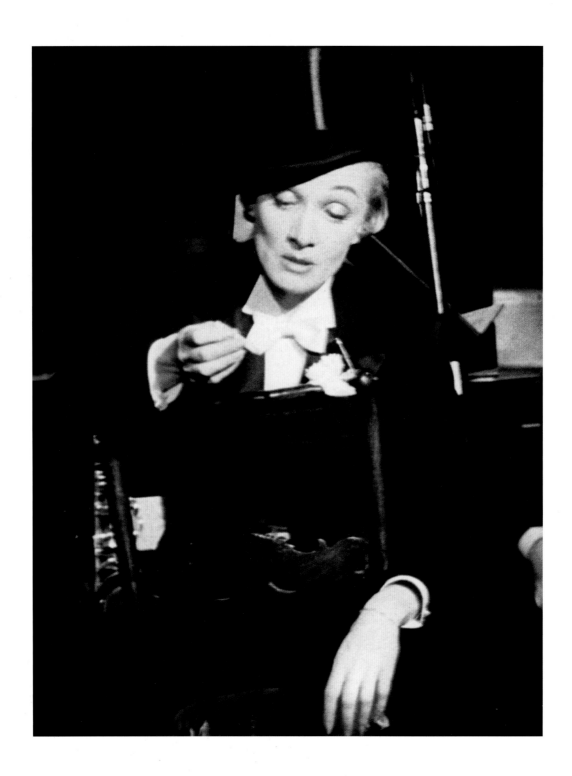

Above: Marlene Dietrich photographed on stage during her last performance of her residency that year at London's Café de Paris. British *Vogue*, November 1955.

Opposite: Anita Ekberg photographed for British *Vogue*, October 1956 at the time of starring as Hélène Kuragina in the film version of *War and Peace*.

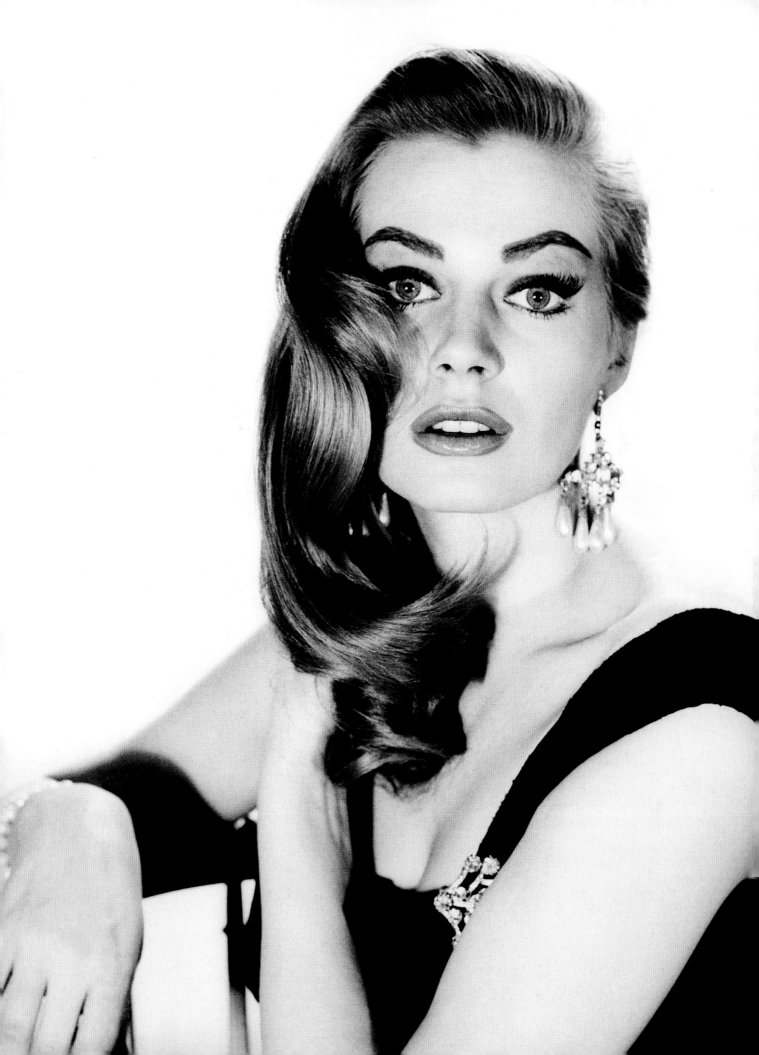

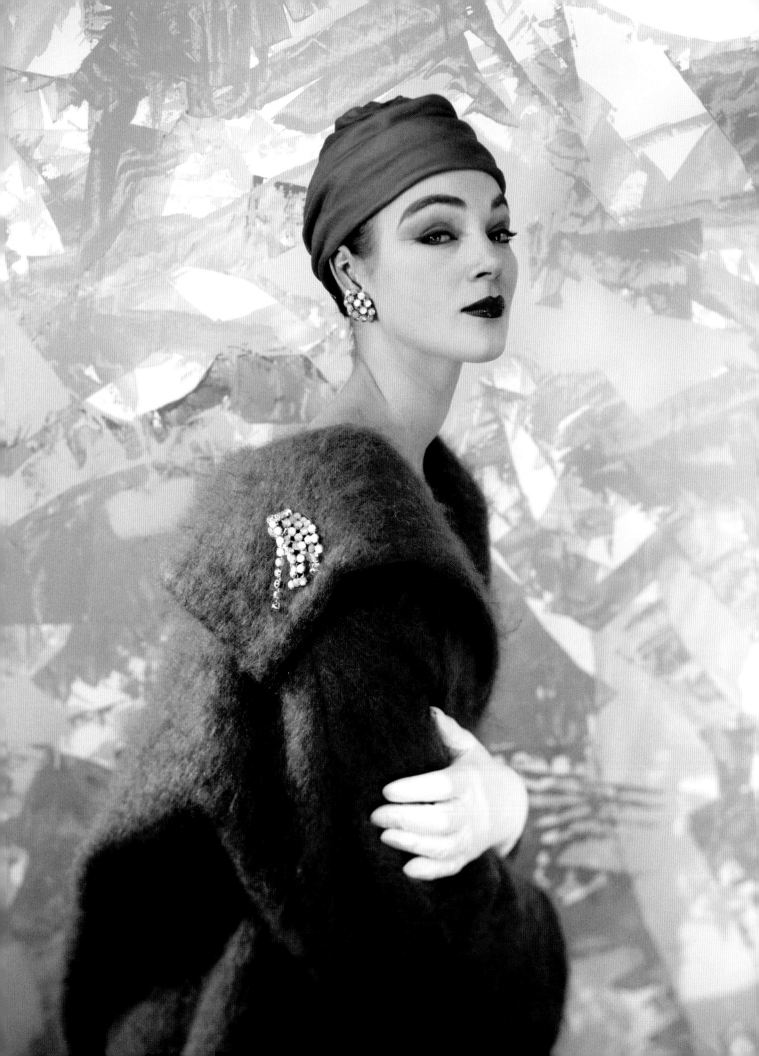

Ivy
Nicholson

Cover of British *Vogue*, October 1956

Ivy Nicholson (1933–2021) was born to working-class Irish parents, growing up in New York, then leaving home at 16 and being scouted in Miami. Her name is synonymous with New York subculture, as she became one of Andy Warhol's first factory superstars in the 1960s.

Known also as possibly one of the most daring models, Ivy travelled to Europe in the 1950s, landing herself a cover modelling assignment with French *Elle* by walking into the office in a designer outfit, with a Rolls-Royce waiting for her outside.

As Ivy stated in an interview for *Bomb* magazine, "One white lie got me a ten-year career in modelling": she had told French *Elle* she was about to be on the cover of American *Vogue*. She soon achieved this, also modelling for *Harper's Bazaar*, *Life* magazine, *Women's Wear Daily*, *Réalités* and British *Vogue*, for which Norman Parkinson shot this cover photograph for the February 1956 issue.

Opposite: Ivy Nicholson modelling a mohair Jaeger coat with Harrods gloves, Dior jewellery and Max Factor make-up. Cover of British *Vogue*, October 1956.

Right: Ivy Nicholson photographed in New York, 1957.

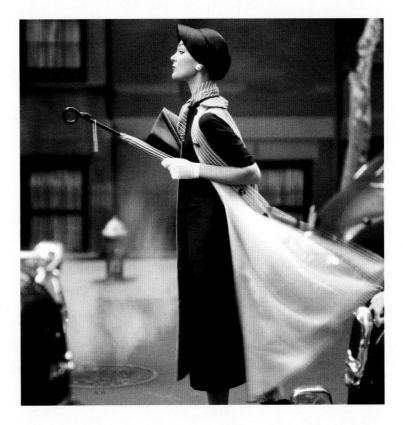

India

British *Vogue*, November 1956

One of Norman Parkinson's most famous, visually stunning shoots, shown on the next few pages, took place in India for British *Vogue*'s November 1956 issue.

Vogue flew out Parkinson, his assistants, the fashion team, and two top models of the time – Anne Gunning and Barbara Mullen. When travelling abroad for fashion shoots, Parkinson often chose to scan the first postcard rail he laid his eyes upon, and from this gauge the country's top destinations for photographing. In this case, he visited the Taj Mahal, Jaipur, Delhi, Madras and the monuments of Kashmir.

Mid-1950s fashion, which was beginning to get a lot more colourful and experimental, had the perfect opportunity for showcasing itself against the beautiful backdrop of India.

The *Vogue* article written by Penelope Gilliatt, a travel writer who accompanied the team on the India shoot, described how the country was made for photography. "The eye is stormed a million times a day: not only by colour of a full-throated kind that makes our own seem constricted, and by strangeness – a peacock pacing along a trunk road – but still more by the Indian instinct for beauty."

Right: Anne Gunning at the City Palace in Jaipur with a hand-painted elephant. She wears a pink mohair coat from Jaeger with jewellery lent by Jaipur's Gem Palace, a silk headscarf from the local bazaar and Elizabeth Arden's Nymph Eye and Rose Aurora lipstick. British *Vogue*, November 1956.

Opposite: Anne Gunning floating in a cotton mousseline dress by Atrima on Dal Lake, India. British *Vogue*, November 1956.

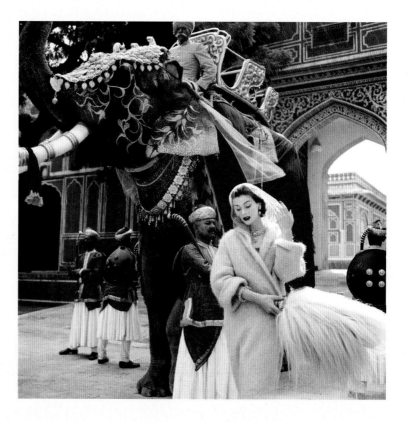

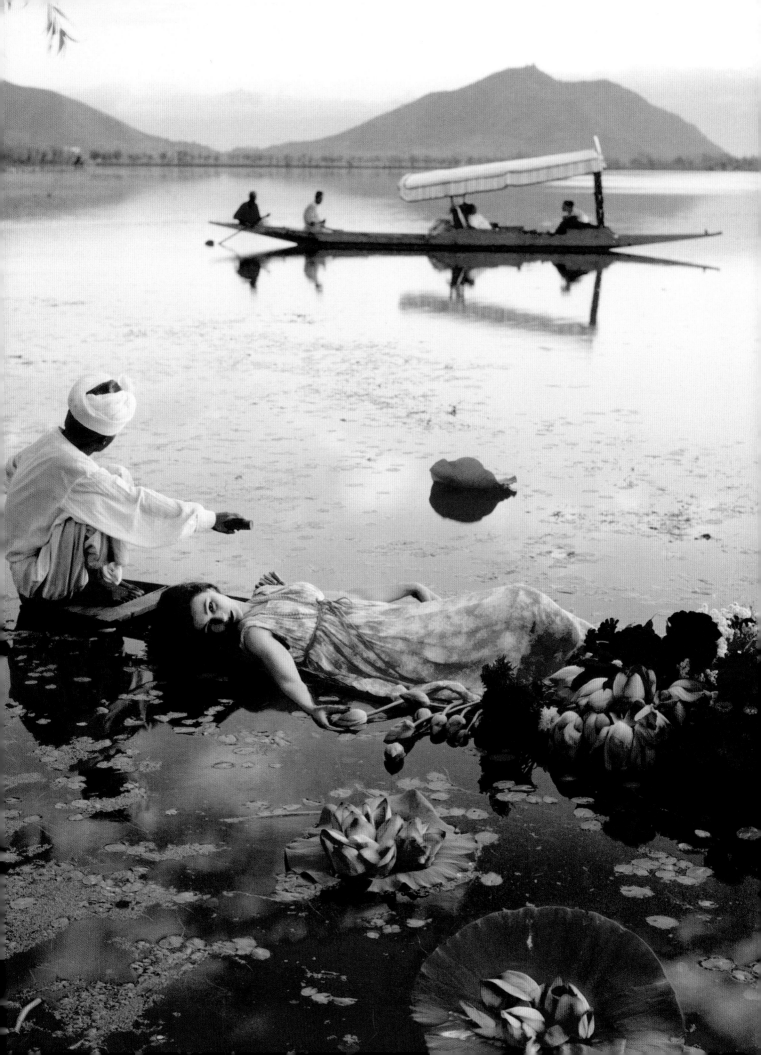

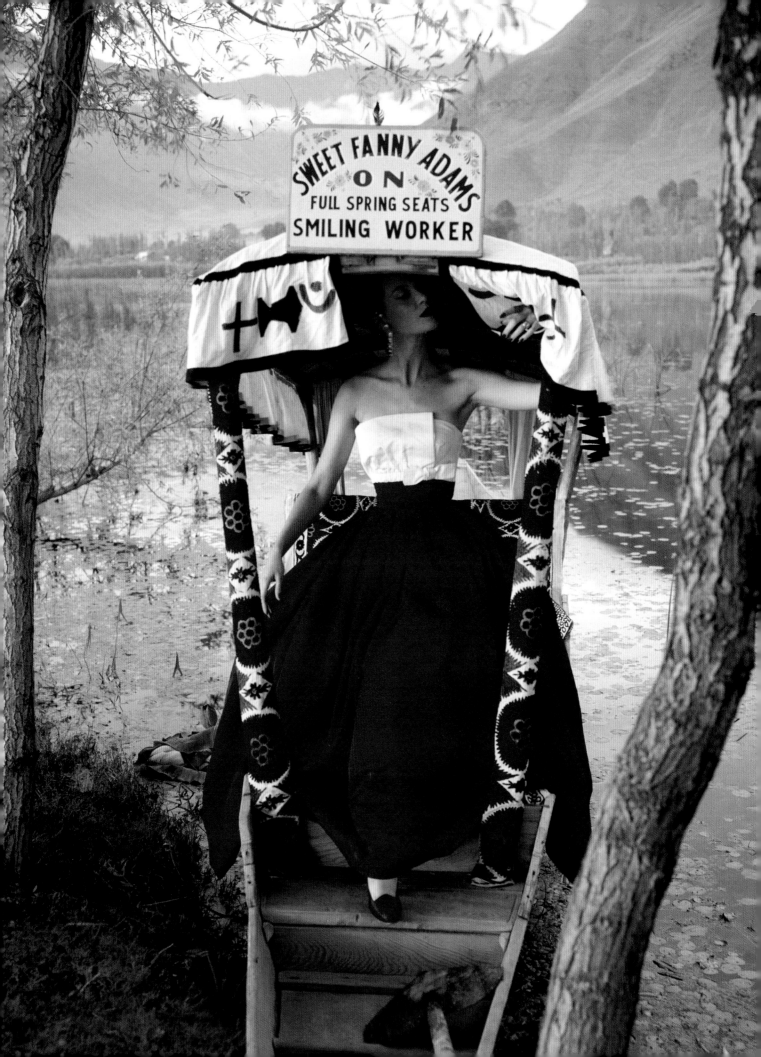

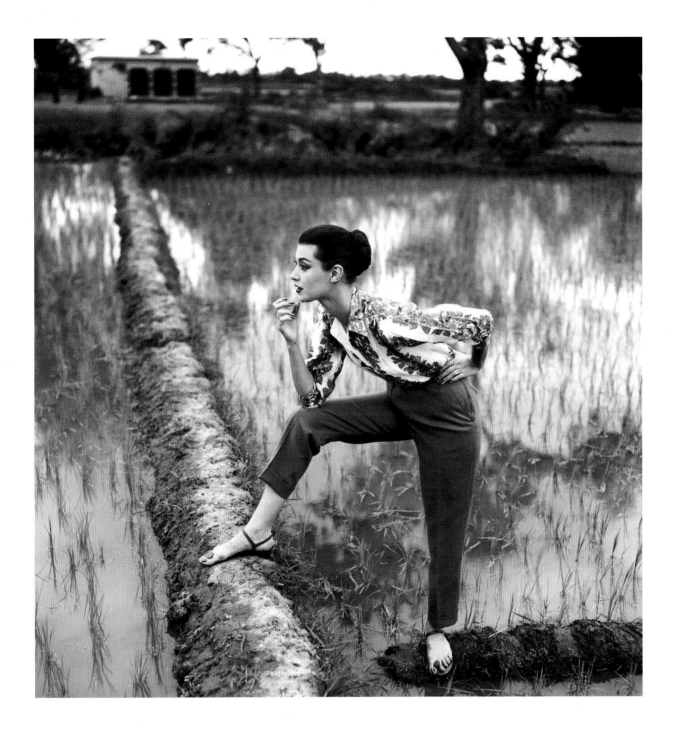

Opposite: Barbara Mullen on a Shikara boat on the Kashmiri Lake, India wearing a grosgrain dress with a scarlet skirt and strapless bodice in white by Frederick Starke and Guerlain's "Flamboyant" lipstick. British *Vogue*, November 1956.

Above: Barbara Mullen in India wearing a rose-printed cotton shirt by Digby Morton, green linen slacks by Daks and Max Factor's Clear Red lipstick. British *Vogue*, November 1956.

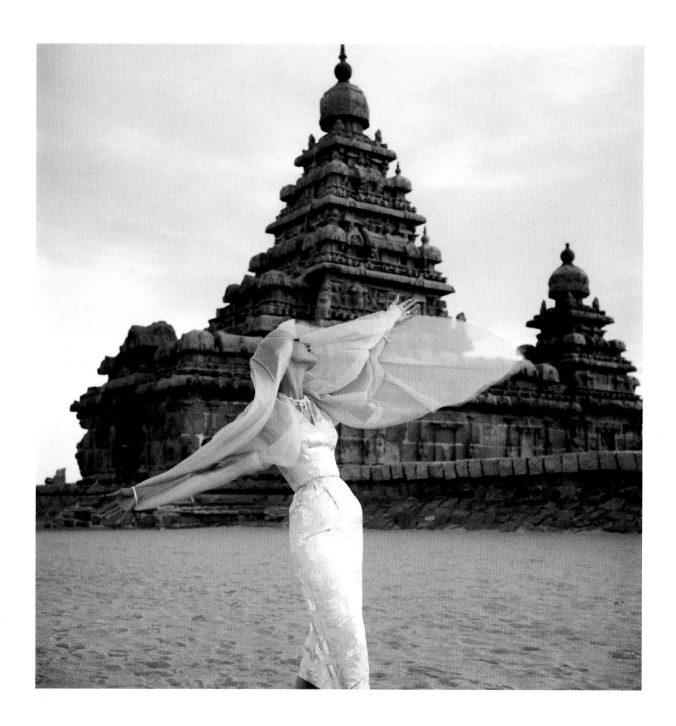

Above: Barbara Mullen at the Shore Temple at Mahabalipuram, India wearing a white organza, silver embroidered dress with a moonstone-blue organza coat by Horrockses with jewellery from Paris House. British *Vogue*, November 1956.

Oppsite: Barbara Mullen at the Taj Mahal, photographed from the back facade across the Jumuna River. She is wearing an orange, black and white printed cotton bathing dress by Emilio of Capri and a palm-leaf hat which cost one rupee at the local market. British *Vogue*, November 1956.

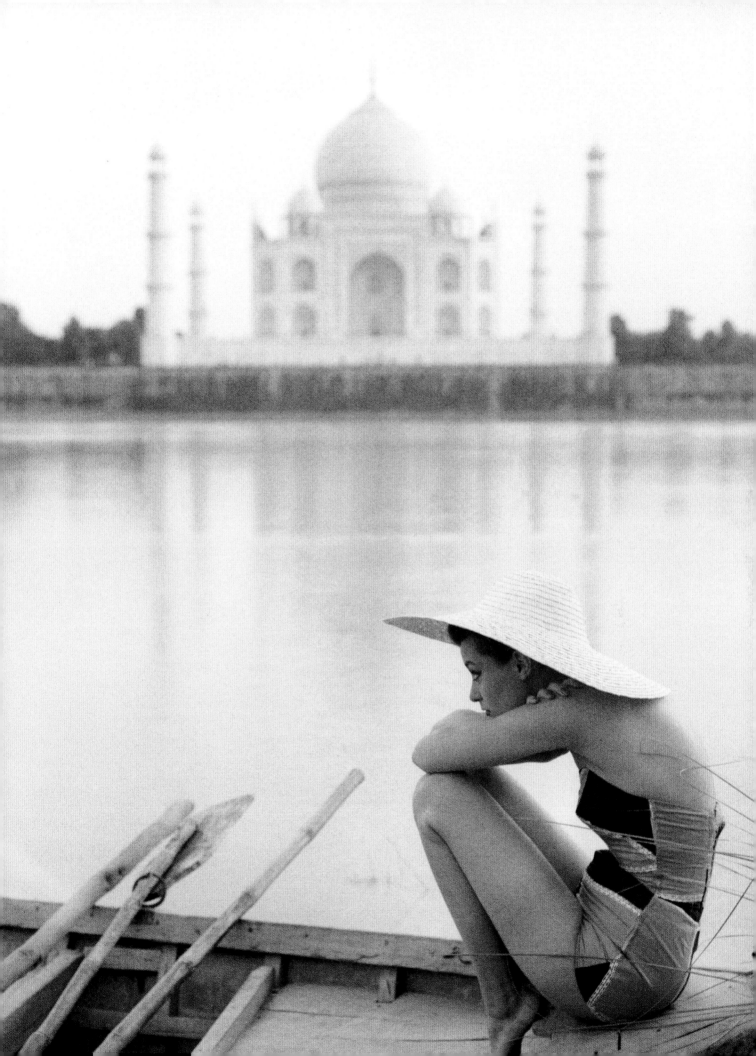

Wenda Parkinson photographed
in Tobago wearing a swimsuit
by Elegance and a Kleinert's
swimcap. British *Vogue*, May 1956.

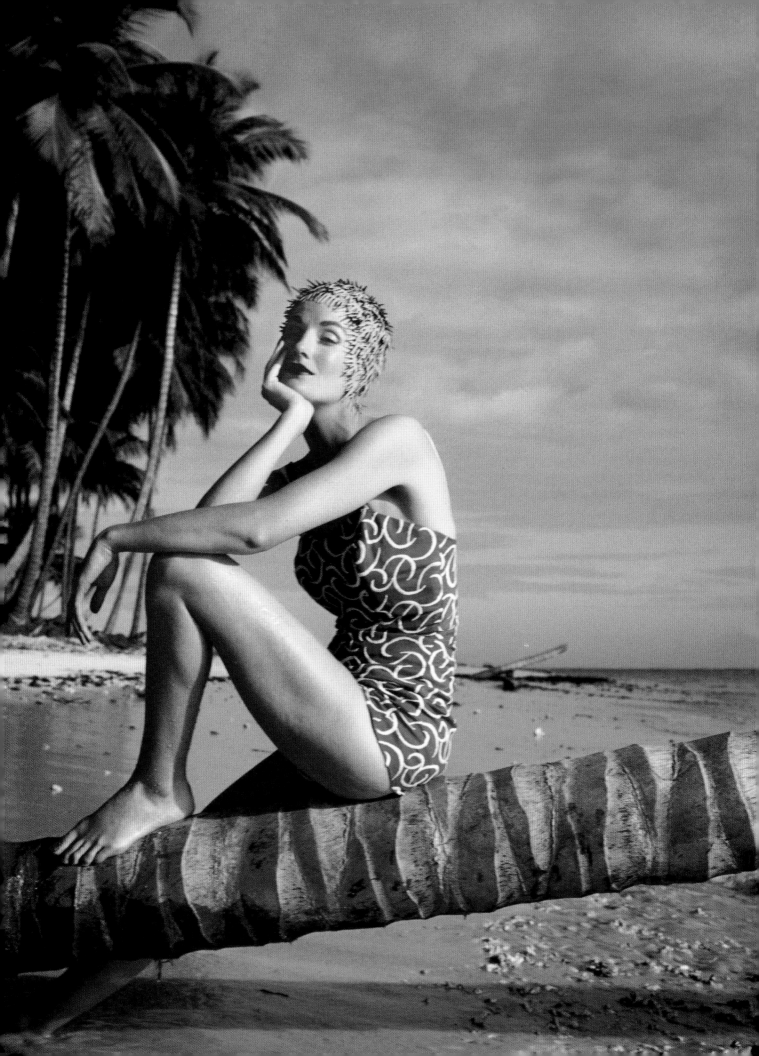

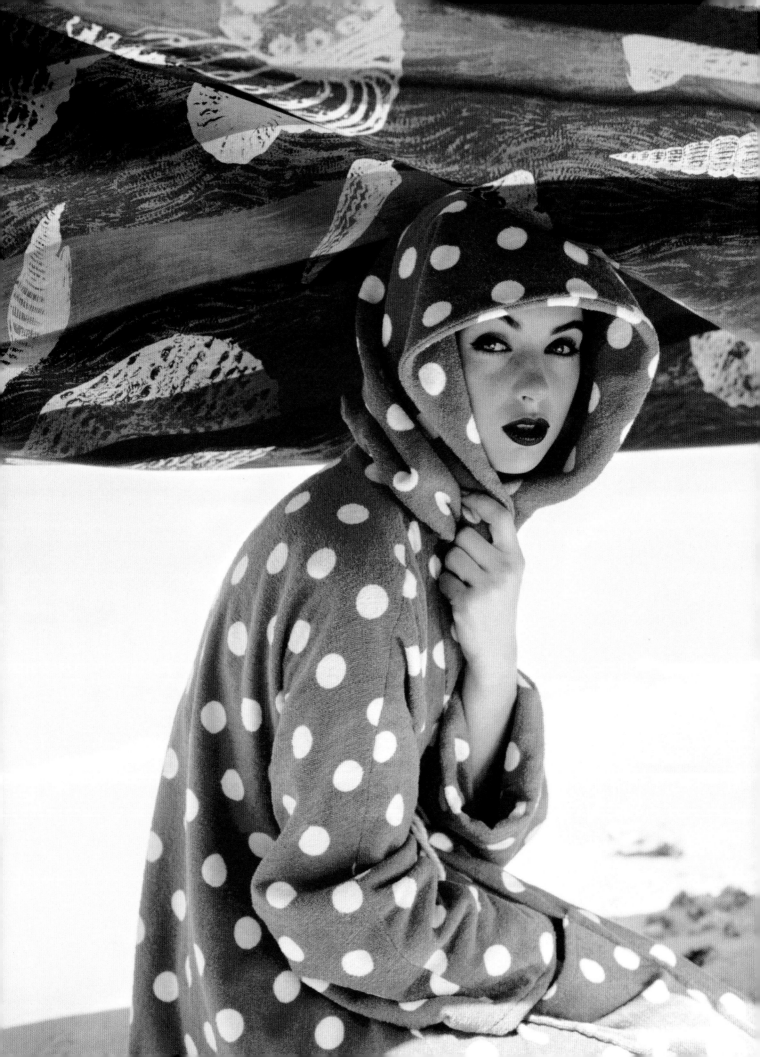

Millie Perkins modelling Lanvin-Castillo
fashion on the beach in Tobago for the
cover of *Vogue*, May 1957.

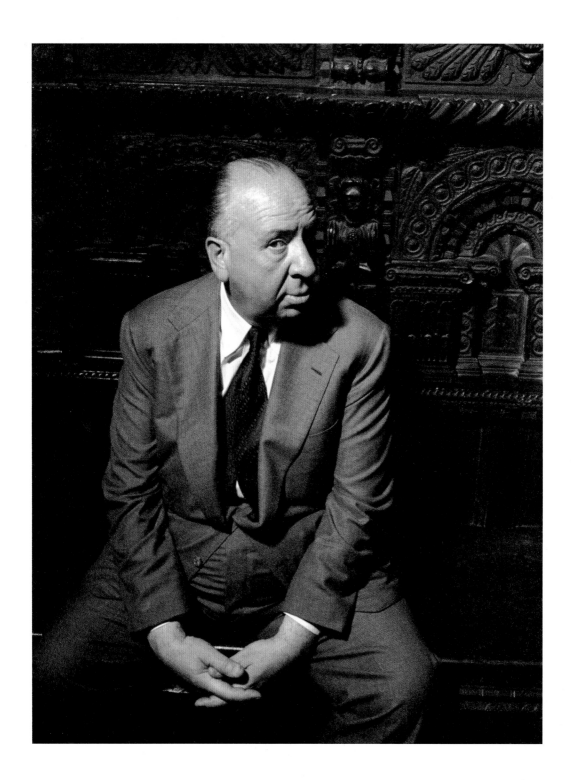

Above: Alfred Hitchcock photographed for British *Vogue*, March 1956 at the Royal Albert Hall during the filming of *The Man Who Knew Too Much*, which starred Doris Day and James Stewart.

Opposite: Jean Seberg photographed on the roof of the Dorchester Hotel at the time of filming Otto Preminger's *Saint Joan* for British *Vogue*, July 1957.

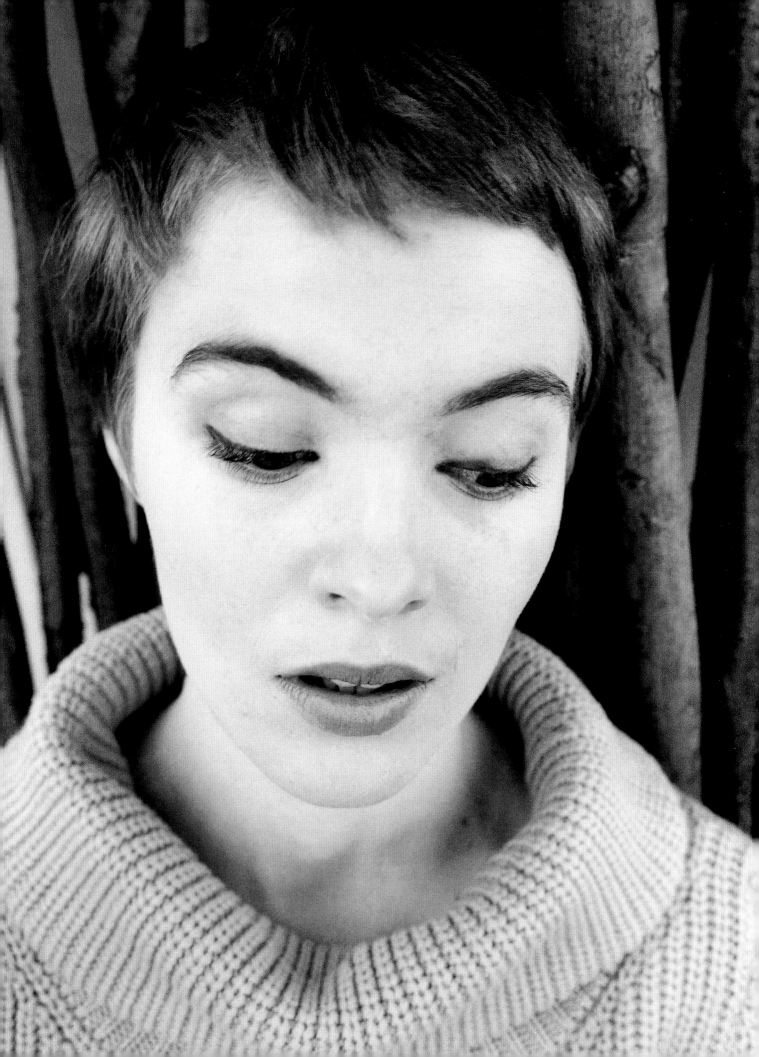

Nena von Schlebrügge

British *Vogue*, July 1958

Norman Parkinson first discovered Nena von Schlebrügge (b. 1941) when she was 14 during a special British *Vogue* issue on Scandinavia in July 1955. Two years later, Nena moved to London to pursue her career in modelling, collaborating several times with Parkinson. She later signed with Eileen Ford at the Ford Modelling Agency in New York City, continuing as an iconic model of the 1950s and '60s. Nena gave birth to her daughter, actress Uma Thurman in 1970.

As Parkinson described her, "Nena von Schlebrügge was not particularly athletic, like Carmen or Plonya [Apollonia von Ravenstein], but she was very cool, calm and ice-smouldering. I have a passion for tall gangling blondes, and as Maurice Chevalier reminded us, ducklings soon grow into elegant swans. Nena did just that. I watched her develop in my camera and long before she was twenty she had become a great star in New York."

Nena von Schlebrügge (later Nena Thurman) photographed in Positano, Italy, wearing fashion by Worth. British *Vogue*, July 1958.

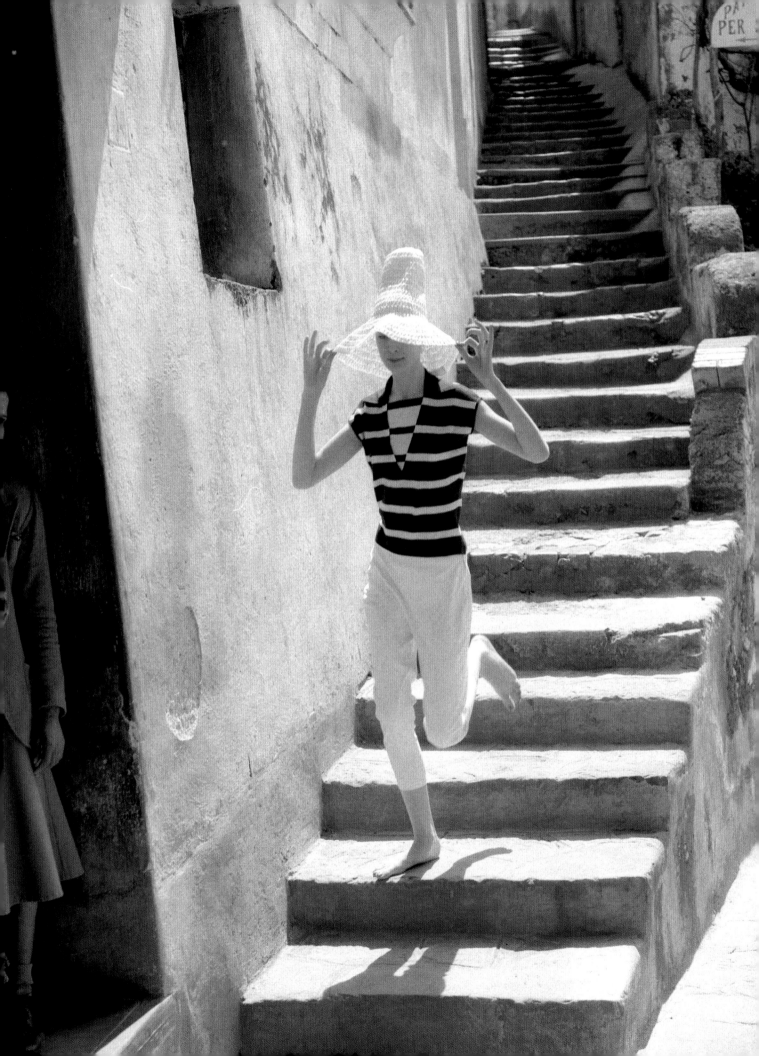

Nena von Schlebrügge outside the
American and Russian pavilions in
Brussels, Belgium, wearing an Estrava
suit with Saxone shoes. British *Vogue*
magazine July 1958.

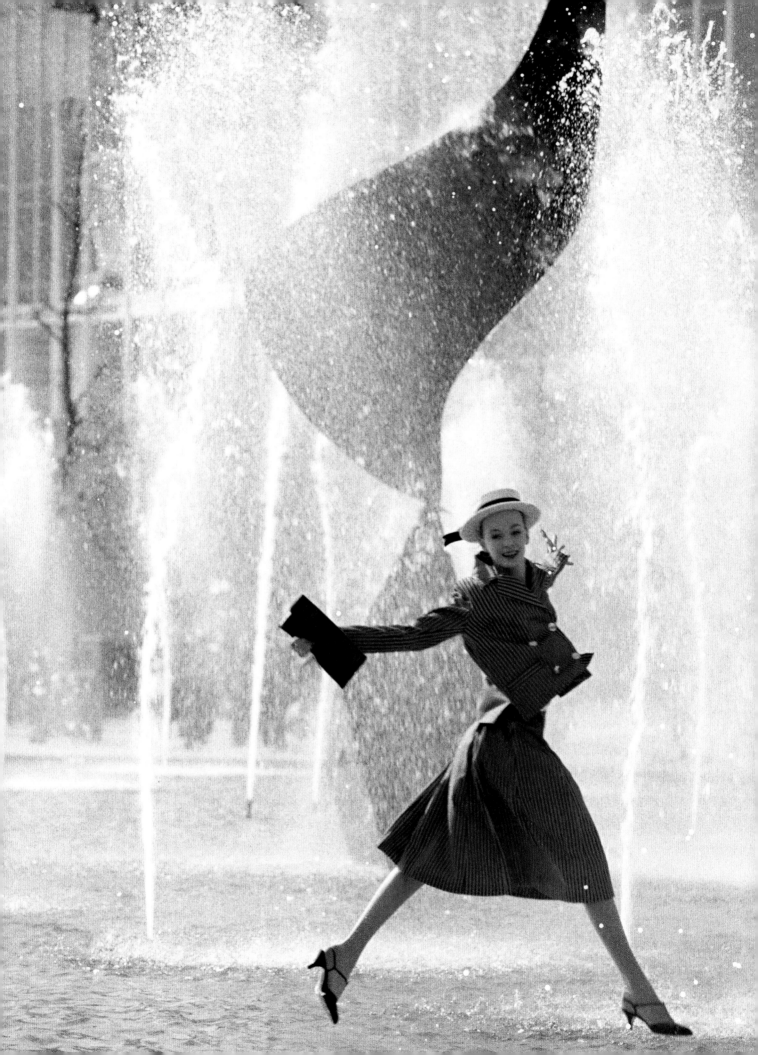

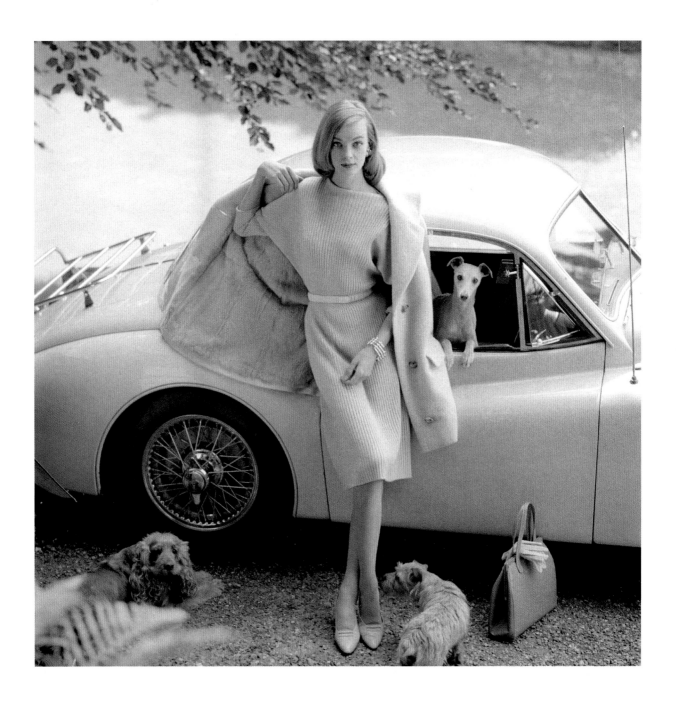

Above: Nena von Schlebrügge wearing a coat by Spectator, dress by Susan Small, bracelet from Cartier and shoes by Italo. British *Vogue*, mid-September 1958.

Opposite: Nena von Schlebrügge wearing a Frederick Starke suit for British *Vogue*, mid-September 1958.

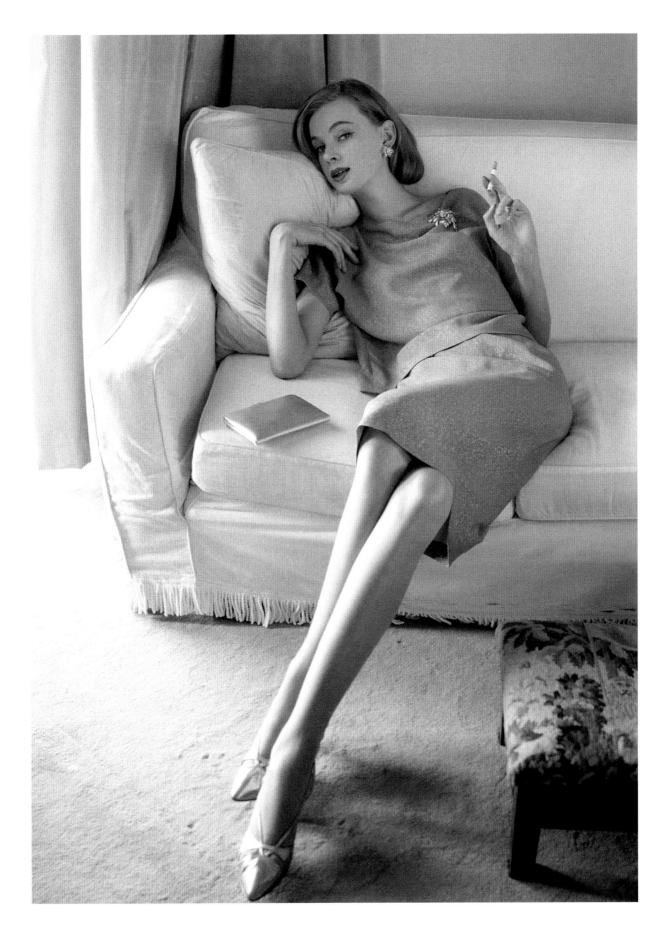

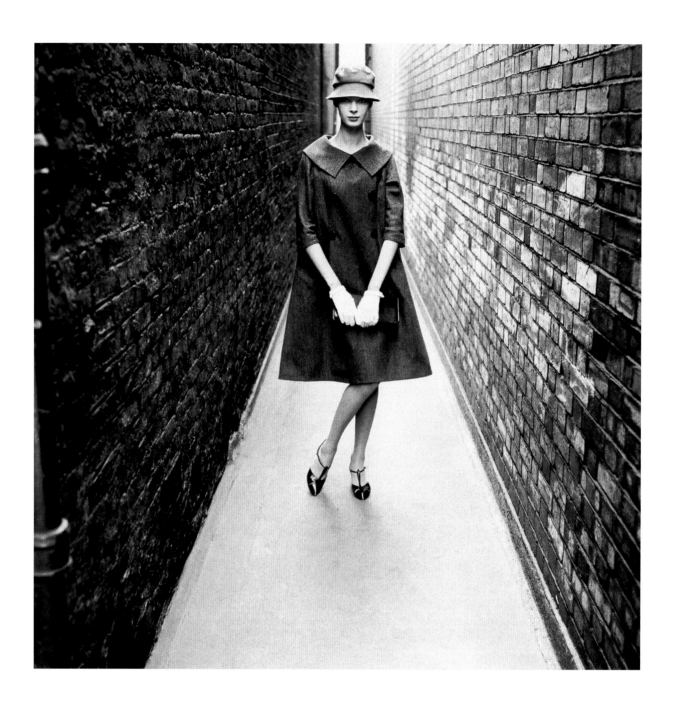

Above: Nena von Schlebrügge at Brydges Place off St Martin's Lane in London, wearing a Blanes dress. British *Vogue*, September 1958.

Opposite: Nena von Schlebrügge at Brydges Place off St Martin's Lane in London, wearing an Estrava coat. British *Vogue*, September 1958.

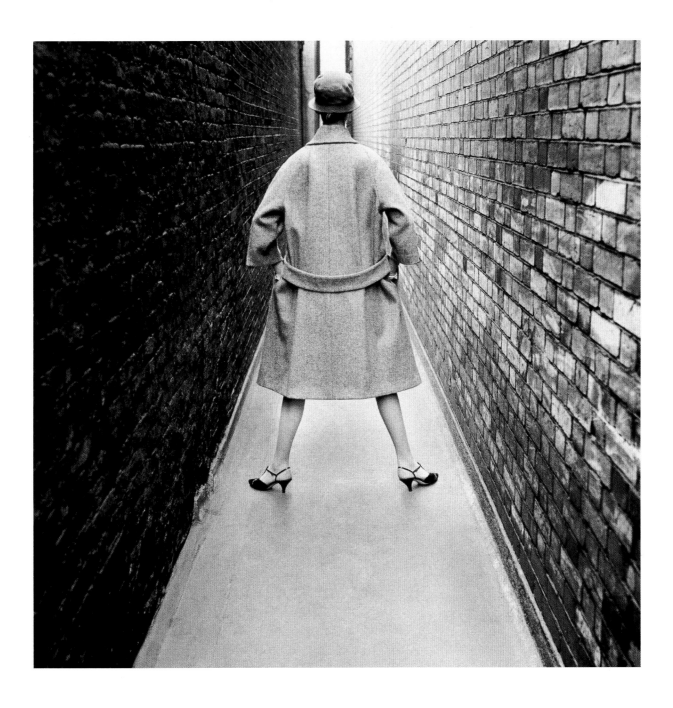

Carmen Dell'Orefice at the Love
Beach in the Bahamas wearing a
linen bush jacket by Donald Davies,
matching shorts by Londonus
and coral red lipstick by Harriet
Hubbard Ayer. Cover of British
Vogue, July 1959.

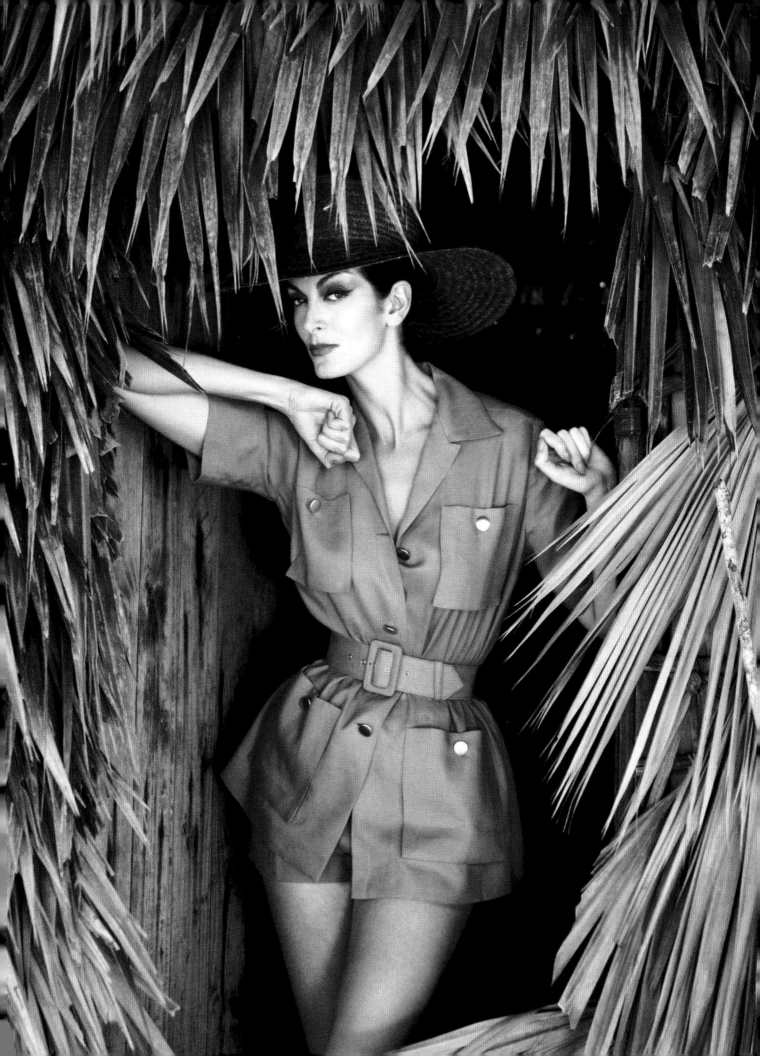

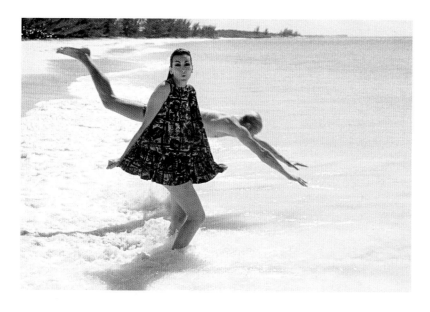

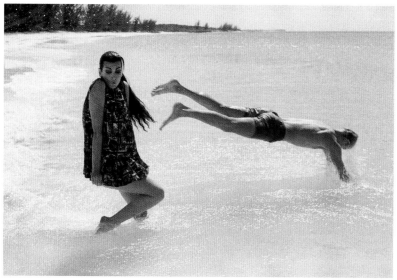

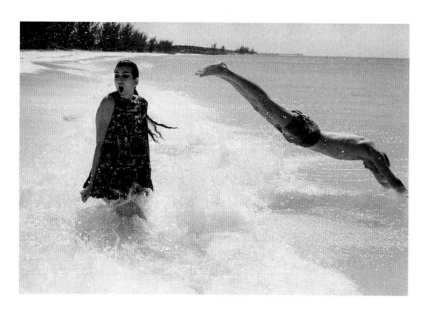

Left: Chip the diver and Carmen Dell'Orefice in the Bahamas wearing a purple and white cotton smock dress by Jean Allen at Dickins & Jones. British *Vogue*, July 1959.

Opposite: Carmen Dell'Orefice wearing a Jean Allen bikini in the Bahamas for British *Vogue*, July 1959.

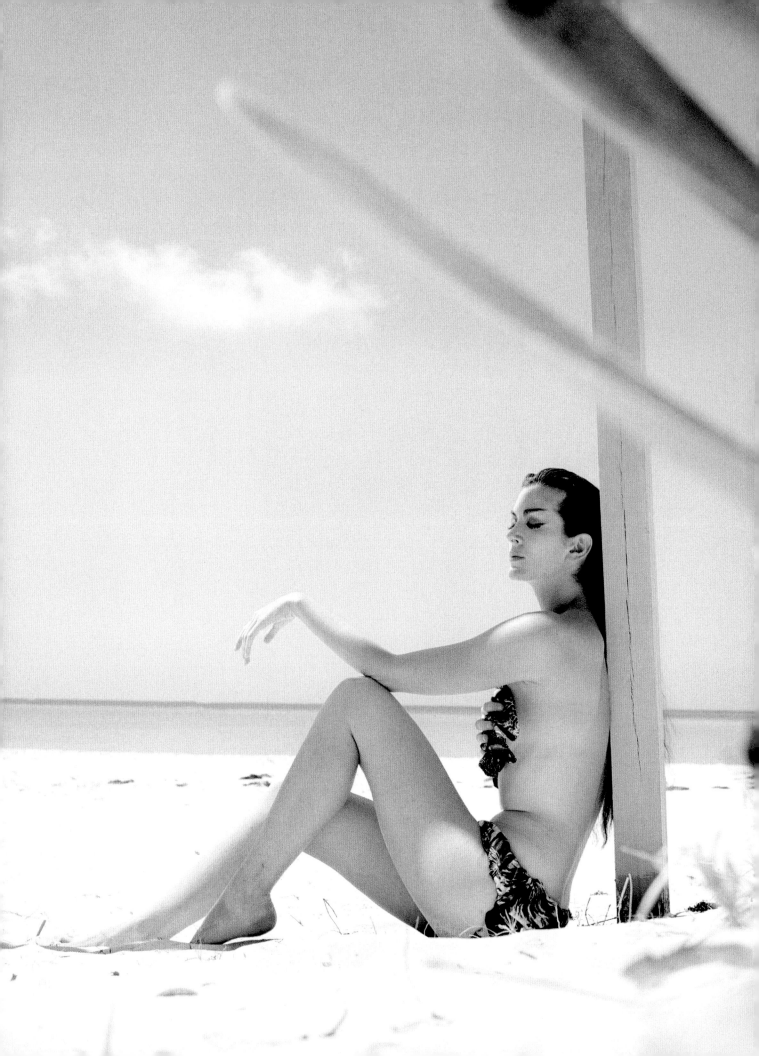

Grace
Coddington

British *Vogue*, October 1959

In a recent interview for British *Vogue*, Grace Coddington spoke of the first time she walked into the British *Vogue* offices, in spring 1959, when she was 18 years old. The magazine was hosting a party for the winners of their Model Contest that year, as well as runners-up, who were photographed for that issue. Grace was the winner in the 'Young Idea' section, open to 18 to 25 year olds.

A recent arrival in London from Anglesey in Wales, she was working in legendary cheap-eats restaurant The Stockpot, in Knightsbridge, which was staffed by young people new to the capital – a world away from the fashion dreams from the copies of *Vogue* she'd read growing up. But she had made it at last.

Coddington remembers the room being filled with editors and photographers – but it was Parkinson she made a beeline for. He had already photographed her once, and would go on to do so many times in the years to come. More than that, when Coddington made the switch from model to fashion editor, it was Parkinson who would shoot the first story she oversaw. Other Parkinson shoots with Grace as fashion editor took place in Jamaica, with Jerry Hall, and Portugal, with the model Mouche. "He truly was one of the greats," she said, "and I've been lucky enough to work with a few of those."

The two would collaborate together across six decades, a regular feature during Coddington's time as a model, her nineteen years at British *Vogue* and her thirty at American *Vogue*.

Grace Coddington photographed for British *Vogue*, October 1959 for a feature called "P.M. parties – in town or out". The 18-year-old Coddington is wearing a cream satin dress by Berkertex Continentals, a Susan of Knightsbridge evening purse and bracelet by Jewelcraft.

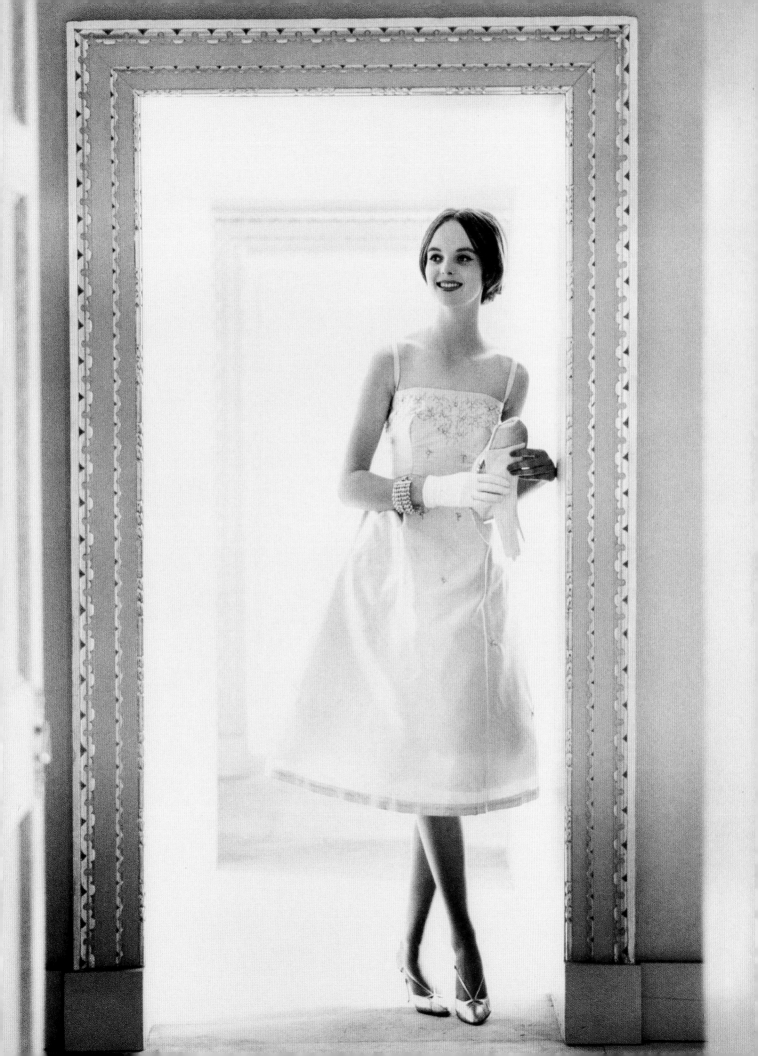

Parkinson's homage to a painting by Dutch artist Kees van Dongen entitled *The Corn Poppy*. Adele Collins is wearing an Otto Lucas velvet toque. British *Vogue*, November 1959.

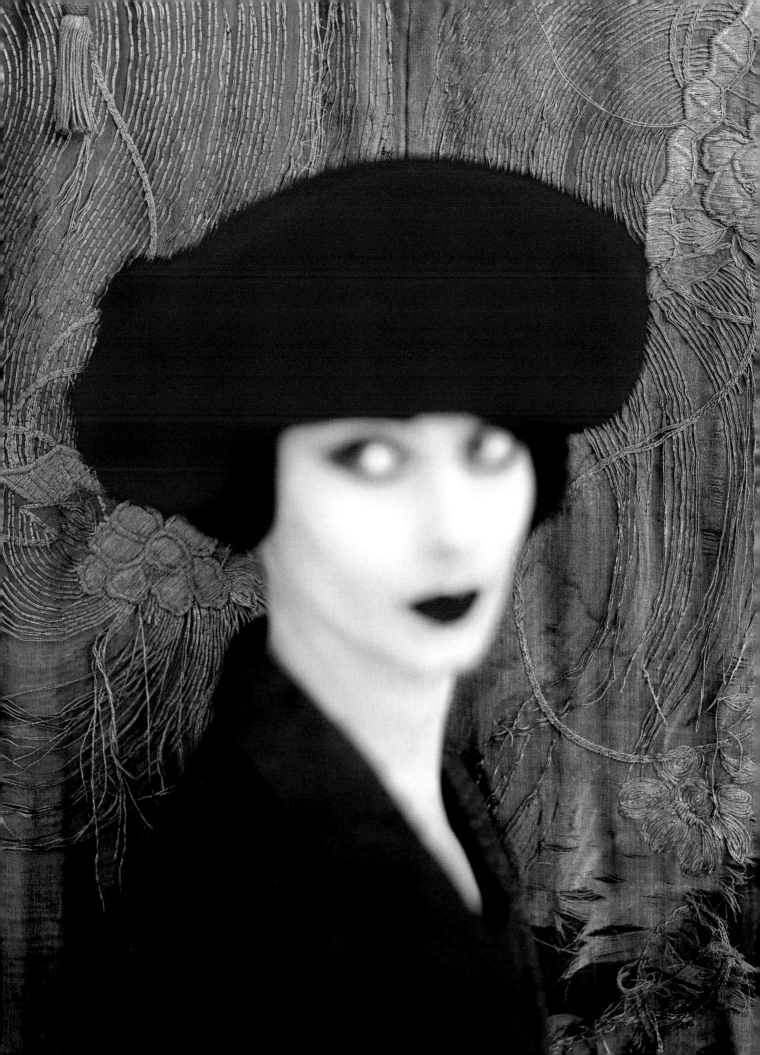

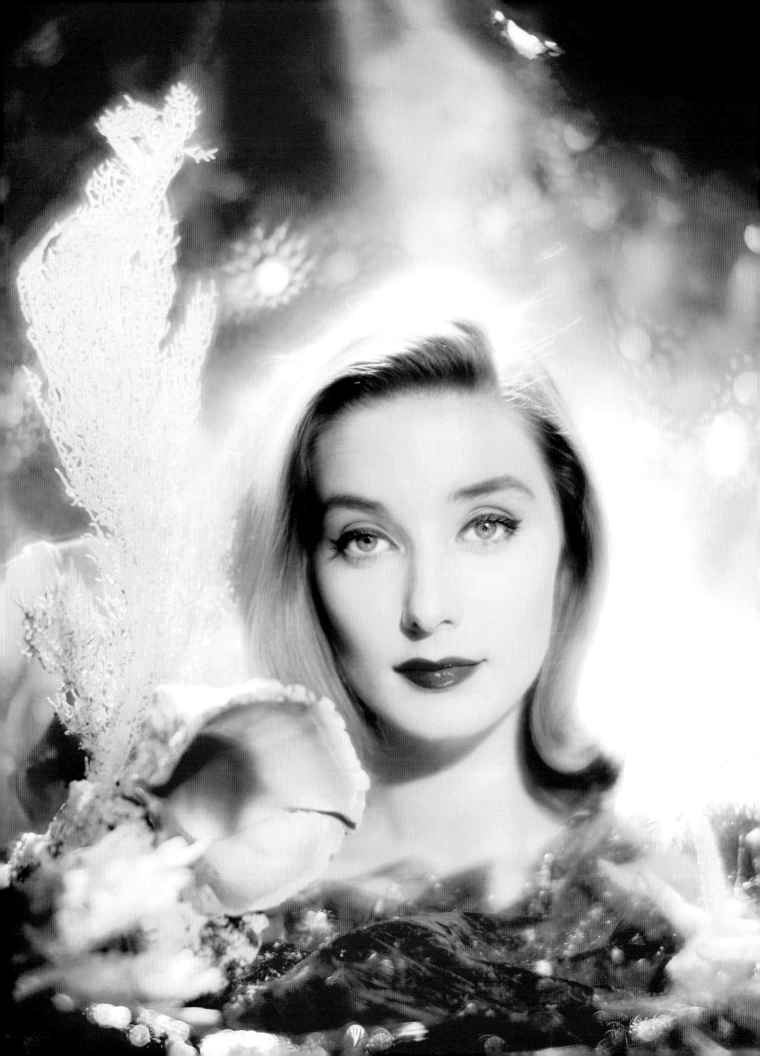

Tania Mallett photographed
for the cover of the first edition
of Australian *Vogue*, Spring/
Summer 1959, wearing Gala
make-up.

1 9

6 0s

Parkinson's fame as one of the top photographers of the Swinging Sixties was achieved earlier on in the decade, although he wasn't working for *Vogue* from 1960 until 1964. His contract with *Vogue* had expired at the end of 1959, and he was replaced at the magazine by a new generation of young photographic rivals nicknamed the Black Trinity – David Bailey, Terence Donovan and Brian Duffy, who were all making a name for themselves.

In the meantime, Parkinson was lured to the newly revived *Queen* magazine, which had been bought in 1957 by Jocelyn Stevens and was temporarily displacing *Vogue* at its time of change. From the first edition of 1960, Parkinson was installed as Associate Editor and Contributing Photographer in the fortnightly title, shooting the majority of covers with models he had talent-spotted over the previous years, including Katherine Pastrie, Carmen Dell'Orefice and Celia Hammond, who was signed to a one-year contract with the magazine which turned her into an international success.

As well as *Queen*, Parkinson was free to work on a number of special editions for *Life* magazine, most notably a 1963 issue that featured a huge cross-section of fashion and interior designers, photographed on the Thames Embankment. In 1963, Parkinson and his wife Wenda moved to Tobago, though they travelled to Europe and America for assignments every six months.

Diana Vreeland was appointed Editor-in-Chief of American *Vogue* in 1962 and was the first person at *Vogue* to use Parkinson again with a rare "at home in London" photostory on the James Bond creator and author Ian Fleming, featuring a profile written by their friend-in-common Robert Darling, who had commissioned many Parkinson photographs for his editorship at *House & Garden*.

Other American *Vogue* commissions continued in 1964, including photostories of the Marquess and Marchioness of Waterford at their home,

Curraghmore; the d'Erlanger house and family in Tunisia; and an important fashion story featuring top 1960s model Jean Shrimpton, photographed on the streets of London. Vreeland's main influence on Parkinson was to send him to distant locations for shoots – for example, Tahiti with Brigitte Bauer for American *Vogue*'s issue of 1 May 1965. Parkinson's love of travel began to inform many of his fabulous 1960s fashion shoots taken in Mexico, Greece and the Caribbean. He would often use tourist postcards as inspirations for exact locations during shoots.

In 1966, Parkinson would take an astonishing image of the African-American model Donyale Luna, who would later appear on the cover of British *Vogue*. Many other young *Vogue* models captured early by Parkinson would go on to become major stars of the era, including Millie Perkins, who played Anne in *The Diary of Anne Frank*, and Maud Adams, who would go on to star in three James Bond films.

It was in the 1960s that Parkinson playfully experimented with his photographic style. His Red Issue for both American and British *Vogue* included that decade's model icons, Celia Hammond and Jean Shrimpton, on the covers of both editions, while inside Donyale Luna and Grace Coddington modelled fun 1960s styles in photographs captured with a red filter. Perhaps most creative were Parkinson's double exposure images for another British *Vogue* photoshoot, of Katherine Pastrie alongside classic artworks by Gustav Klimt, taken at the time of an important exhibition of the artist.

As the years progressed, new stars of British film were featured in *Vogue*, namely *Blow-Up* actors Vanessa Redgrave and Jane Birkin in a memorable portfolio taken at the aristocratic setting of Aspley House with wigs by Vidal Sassoon. Parkinson's 1960s *Vogue* photographs were intrinsic documentations of groundbreaking fashion designs by legendary names such as Mary Quant, Rudi Gernreich and Pierre Cardin.

Tania Mallett

Cover of British *Vogue*,
Mid-March 1960

Tania Mallett's modelling career began in 1958 before her 17th birthday. After graduating from the Lucie Clayton College, then Britain's pre-eminent modelling agency, she was hired by Norman Parkinson, who saw her during a visit to *Vogue*'s office in Hanover Square. As Mallett recalled of the day in an interview with Becky Conekin, "I hadn't got a clue who he was, what *Vogue* was, absolutely nothing. I was living in a little flat just behind Marble Arch in the Park West block of flats. It was pouring with rain, but I thought it was a short walk to Hanover Square because, you know, I was a country girl and so I trudged across wearing what might have even been my riding trousers.

"When I arrived, my hair was dripping wet, and I was told to go to the sixth floor. I walked into the room and there were all these gorgeous women sitting around. I kind of slunk into a corner, and then this very funny-looking man came in, with a funny hat on his head and a sort of bristling moustache, and he looked round the room and said to me, 'What's your name?' and I said, 'Tania Mallett' and he said, 'You're hired.'"

Tania Mallett in front of the Blackburn Mill chimneys in Lancashire wearing a Horrockses jacket with a Christian Dior hat and Coty make-up. Cover of British *Vogue*, Mid-March 1960.

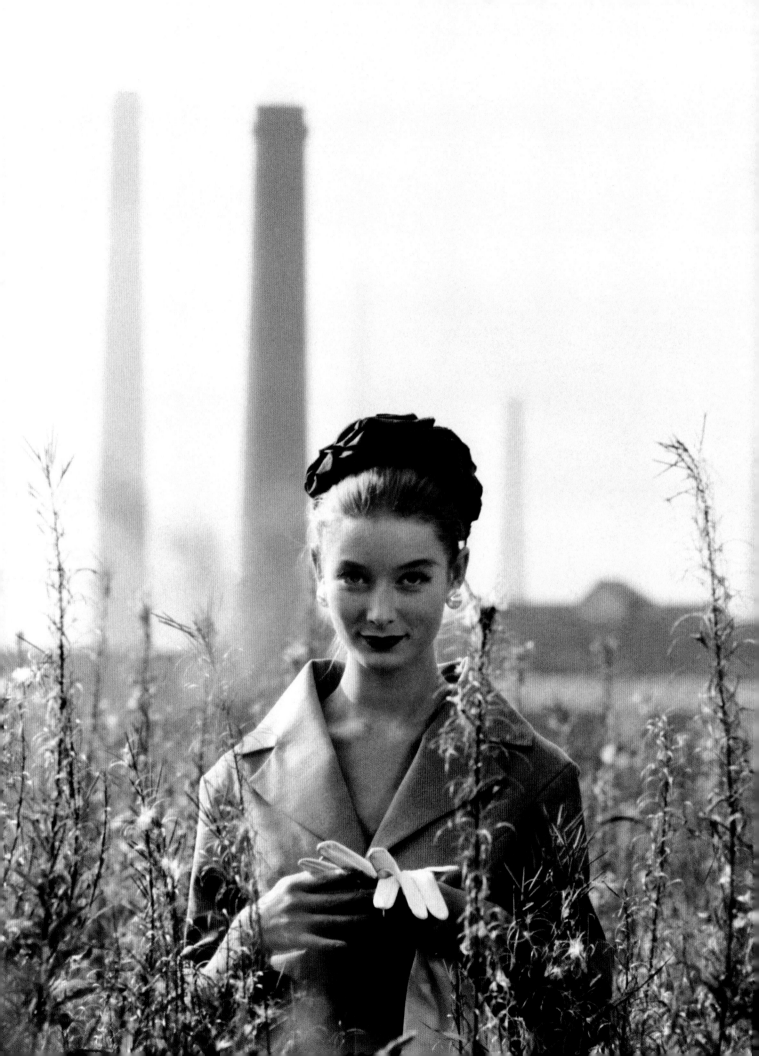

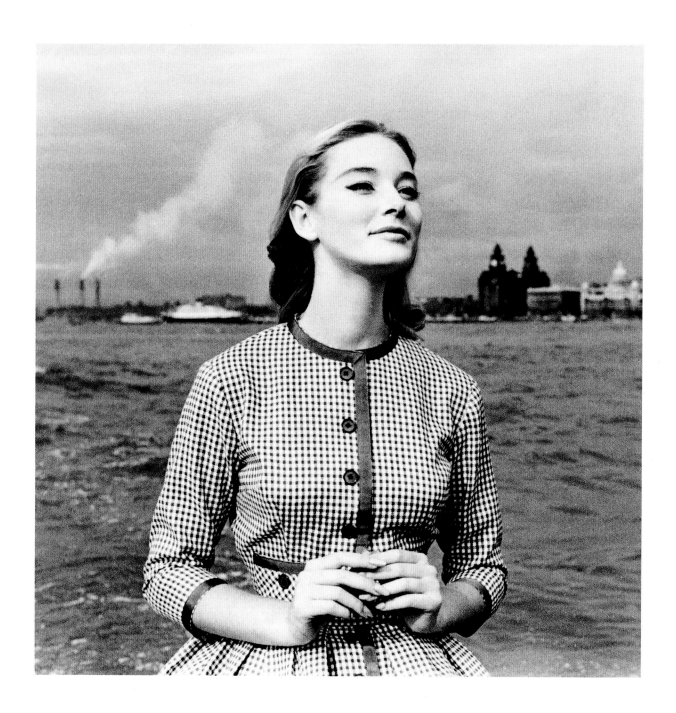

Above: Tania Mallett at Liverpool's Dockyards for the British *Vogue*, Mid-March 1960 fashion feature "Lancashire". Mallett wears a grey and white Hollins Mill checked cotton dress from Sambo. In the background Cunard's passenger ship *Caronia* is coming in to dock at Princes Landing Stage.

Opposite: Tania Mallett modelling for a Terylene advert on a Bond Minicar with a coat from Morcosia and Londonus trousers. British *Vogue*, Mid-March 1960.

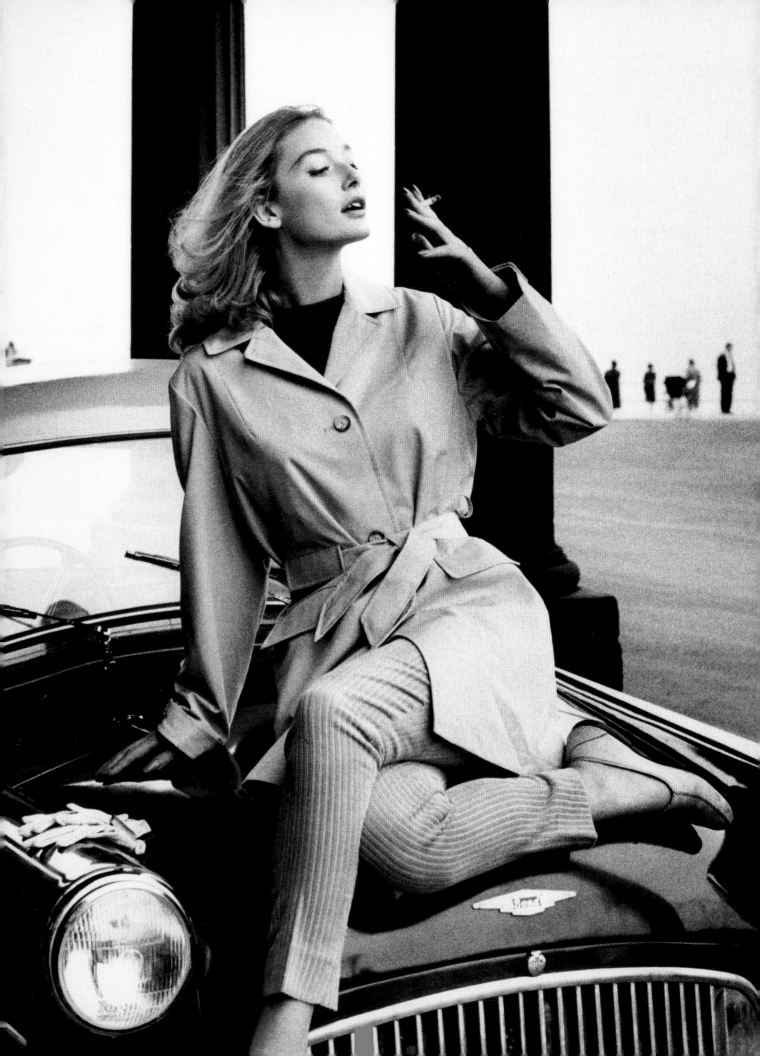

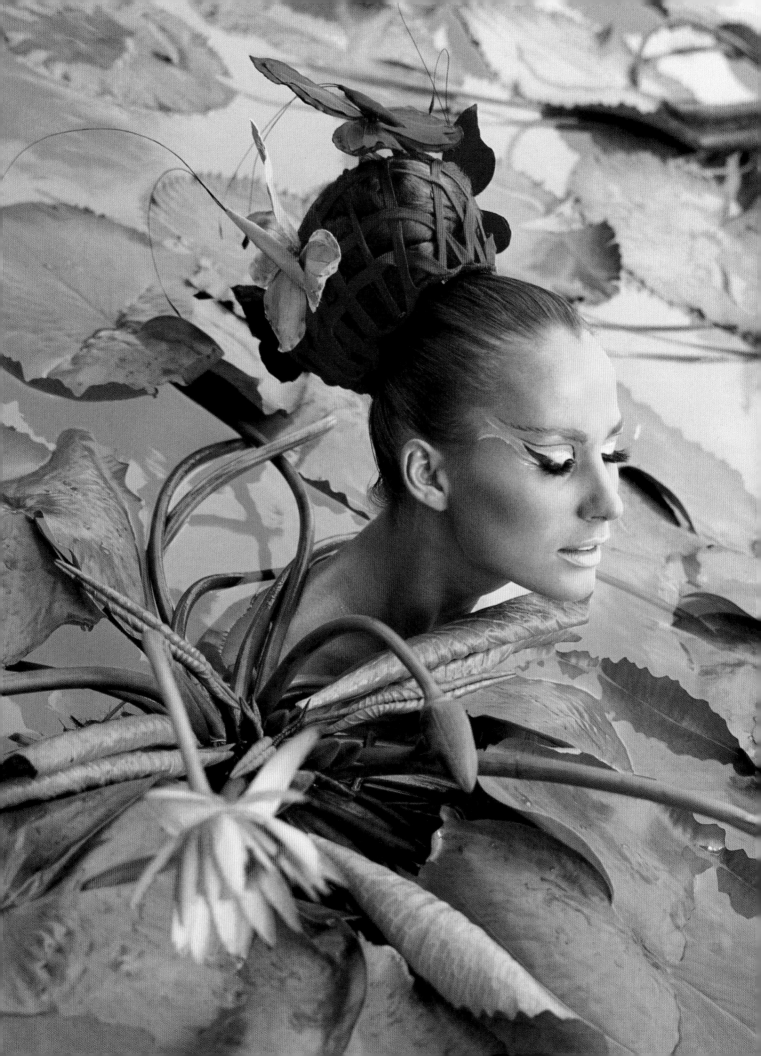

Brigitte Bauer photographed in
Tahiti wearing Estée Lauder make-
up and hair styled by Kenneth.
American *Vogue*, 1 May 1965.

Katherine Pastrie

British *Vogue*, 1965

Norman Parkinson worked with Katherine Pastrie throughout the 1960s, first photographing her regularly for *Queen* magazine and later for British *Vogue* and *Life* magazine. They frequently travelled to glamorous locations, with a checklist that included Tahiti, Jamaica, Mexico, Thailand, Barcelona and Paris. Parkinson also included studies of Pastrie for his 1960 retrospective exhibition at Jaeger.

This fashion shoot for British *Vogue* magazine includes all the most beautiful Gustav Klimt paintings as backdrops for spectacular 1960s French couture. The Klimt images were to tie in with one of his exhibitions in London.

Right: Katherine Pastrie in front of Gustav Klimt's painting *Jurisprudence* wearing a Dior coat made from Bianchini-Férier fabric. British *Vogue*, 1 September 1965.

Opposite: Katherine Pastrie in front of a Gustav Klimt's painting *Life and Death*, wearing a Cardin dress with make-up by Carita and hair by Prisca of Carita. British *Vogue*, 1 September 1965.

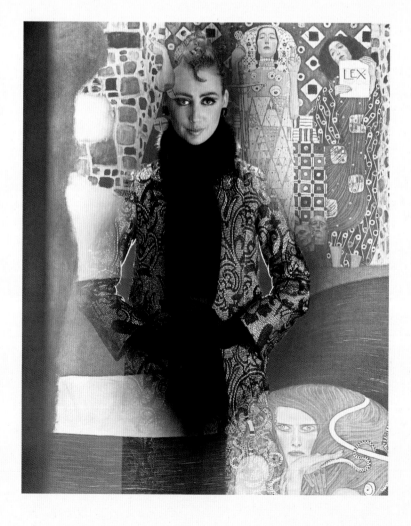

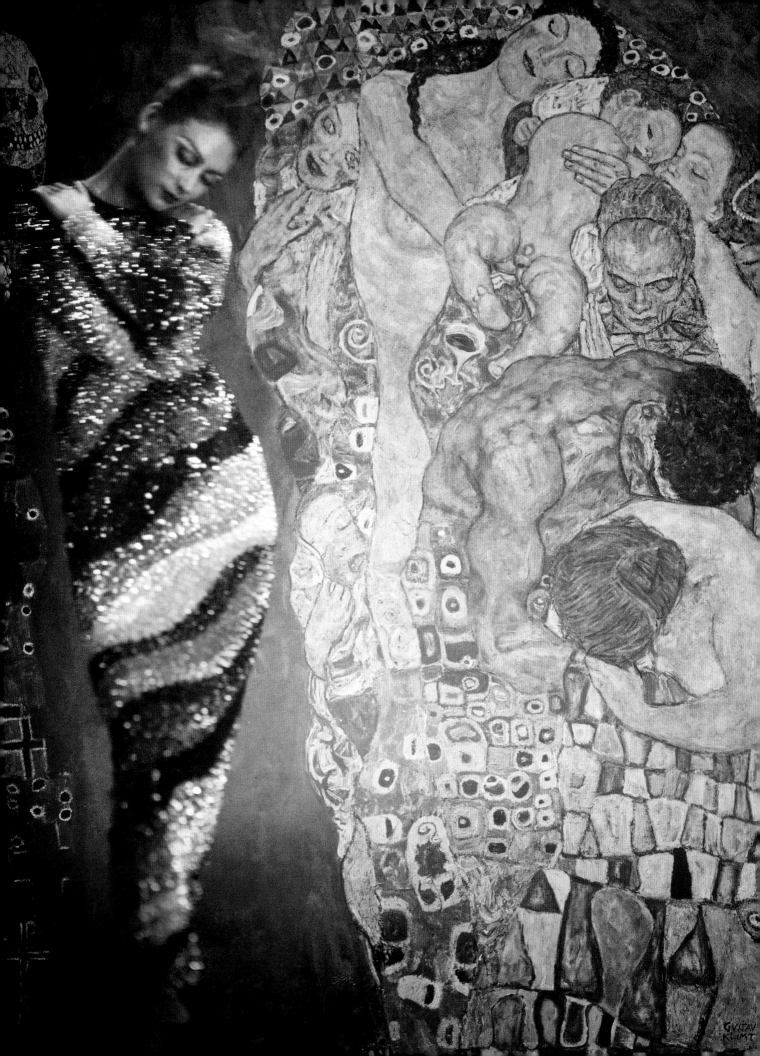

Princess
Elizabeth of Toro

British *Vogue*, October 1965

Princess Elizabeth was the first East African female lawyer to be admitted to the English Bar in 1962. She was crowned in 1965 and became the first Ugandan female lawyer.

In her autobiography, she recounts how her appearance in *Vogue* came about. Having graduated from Cambridge and moved to London, Elizabeth was seen by Beatrix Miller, editor-in-chief of *Vogue*, and invited to be interviewed for a feature article by Polly Devlin. Norman Parkinson accompanied the writer and photographed Elizabeth in both traditional Ugandan garments and a Guy Laroche dress.

Elizabeth has noted how these early photographs differed from those later in her career – once she had become a professional model – as they felt more natural to her. It was partly on the strength of these photographs that she was invited by Princess Margaret to model in a show.

Of the modelling career that followed, Elizabeth has explained that she undertook it not for money or prestige, but to make an important point via photography about her beloved Uganda. In her autobiography, she notes: "Milton Obote had done and was doing his utmost to erase the monarchy in Uganda from the national consciousness. The monarchy was, to all intents and purposes, extinct. It was not my aim to revive it, but, in adopting my new and, I must say, very different role from hitherto, I hoped to bring to the attention of the world my pride in my heritage, to emphasize my ancestral identity which, with one stroke of his pen, Obote thought he could eradicate. The language of clothes, of fashion and its attendant publicity is a significant one. And I was utterly determined to utilize such a powerful weapon to remind everyone that Uganda's culture was still a force to be reckoned with."

Opposite: Princess Elizabeth of Toro wearing a traditional African dress. British *Vogue*, 1 October 1965.

Overleaf: Princess Elizabeth of Toro wearing a Guy Laroche dress. British *Vogue*, 1 October 1965.

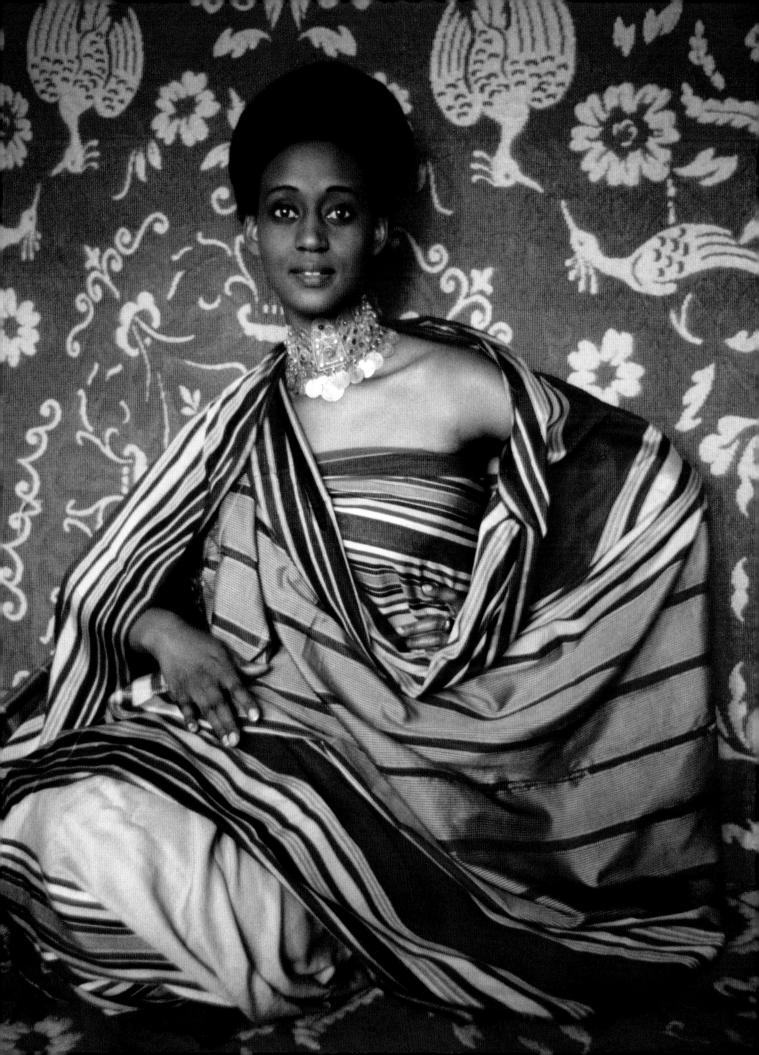

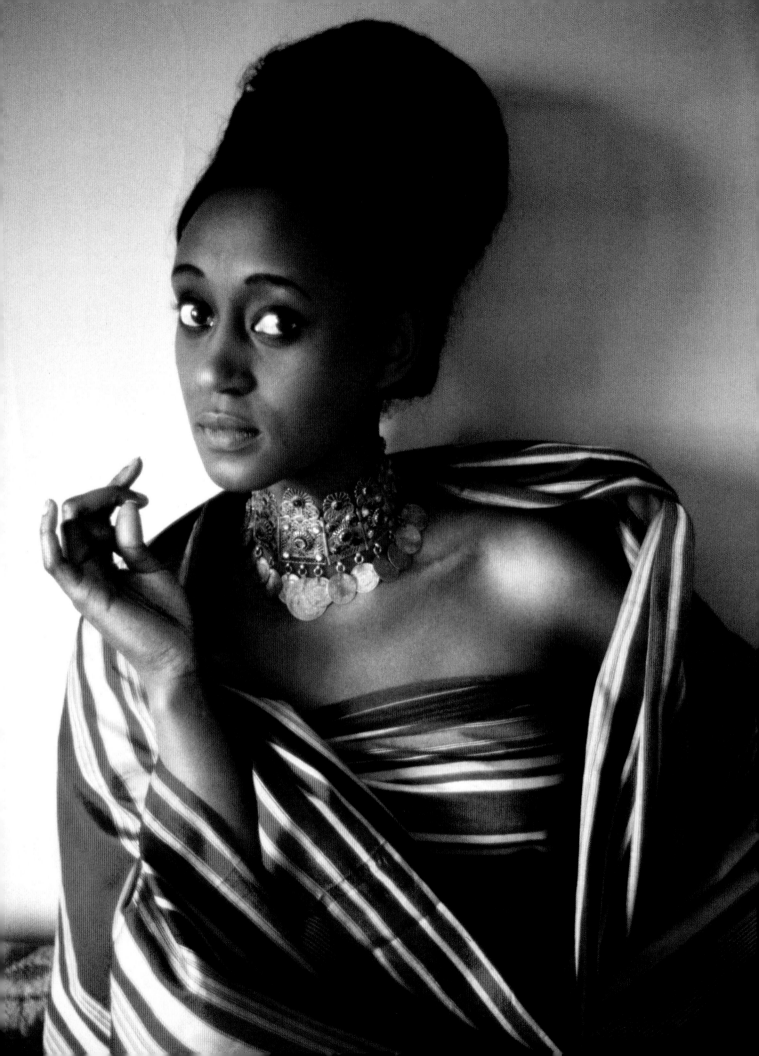

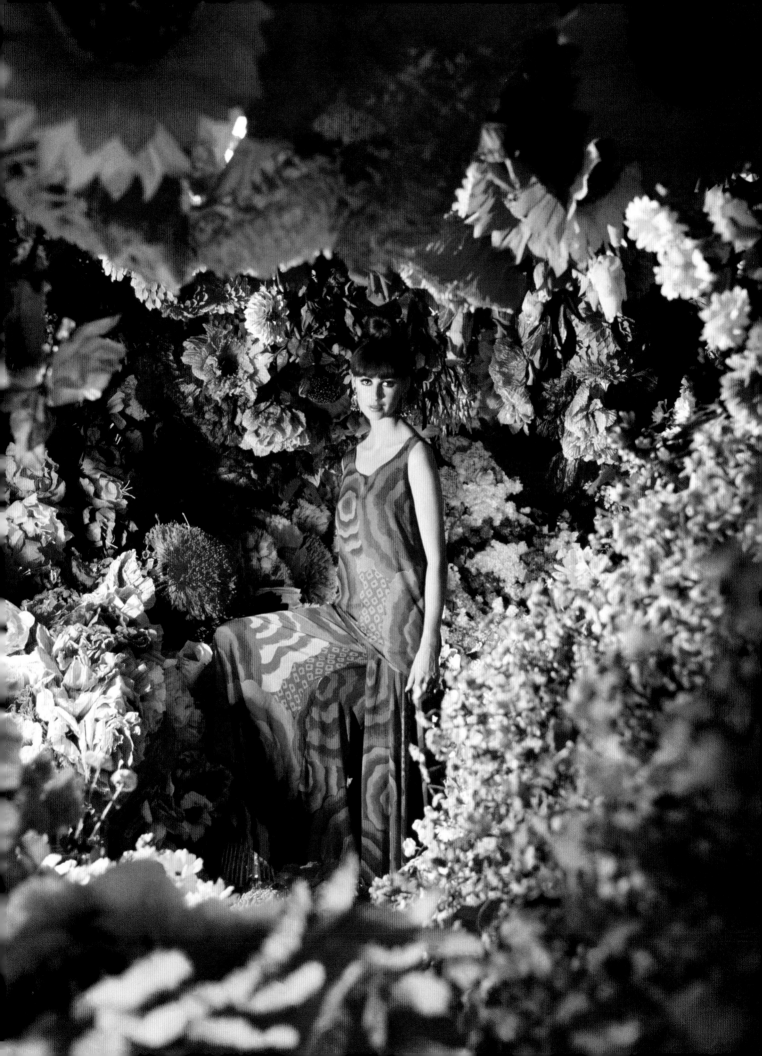

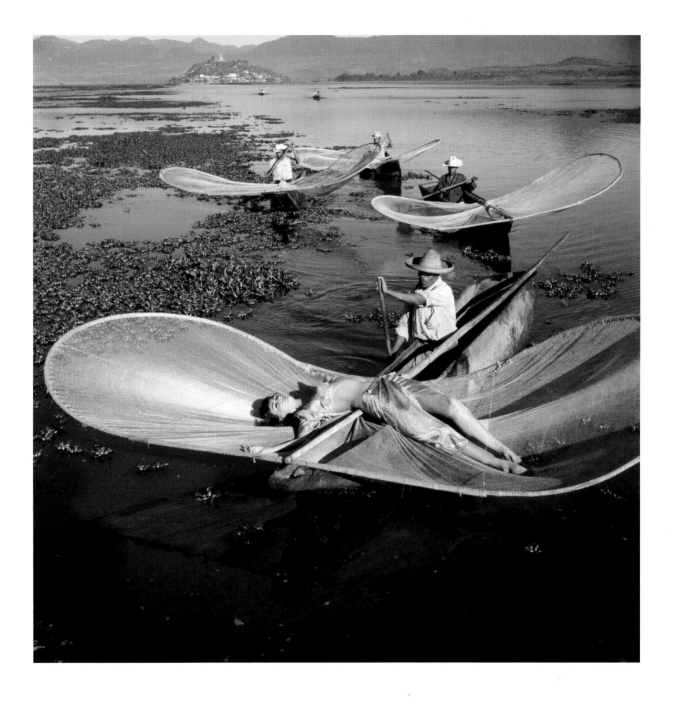

Opposite: Katherine Pastrie wearing Ken Scott pyjamas from Fortnum & Mason with tissue flowers handmade by the family firm Jesus Tamayo. Photographed in Mexico for British *Vogue*, January 1966.

Above: Katherine Pastrie in Mexico wearing fashion by Tiktinex at Fortnum & Mason. British *Vogue*, January 1966.

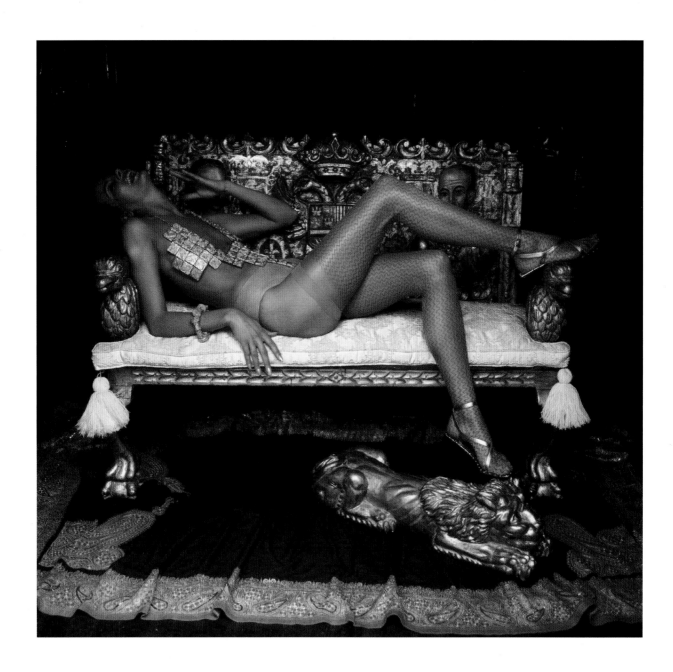

Above: Dolores Wettach in Peru on a seventeenth-century sofa made in a village near Cuzco. Nylon stockings from Hudson, with sandals from Saks Fifth Avenue and gilded bikini made to order from Bonwit Teller. American *Vogue*, 1 July 1966.

Opposite: Joan Delaney, model and film actress, wearing a dress by Lotte for Paul Parnes with a Martinique shoe. Photographed in Peru for American *Vogue*, 1 July 1966.

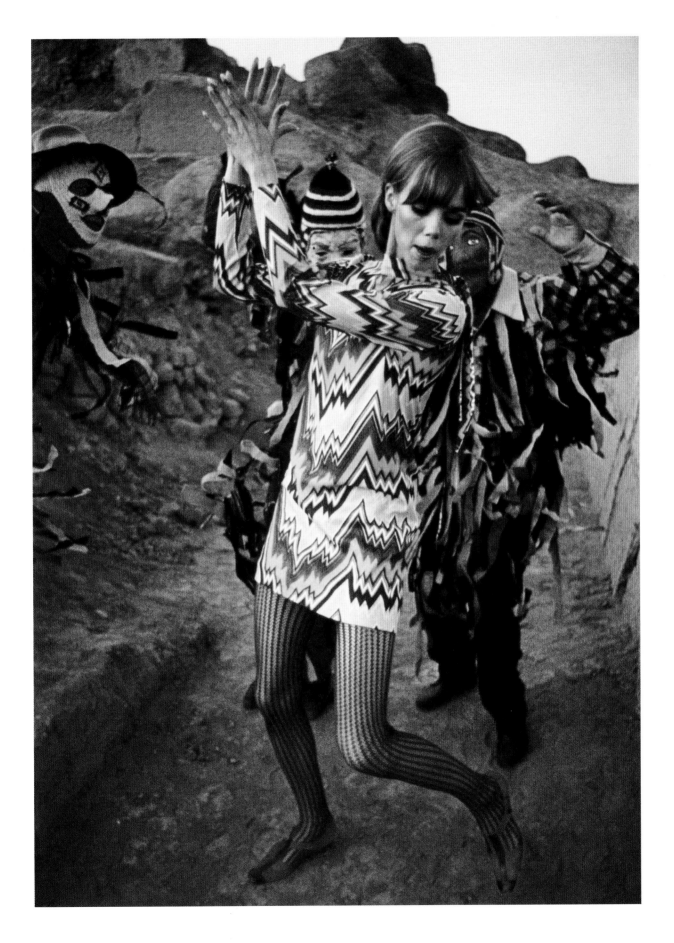

Donyale Luna

British *Vogue*, August 1966

Donyale Luna (1945–1979) was the first African-American to appear on the cover of British *Vogue* in May 1966, photographed by David Bailey. A year before, a fashion illustration of Luna by Katharina Denzinger appeared on the cover of the January 1965 issue of *Harper's Bazaar*, also charting her as the first black woman to be portrayed on a *Harper's Bazaar* cover.

Norman Parkinson photographed Luna a few months after her cover shot, for the August 1966 issue of British *Vogue* as part of the feature "Vogue Sees Red".

Tragically, Luna died of a heroin overdose in 1979 at the young age of 33. Her importance was initially overlooked by the media – and the fashion industry – but in recent years, her legacy has started to be documented and rightly celebrated. Naomi Campbell recognized Luna in her CFDA acceptance speech in 2019 and famed make-up artist Pat McGrath used Luna as the inspiration behind the sixth edition of her Mothership makeup palette. Luna's daughter, Dream, wrote a touching essay about her mother for British *Vogue*, 40 years after her passing.

Donyale Luna photographed for the August 1966 issue of British *Vogue* as part of the feature "Vogue Sees Red". Donyale's outfit is pieced together with clothing by Garigue, Tissus Michels, Galloway Reels, Soieries Nouveautés, Burt & Willis, Heather Mills, Gaeltarra Eireann, George Roberts and Jaska with make-up by Max Factor.

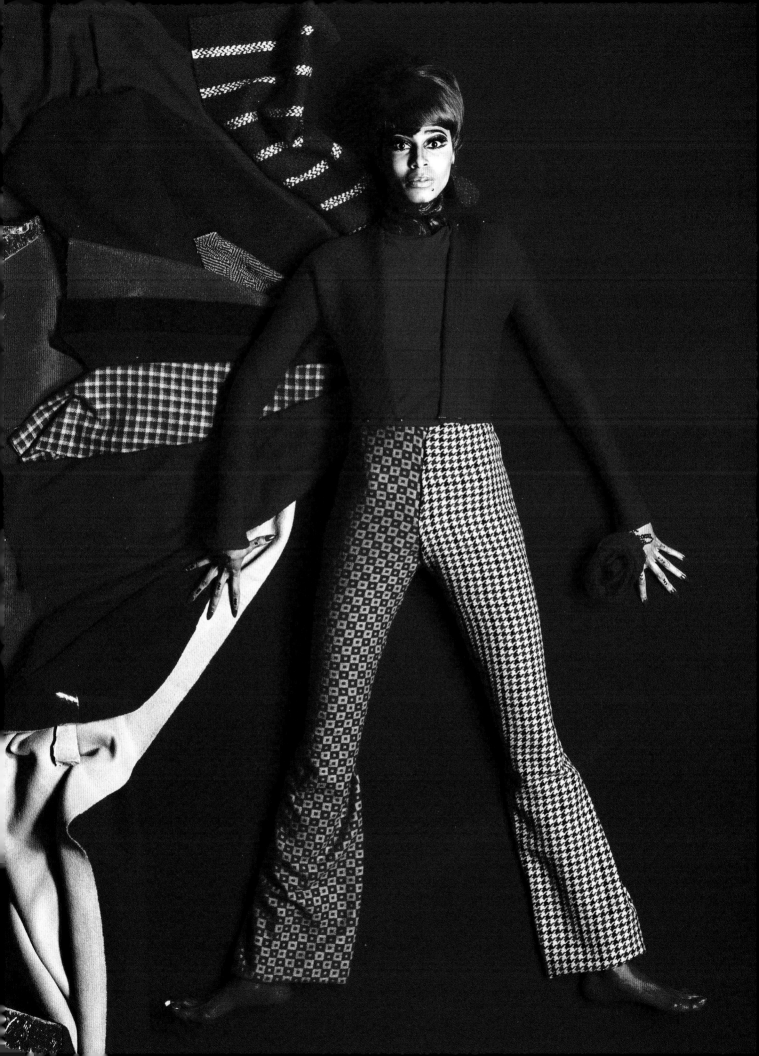

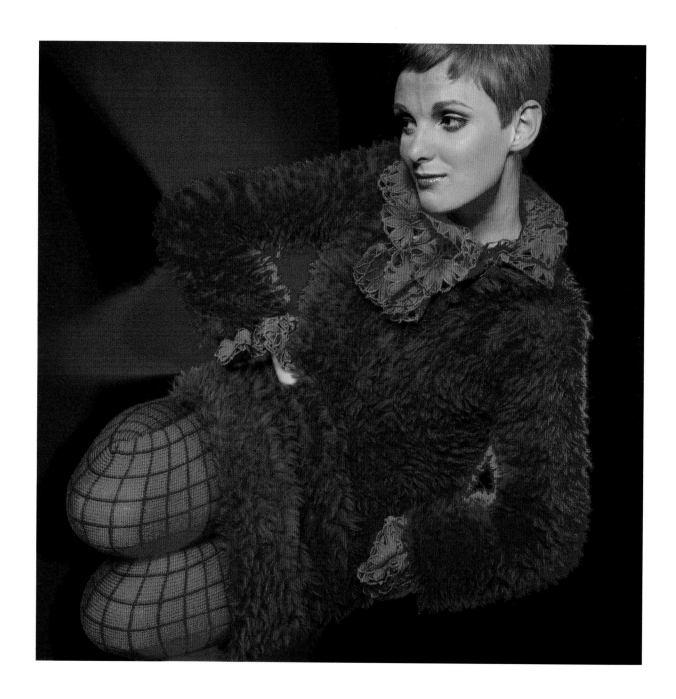

Above: Grace Coddington, model and later Creative Director-at-Large of American *Vogue*, wearing a fleece collarless coat-dress by Jane & Jane. British *Vogue*, August 1966.

Opposite: Celia Hammond modelling fashion by Ellen Brooke and Malbé with Yardley make-up and hair by Michael at Leonard. Part of a cover story for American *Vogue*, 1 August 1966.

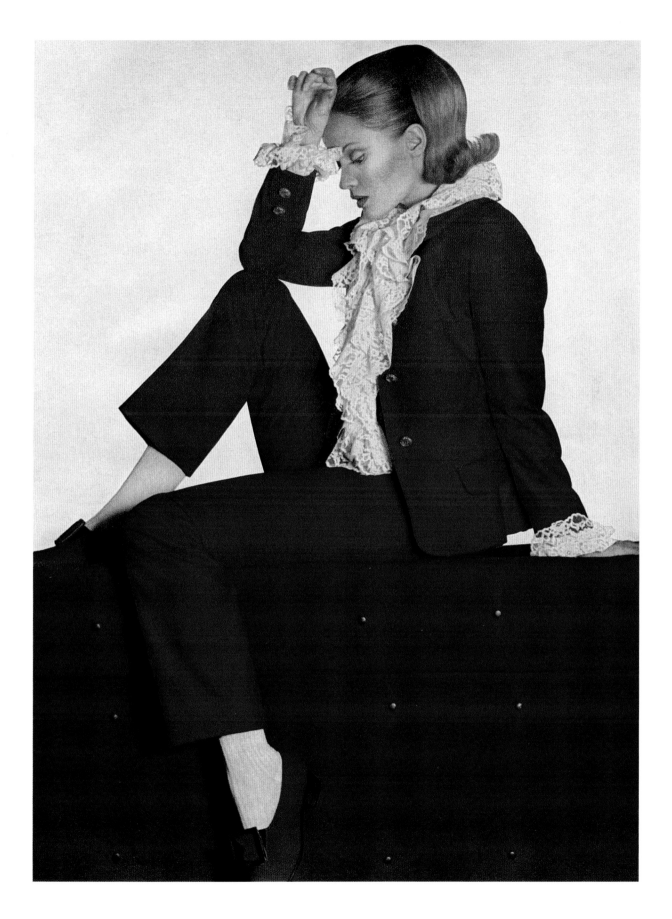

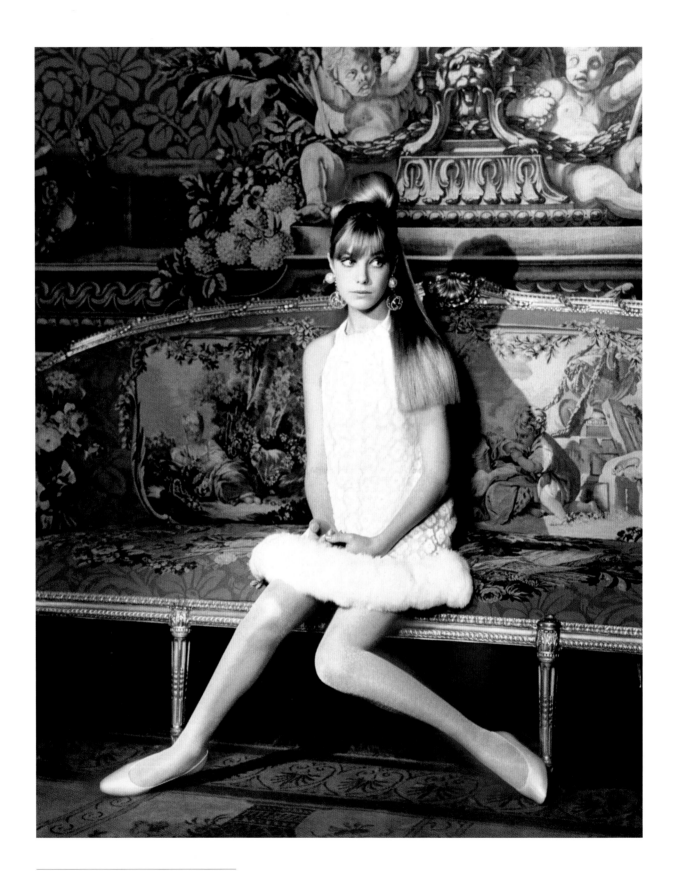

Jane Birkin photographed at Osterley Park
House wearing a white silk chiffon dress by
John Bates. American *Vogue*, 1 August 1966.

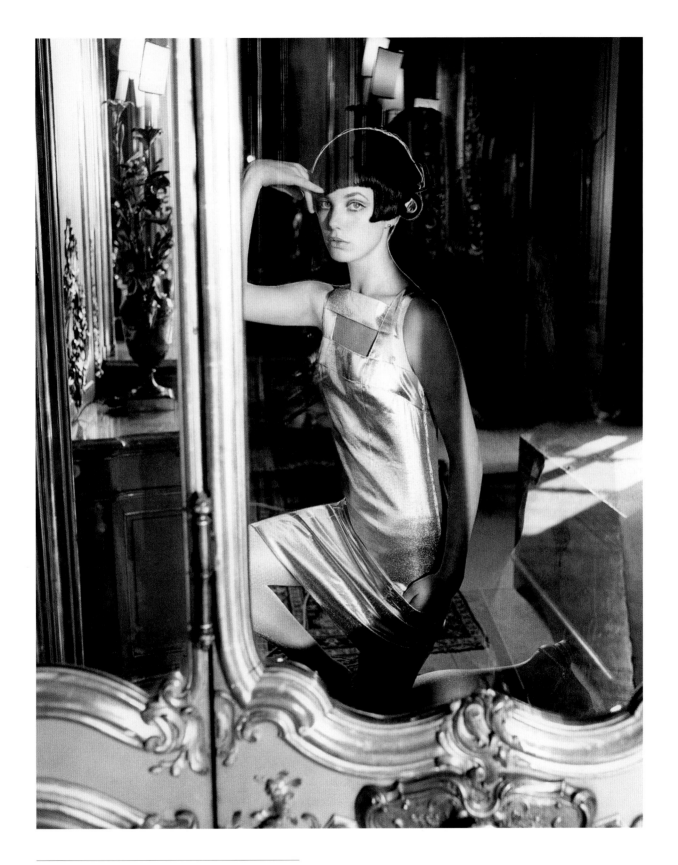

Jane Birkin photographed at Osterley Park House wearing a silver dress by Emmanuelle Khanh with a wig cut by Joshua of Vidal Sassoon. American *Vogue*, 1 August 1966.

Twiggy

British *Vogue*, February 1967

Twiggy was first photographed by Norman Parkinson in December 1966 for two stories for the February 1967 edition of British *Vogue* at Vogue Studios, the same year she was proclaimed as the new "Face of 1966". The two would work together several more times in the following decade.

There is memorable 1968 film of Twiggy dancing to 'Jimmy Mack' by Martha & The Vandellas for Parkinson on his BBC television documentary "Stay, Baby, Stay" in the *One Pair of Eyes* series. In the TV interview with Twiggy, Parkinson remarks "People say Twiggy looks like a boy, she doesn't. She's just adorable. In fact, in America, they call her the thinking-man's Sophia Loren."

Parkinson would later photograph Twiggy when she was expecting her daughter Carly and shortly after the birth with her husband Michael Whitney. Twiggy was captured posing against ferns also for Parkinson's 1977 book *Sisters Under the Skin*.

In her 2009 book *A Life in Photographs*, Twiggy recalled, "I'm so glad I had the chance to work with Norman Parkinson. We did a shoot together once during the 1960s, but the shots I like the best were taken in the late 1970s. He was delightful. Completely eccentric, he was very tall and thin with a large moustache, and he always wore a beautiful embroidered Kashmiri wedding hat and very hippy-ish clothes, which I loved. He was in every way unique."

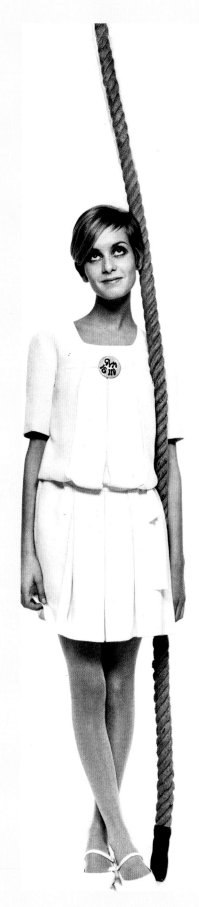
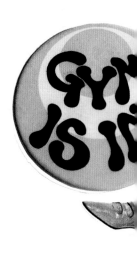

"Young Idea says Gym is in"
– British *Vogue* February 1967
fashion story with Twiggy
modelling designs from Marrian
McDonnell, Mary Quant and John
Bates with accessories from John
Lewis and Kurt Geiger. Original
retouched vintage print from the
Norman Parkinson archive.

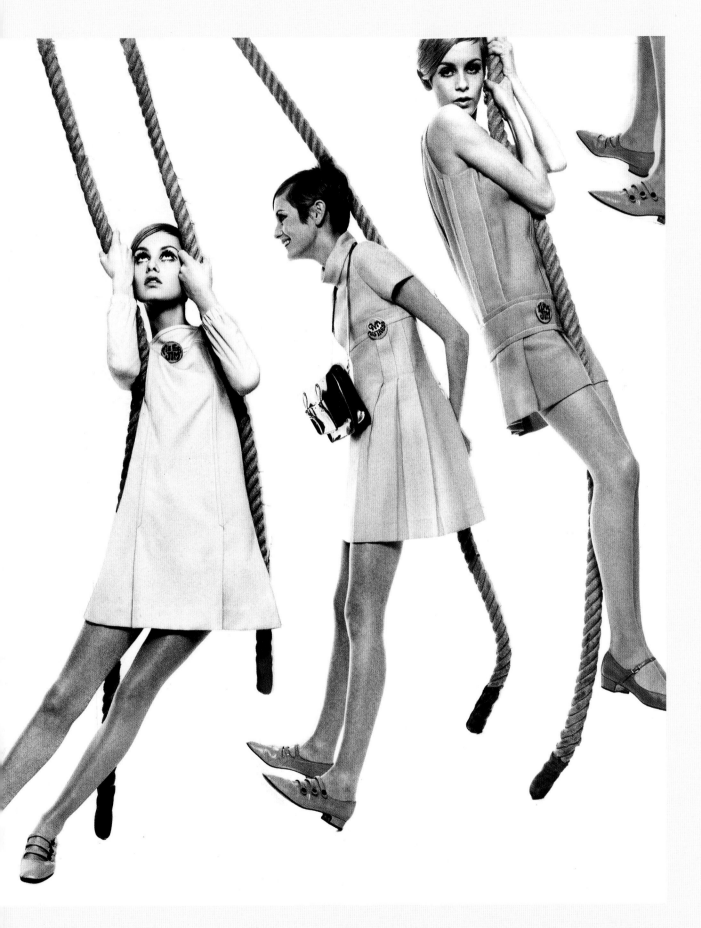

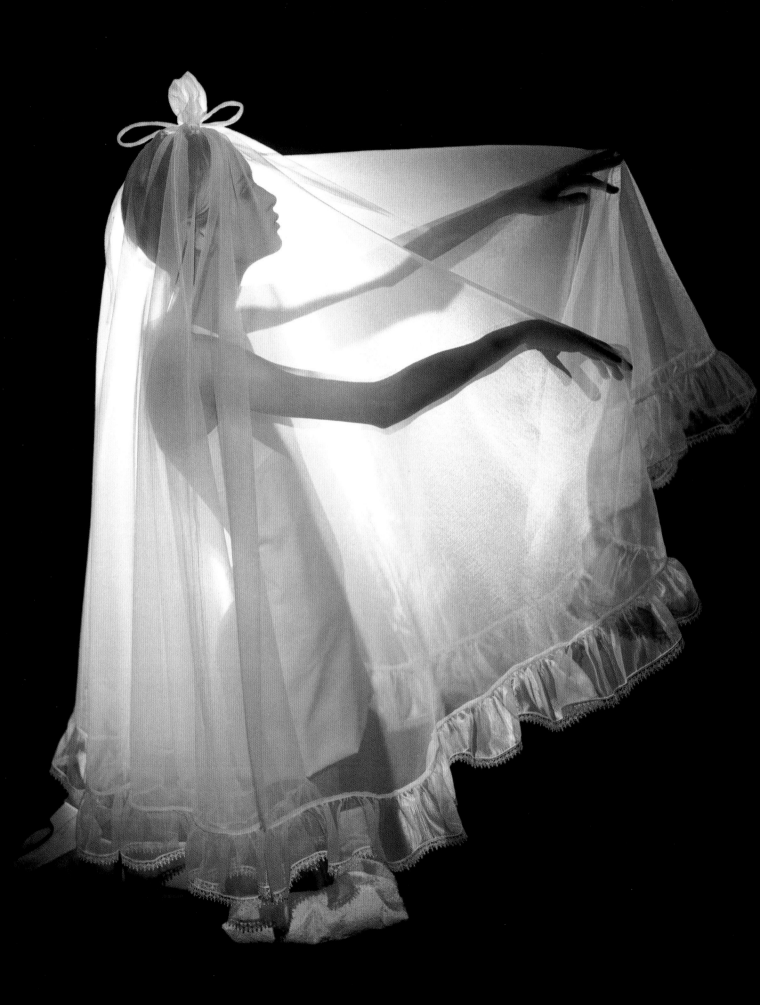

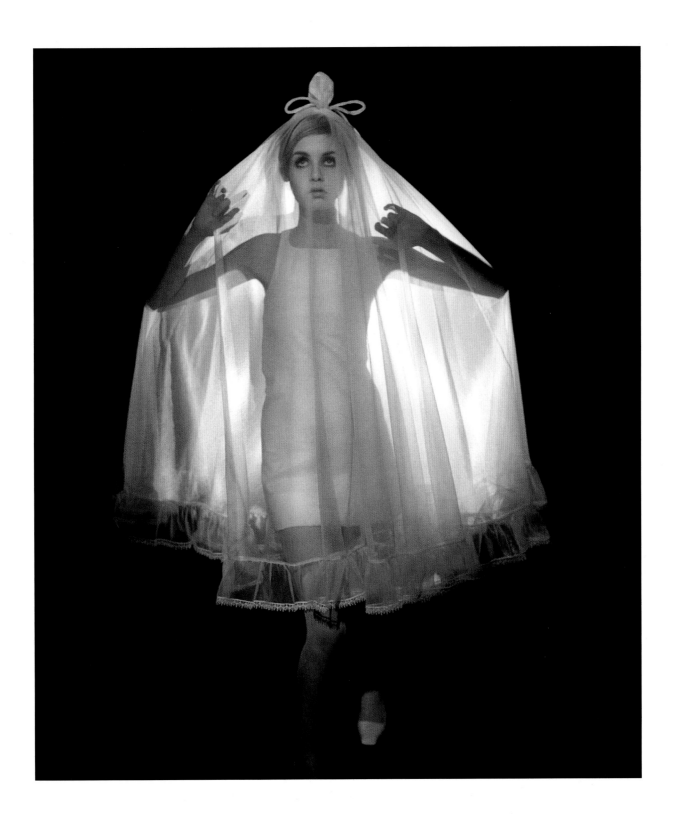

Twiggy wearing a "Very New Wedding Look"
by John Bates for Jean Varon, British *Vogue*,
February 1967.

Overleaf: Pattie Boyd wearing *broderie anglaise*
playsuits from Fenwick with hair by Martin at
Leonard. British *Vogue*, August 1967.

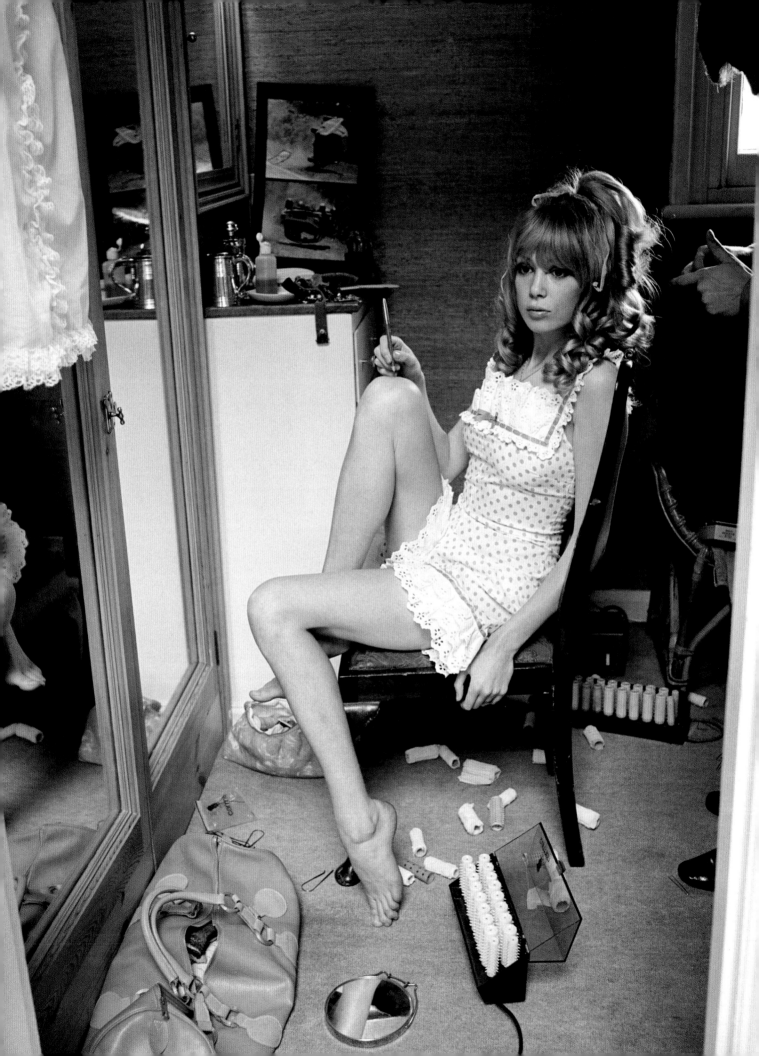

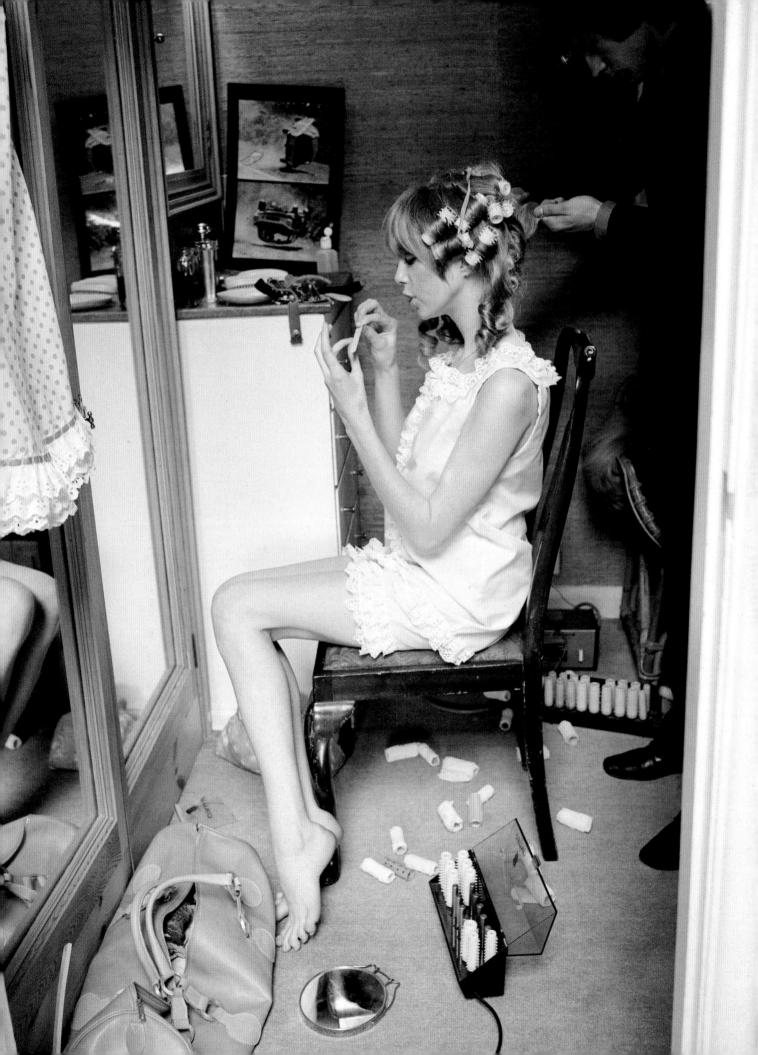

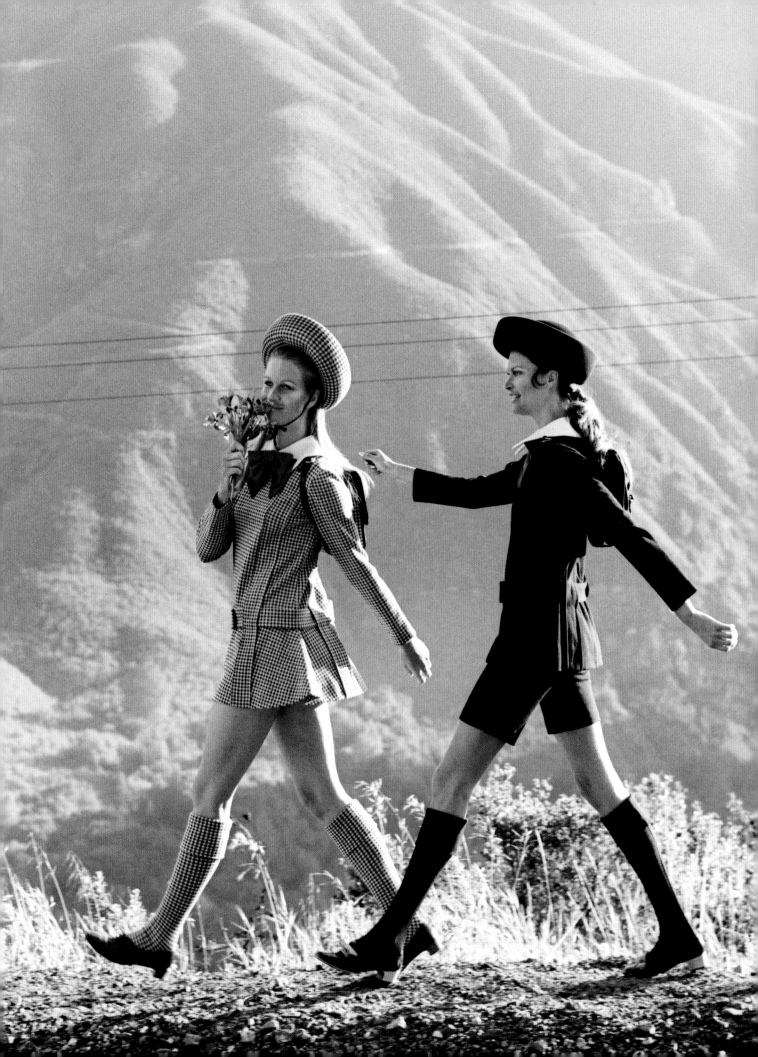

"After-School Suits" in black-and-white checked Japanese style by Rudi Gernreich for Harmon Knitwear, worn with matching hats by Layne Nielson and Charles Jourdan shoes. Photographed at California's Big Sur for American *Vogue*, 15 August 1967.

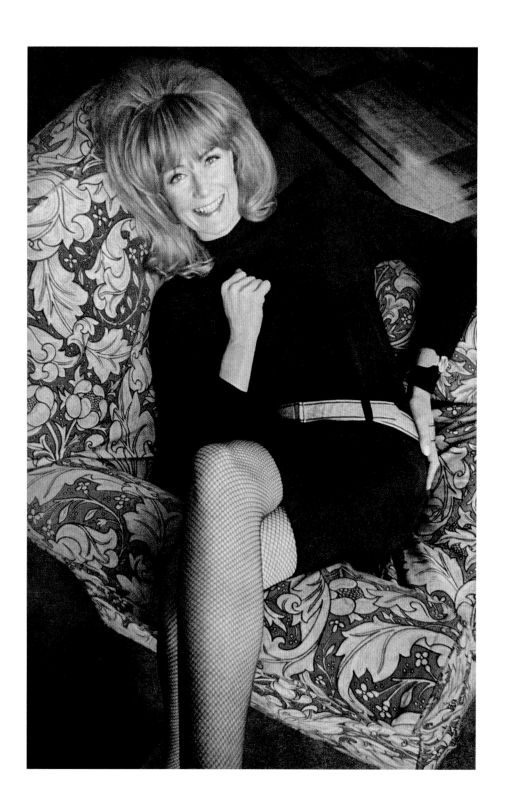

Vanessa Redgrave wearing a wool jersey
dress by Anne Klein with a Schiaparelli watch.
Photographed at Woodrow Wyatt's eighteenth-
century Tower House in London for American
Vogue, 1 August 1966.

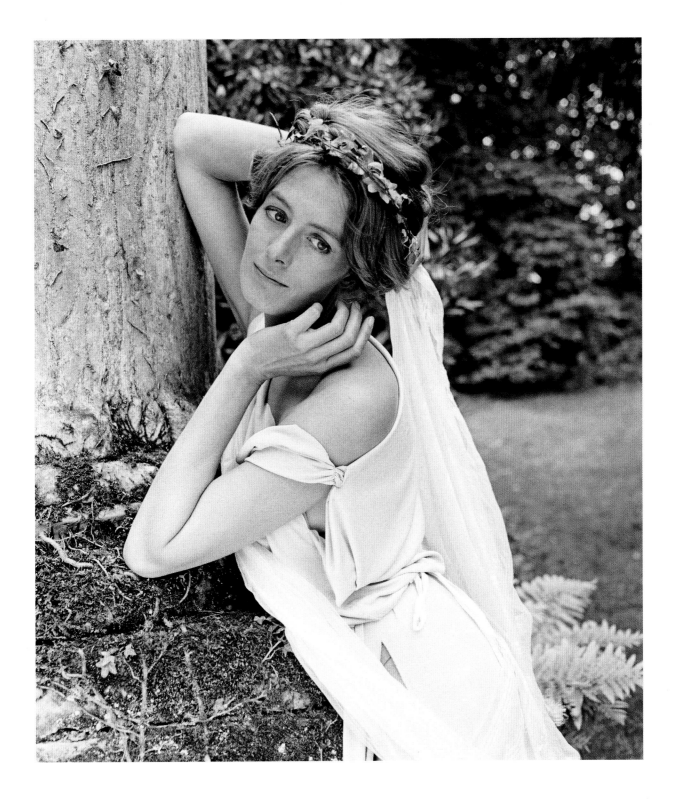

Vanessa Redgrave rehearsing for Karel
Reisz's film *Isadora*, for which she won a
Golden Globe and an Oscar nomination.
Photographed at Virginia Water for
American *Vogue*, 15 November 1967.

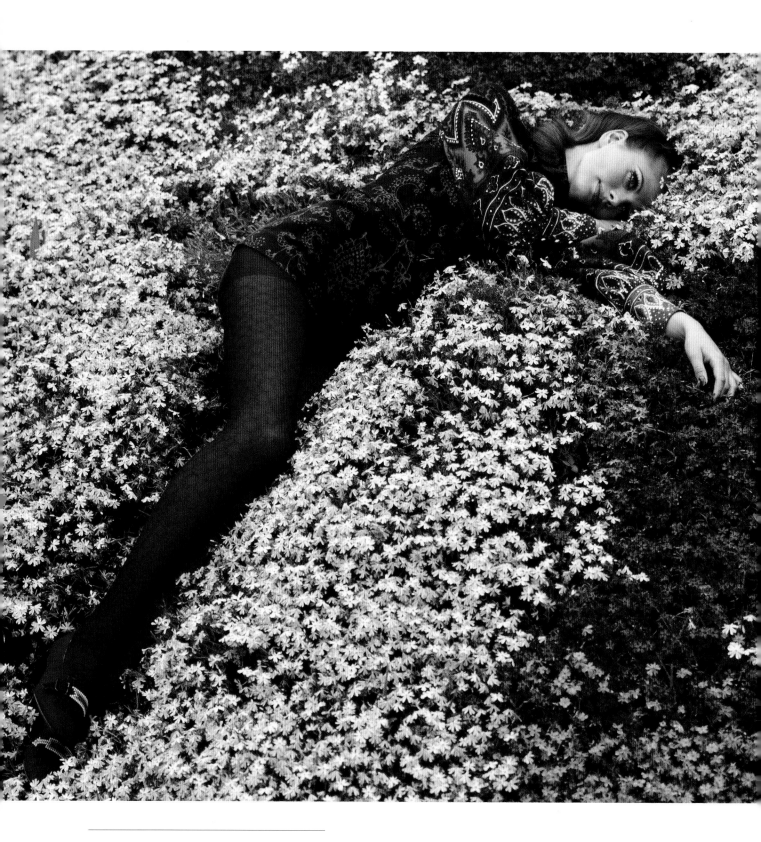

Above: Maud Adams wearing pumps by Evelyn Schless with Best & Co. tights and a tunic by Gregory for American *Vogue*, August 1968.

Opposite: Maud Adams wearing boots by Delman with Adler stockings and a velvet shirt by Gregory. American *Vogue*, August 1968.

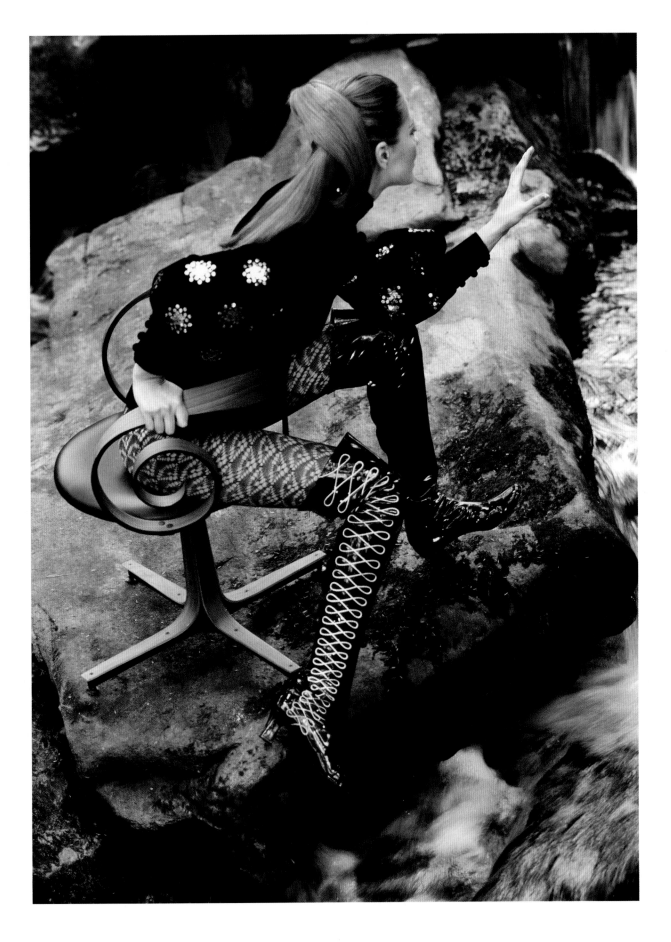

Jan
Ward

British *Vogue*, October 1968

Jan de Villeneuve is one of few models to have enjoyed a six-decade career in fashion. She began in her early twenties, leaving her hometown Detroit to sign with the Ford Modelling Agency in New York City. Working under the name Jan Ward – which she took from her first husband – she was photographed by other renowned photographers such as William Klein and David McCabe.

In 1968, Jan travelled to Europe and met Norman Parkinson, collaborating him with on many stunning fashion shoots until the late 1970s. Her first assignments for Parkinson were advertisements for the fashion brand Jaeger, published on the back covers of British *Vogue*. She signed with Models 1 during this period, and the agency has represented her ever since.

Now in her seventies, Jan still graces the covers of magazines to great acclaim. She married Justin de Villeneuve, the ex-boyfriend and manager of Twiggy, in 1975. They have two daughters: the illustrator and writer Daisy, and Poppy, a director and photographer.

Jan Ward (later Jan de Villeneuve) wearing a silk two-piece from Savita and jewellery by Malabar & Ken Lane at Peter Kerr-Jarrett's estate near Montego Bay, Jamaica for British *Vogue* magazine, 15 October 1968.

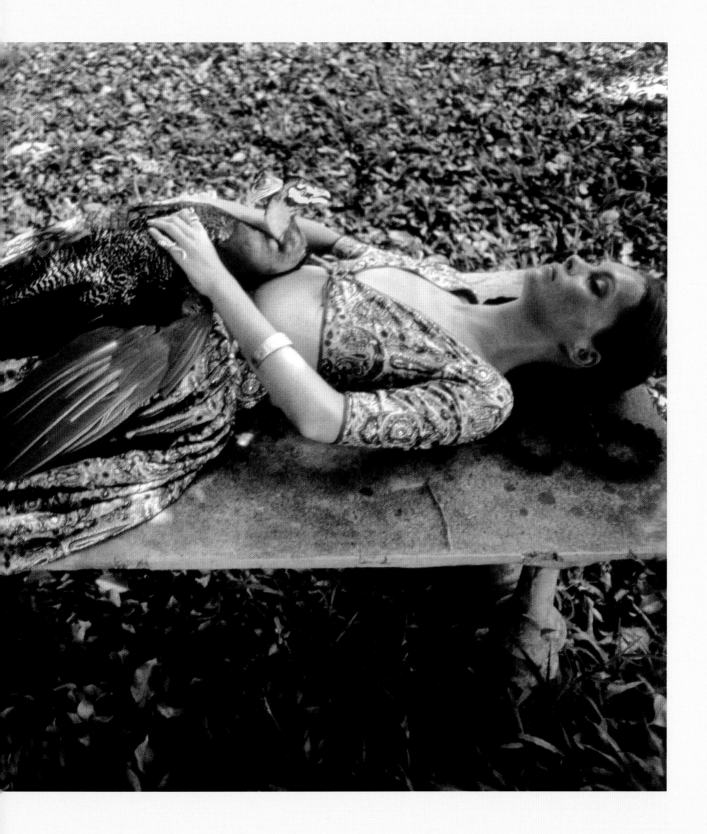

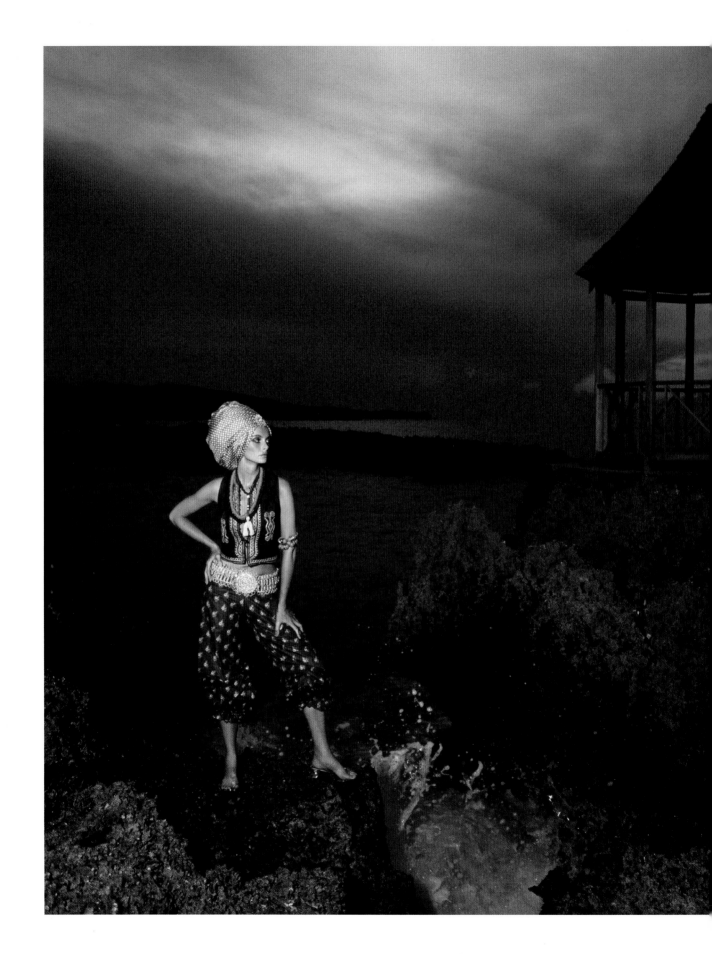

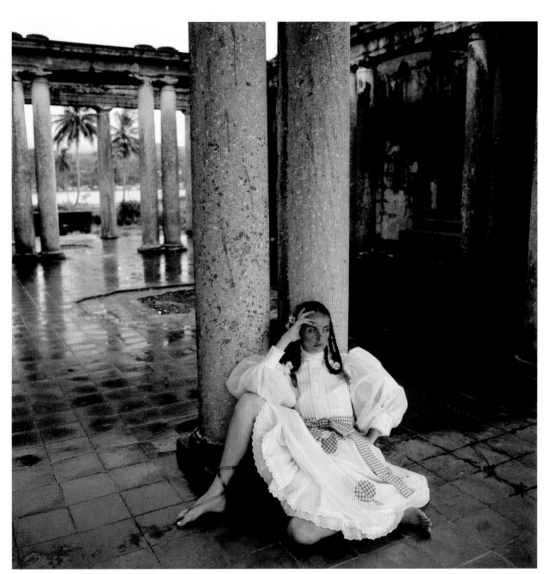

Opposite: Jan de Villeneuve photographed in Jamaica at Port Antonio besides Trident Villas Hotel for the British *Vogue*, 15 October 1968. Jan wears a waistcoat, harem trousers and necklace from Thea Porter with scarves by Ascher, jewellery by Ken Lane and Cadoro, and Guerlain lipstick.

Above: Jan de Villeneuve photographed in Jamaica at Port Antonio at The Folly for the 15 October 1968 issue of British *Vogue*. Jan wears a maxi dress by Susan Small with lipstick by Dorothy Gray and hair by Leonard.

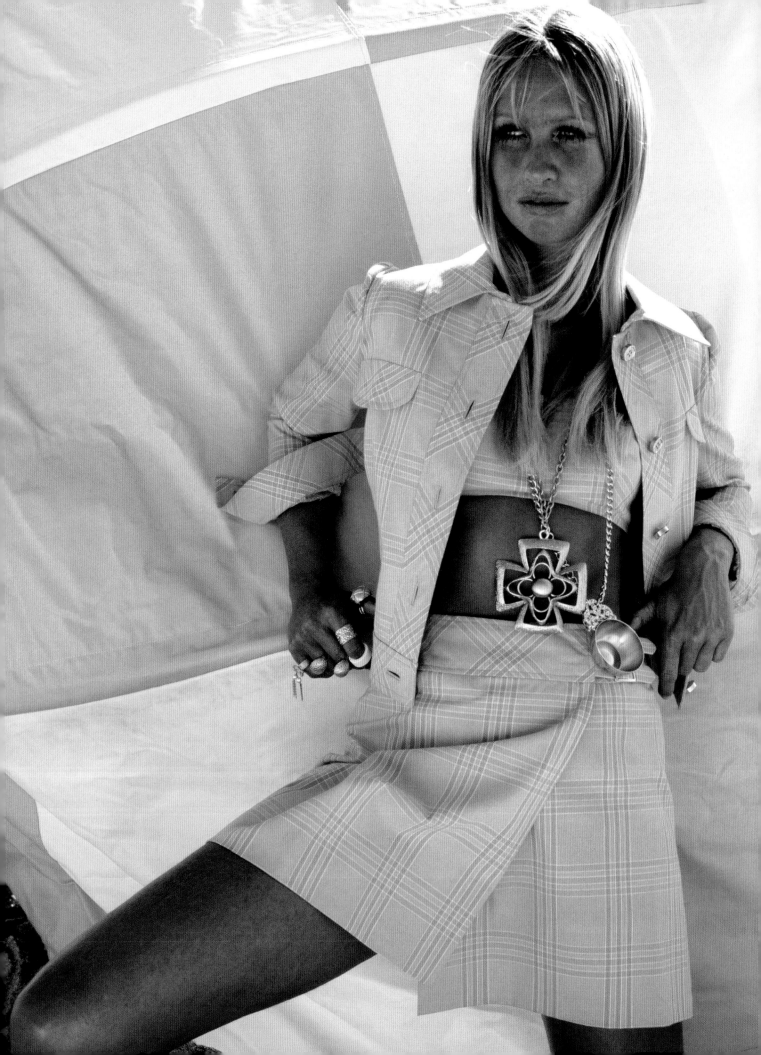

Françoise Rubartelli, Swiss-born model, photographed for the January 1969 issue of British *Vogue*. Rubartelli wears a three-piece suit by Ginori with jewels by Napier and Vendome.

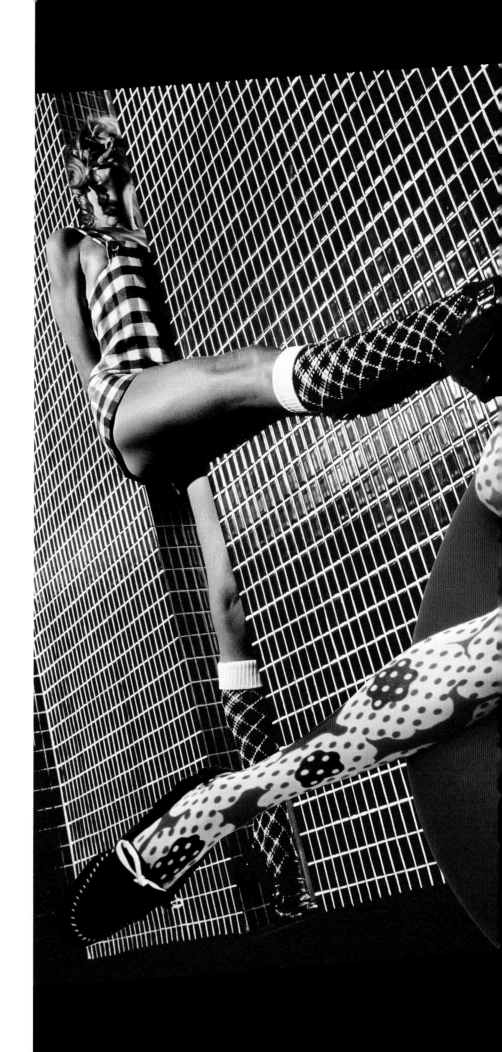

"The New Emphatics: for feet and legs – drama from the ground up", fashion story photographed at El Conquistador Hotel in Puerto Rico for American *Vogue*, 15 February 1969. The fantastic tights are by Rudi Gernreich and paired with shoes by Golo and Roger Vivier. The left model is wearing a checked jumpsuit by Erika Elias and on the right a striped shirt by Adelaar.

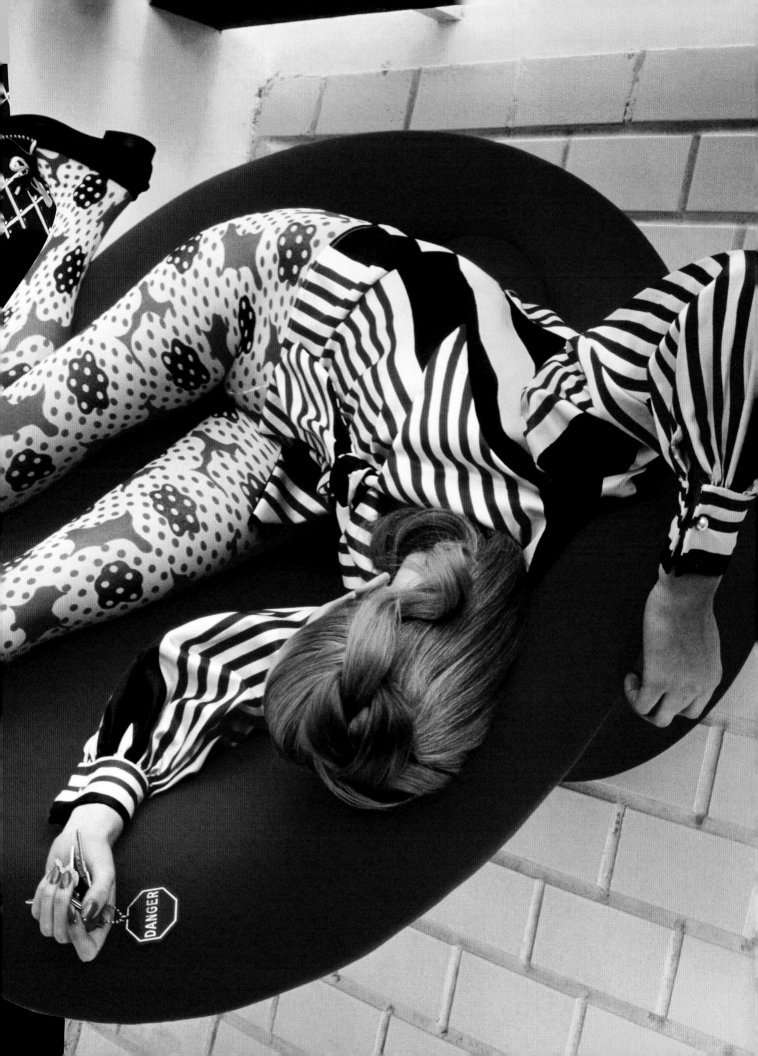

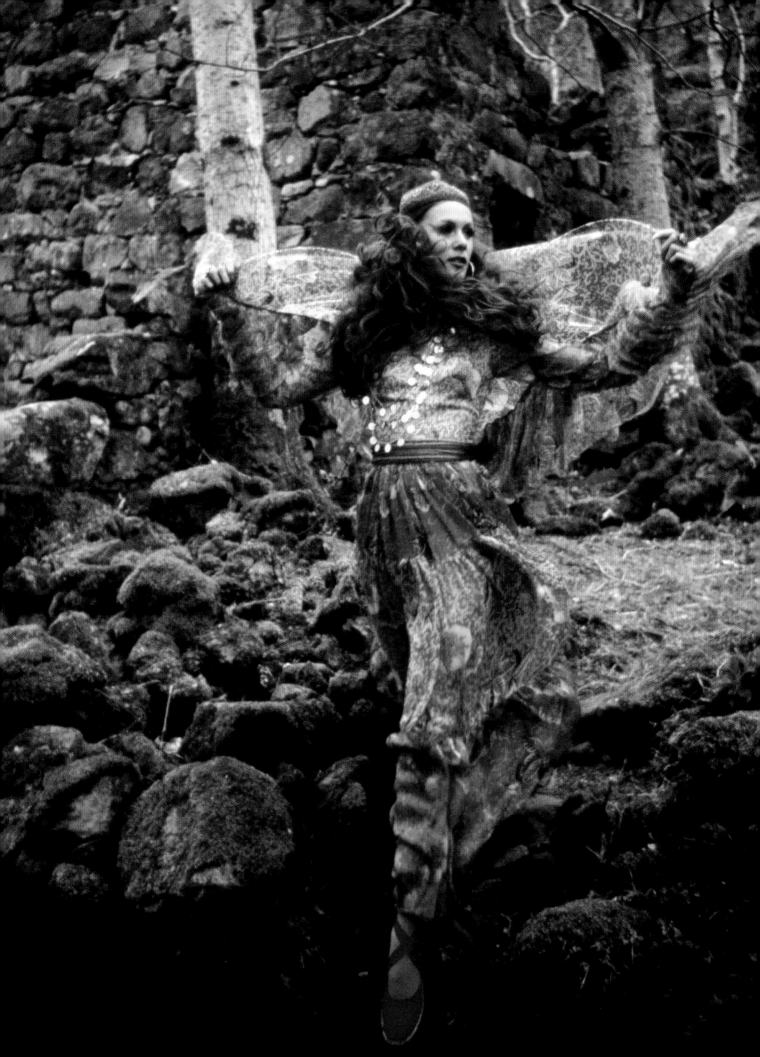

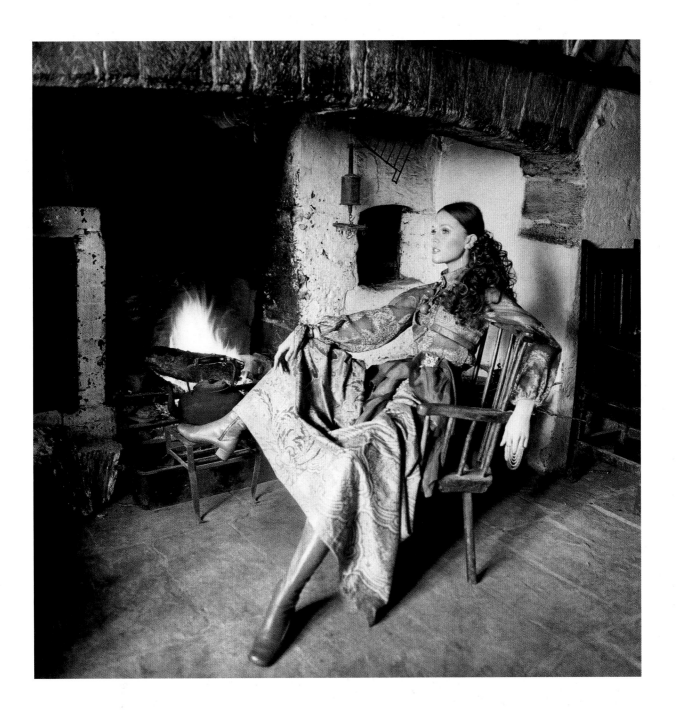

Opposite: Pirkko Bechinie photographed in Arthog, Wales, wearing a dress and shawl from Susan Small, shoes by Simpson and tights by Mary Quant. British *Vogue*, July 1969.

Above: Pirkko Bechinie at Parc near Afon Crosesor wearing fashion from Thea Porter with Ascher scarves, Elliott boots and a pin from Ken Lane. British *Vogue*, July 1969.

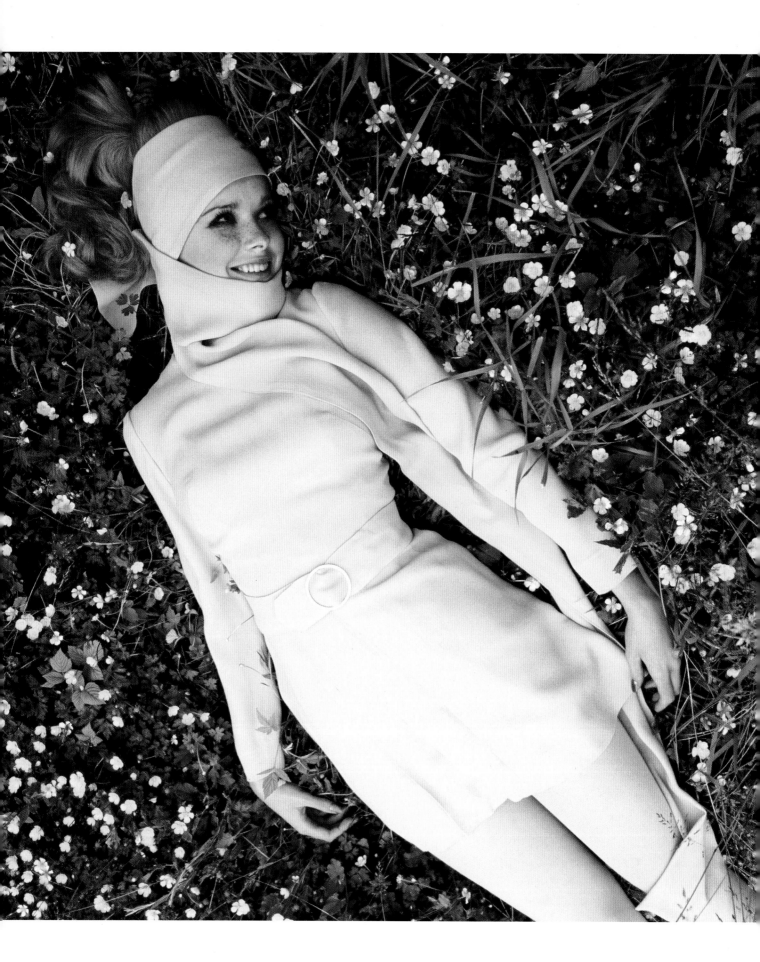

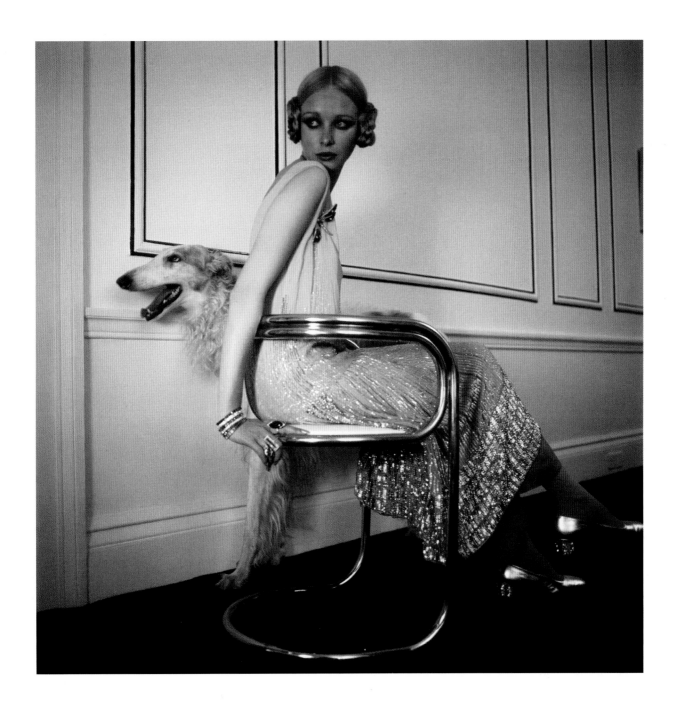

Opposite: Maudie James wearing fashion by Mary Quant Ginger Group. British *Vogue*, 15 September 1969.

Above: Maudie James wearing fashion from The Purple Shop. British *Vogue*, December 1969.

1 9

7 0s

Parkinson's last decade at *Vogue* produced many of his most stylish and long-lasting images, reflecting the greatest fashions and fashion photography of the time.

At the beginning of the 1970s, he took a timeless set of images partly to honour the legacy of the British inventor of photography, William Henry Fox Talbot, at his former home Lacock Abbey (now a museum). Ingrid Boulting, daughter of Enid Boulting with whom Parkinson had worked extensively in the 1950s, was very much "one of the faces of Biba", appearing on their iconic posters. Ingrid's pose against the Gothic archway shows her dressed for *Vogue* in Ossie Clark and Celia Birtwell, acknowledged as fashion history classics.

Yves Saint Laurent's style was perfectly presented by Parkinson in 1970 in a photograph that is an early example of "street fashion", featuring model Chandrika Angadi framed by her two Borzoi dogs. This decade would also mark the start of many images taken of Ann Schaufuss, the former ballet dancer who became one of the top models of the time before dramatically withdrawing from fashion at the height of her fame. Parkinson took many images of Ann alone and with another important model, Jan Ward, who would go on to marry Twiggy's ex-manager and mentor, Justin de Villeneuve.

Parkinson had taken memorable images of the 19-year-old Princess Anne in 1969. In 1971, *Vogue* celebrated her 21st birthday with Parkinson photographs that made him the most recognized new official Royal photographer. Romantic Royal wedding photographs for the Princess would follow in 1973, and further *Vogue* cover shoots.

In 1971, Parkinson was able to celebrate his friendly rivalry with Cecil Beaton, who had been the official Royal photographer until 1965. After the huge success of Beaton's 40-year photographic retrospective at the National Portrait Gallery in 1968 (the first time that a photographer had been shown in a London museum), Beaton was now curating an exhibition at the Victoria and Albert Museum of vintage couture, having persuaded designers and many of his friends to donate. *Vogue* honoured this occasion by asking Parkinson to photograph the historic garments. These were modelled by Marisa Berenson, the granddaughter of designer Elsa Schiaparelli and herself now a fashion icon as well as an actress – she a favourite of both photographers.

In the same year, Parkinson travelled to the mainly unexplored Seychelles on a three-week expedition. With fashion editor Grace Coddington, he concocted an elaborate storyline for the fashion shoot based around a shipwreck. They visited Bird Island with model Apollonia van Ravenstein, who would work again with Parkinson and Coddington in Barbados two years later, in another extended photo-essay that included locations such as the Crane Beach Hotel and the house of Oliver Messel, the artist and stage designer.

Highlights of 1974 were Parkinson's portfolio of five French fashion designers in a story headlined "The Perfectionist". Two are included here: Yves Saint Laurent with his muse Loulou de la Falaise and Hubert de Givenchy at his Parisian studio. The year 1975 was the most iconic for Parkinson, the year when he shot stunning *Vogue* cover images of Jerry Hall in Jamaica and Russia. In 1977 *Vogue* would offer yet more treasured fashion photographs by Parkinson, of Iman at the beach near his home in Tobago.

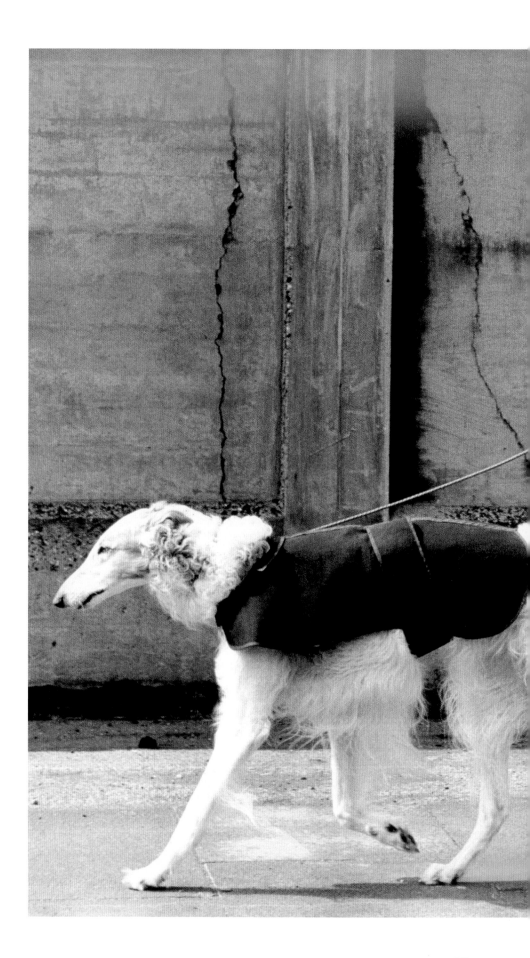

Chandrika Angadi
photographed wearing
Saint Laurent. British
Vogue, July 1970.

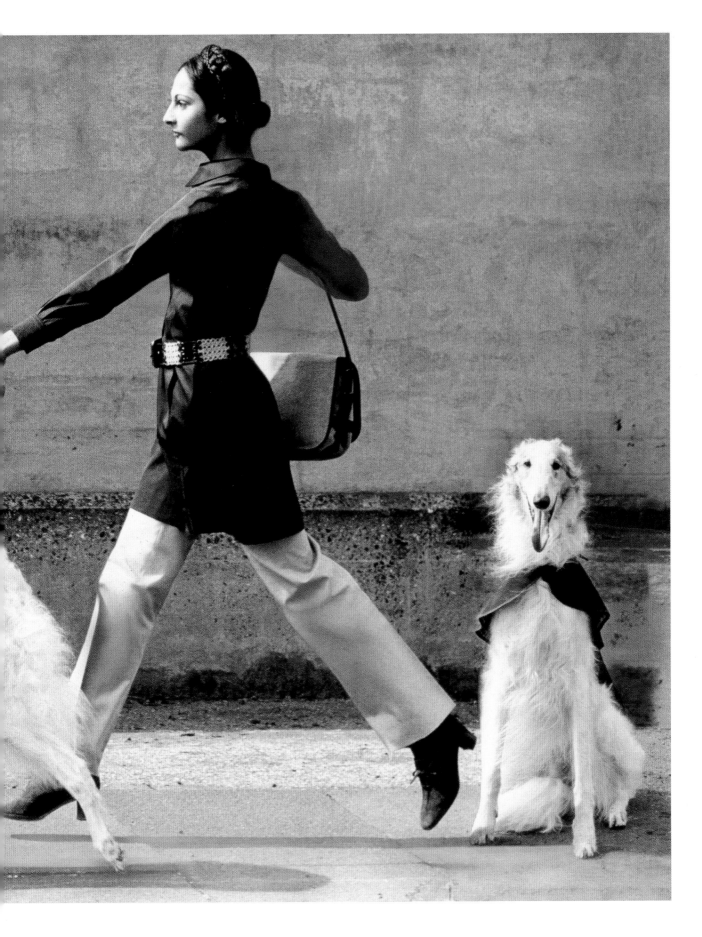

Jan Ward wearing a dress by Jean
Muir, photographed in Monument
Valley between Arizona and Utah.
British *Vogue*, January 1971.

"In Great British Fashion" – Jan Ward
wearing a tunic and trousers from Young
Jaeger and Ann Schaufuss wearing a
Marrian McDonnell dress. Hats from
Malyward. Photographed at T. Hilling & Co's
nurseries, Chobham. British *Vogue*,
15 September 1970. The two models are
holding a Polaroid, which Parkinson often
took first for a reference and to encourage
his subjects to relax.

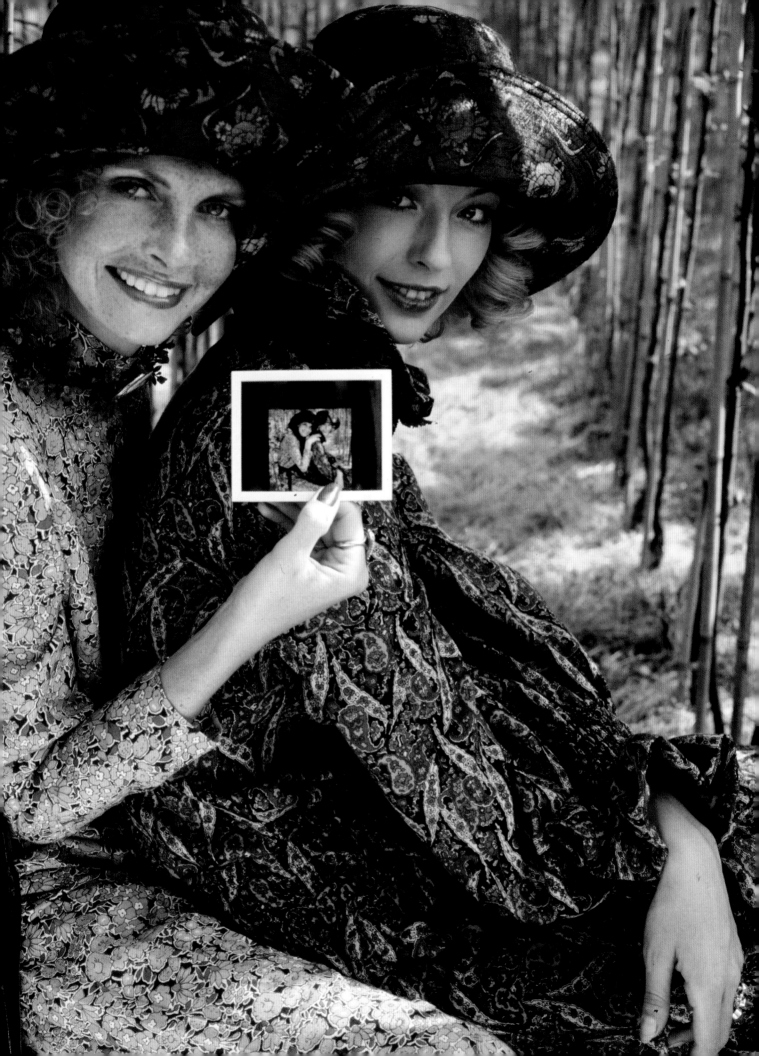

Her Royal Highness, Princess Anne

British *Vogue*, September 1969

Princess Anne Elizabeth Alice Louise was the only daughter of Queen Elizabeth II and Prince Philip, Duke of Edinburgh. She was born at the Royal Residence Clarence House on 15 August 1950, a few decades into Parkinson's career.

Known predominantly for his fashion work before, Norman Parkinson received his first important Royal commission in 1967. He was invited by Lord Snowdon and Princess Margaret to photograph the Queen's sister and her family in the gardens of their house in Kensington Palace, succeeding Cecil Beaton as their Royal Photographer of choice.

Parkinson's two following Royal commissions in 1969 created a huge impact when he took official photographs of Prince Charles at Windsor Castle for his investiture in Cardiff as Prince of Wales.

In the same year, Parkinson was asked to photograph Princess Anne riding her horse High Jinks in Windsor Great Park to celebrate her 19th birthday. He again photographed Anne for her 21st birthday in 1971 for British *Vogue*, fashionable images that are shown here.

Princess Anne photographed against a landscape painted for her birthday by Gordon Davies for the 1 September 1971 issue of British *Vogue* celebrating her 21st birthday. Her tiara originally belonged to her grandmother, Princess Alice of Battenberg, who had given it to Queen Elizabeth II as a wedding present. The Queen loaned the tiara to Princess Anne in 1969 and it was given to her in 1972.

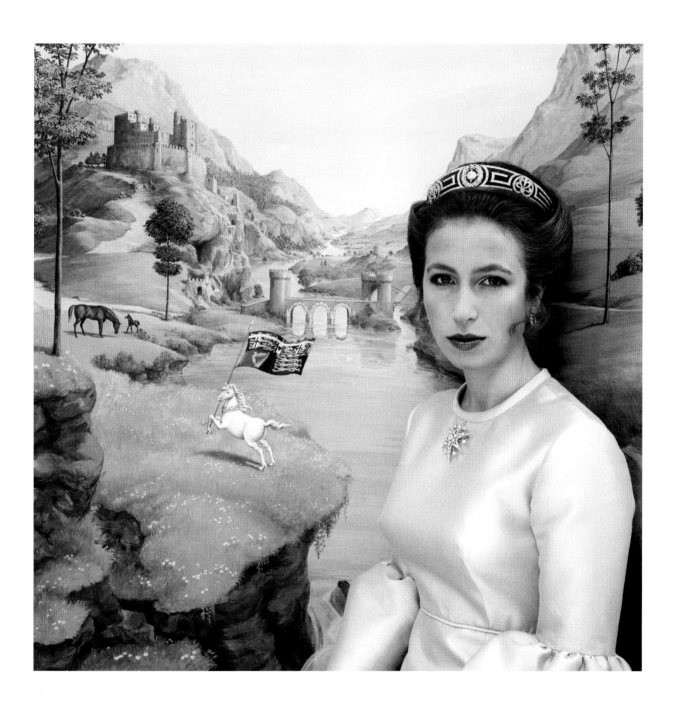

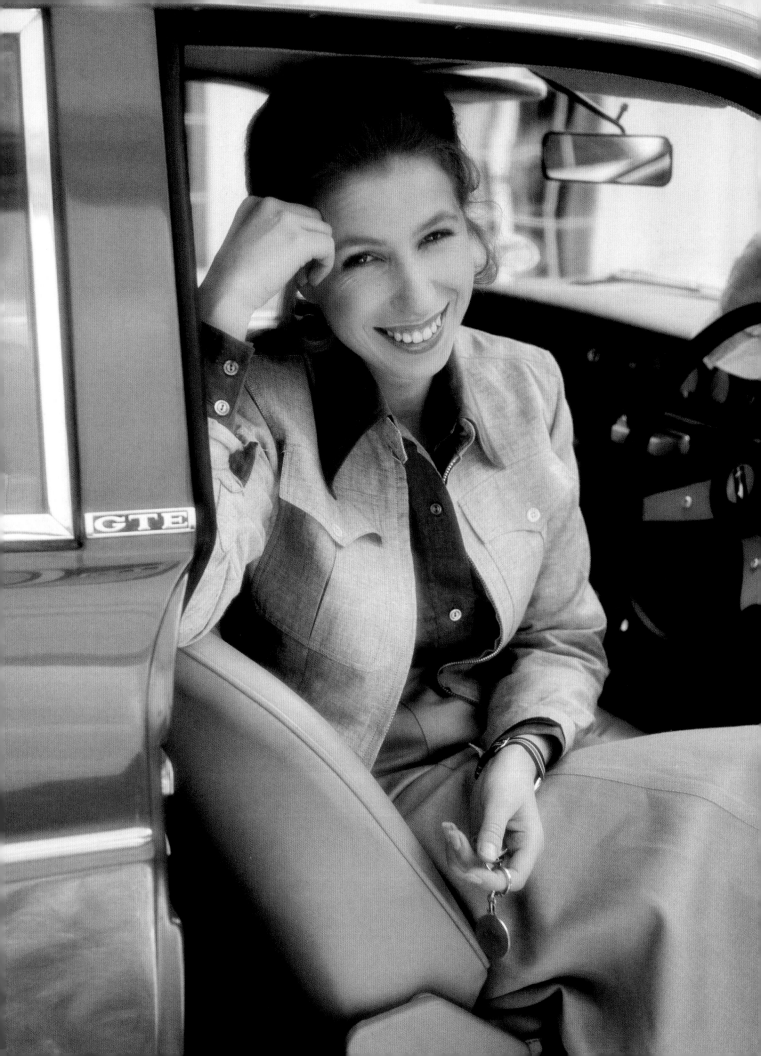

Princess Anne photographed in
a Scimitar GTE car, a birthday
present from the Queen, Prince
Philip and Prince Charles. British
Vogue, 1 September 1971.

Opposite: Cecil Beaton and Marisa Berenson
photographed for his fashion exhibition at the
Victoria and Albert Museum. Marisa wears a
1912 Fortuny dress with Pinet shoes and David
Morris jewellery. British *Vogue*, 1 October 1971.

Above: Cecil Beaton and Marisa Berenson
photographed for his fashion exhibition at the
Victoria and Albert Museum. Marisa wears
a 1937 Chanel sequin suit with Rayne shoes,
Mary Quant tights and Adrien Mann jewels.
British *Vogue*, 1 October 1971.

Apollonia
van Ravenstein

British *Vogue*, December 1971

As Norman Parkinson stated, "The maddest, funniest, the hardest working model who ever earned a fortune was Apollonia van Ravenstein, or 'Plonya' as she is known to half of us, 'Apples' to the rest. She is still hard at it and looks wonderful. I give a private round of applause to this intrepid and fearless girl for she has given me two or three of the best ten pictures I will ever take."

Apollonia van Ravenstein began her career aged 15, posing for a tights collection in the Netherlands. Shortly after, van Ravenstein's brother Theo made her an appointment with the Amsterdam-based model agency of Corine Rottshäfer. Van Ravenstein shot to fame as a cover model, and travelled to Paris and New York, signing an exclusive contract with American *Vogue* in 1972 after first working with Norman Parkinson for British *Vogue* in 1971 with fashion editor Grace Coddington.

Right: An out-take of Apollonia van Ravenstein with white birds in the Seychelles for British *Vogue*, December 1971.

Opposite: Apollonia van Ravenstein on Bird Island, Seychelles wearing a dress by Mrs Caswell for Angela at Rosie Nice, Kensington Antique Market with a Herbert Johnson straw hat and jewellery by Adrien Mann. British *Vogue*, December 1971.

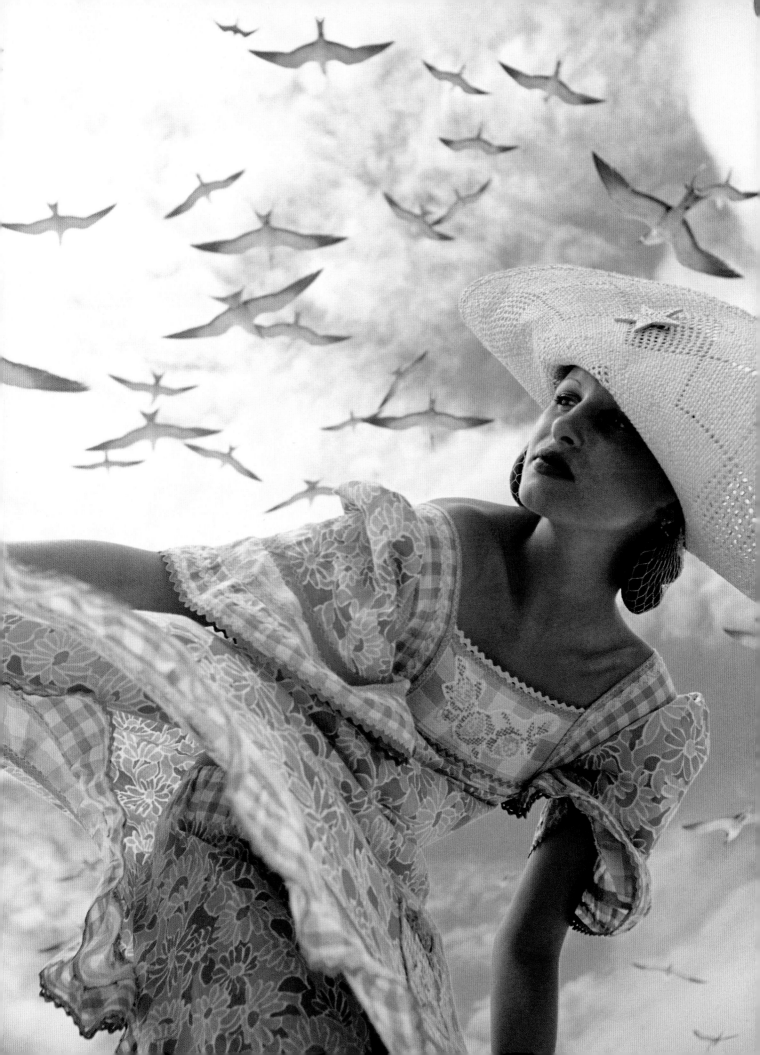

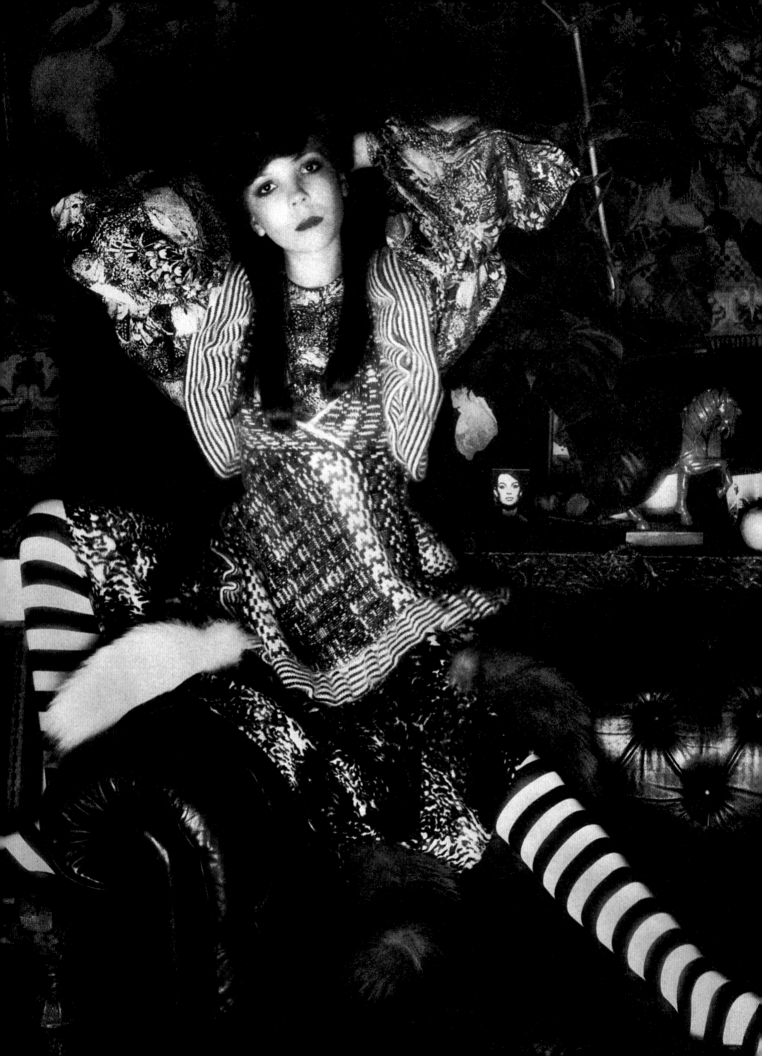

Penelope Tree's collaboration with
Norman Parkinson included this shoot
for the 1 October 1972 issue of British
Vogue, in which she is photographed
in David Bailey's lacquer drawing
room wearing a Bill Gibb outfit with
hair by Celine at Leonard.

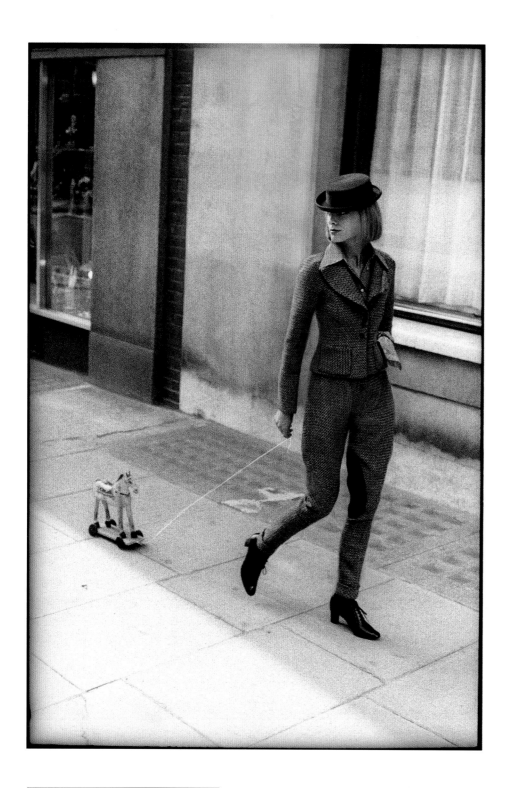

Above: Christina Steidten wearing jodhpurs and jacket by Ann Buck and Katharine Hamnett with a Walter Albini blouse and Saint Laurent Rive Gauche shoes

Opposite: Steidten passing Alfred Strutt's painting at Maas Gallery in London, wearing Biba jodhpurs and a Walter Albini sweater with Saint Laurent shoes. British *Vogue*, 15 October 1972.

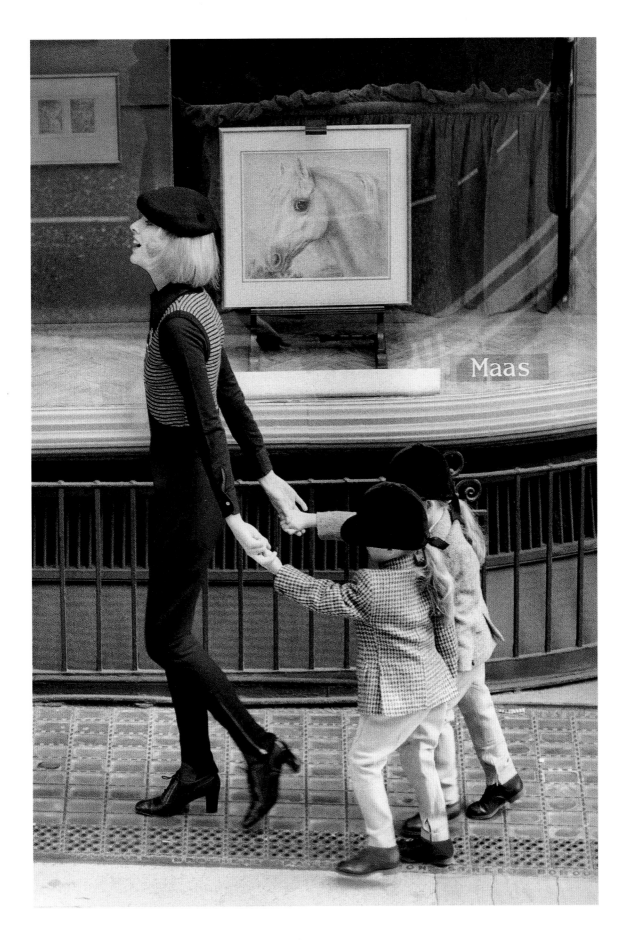

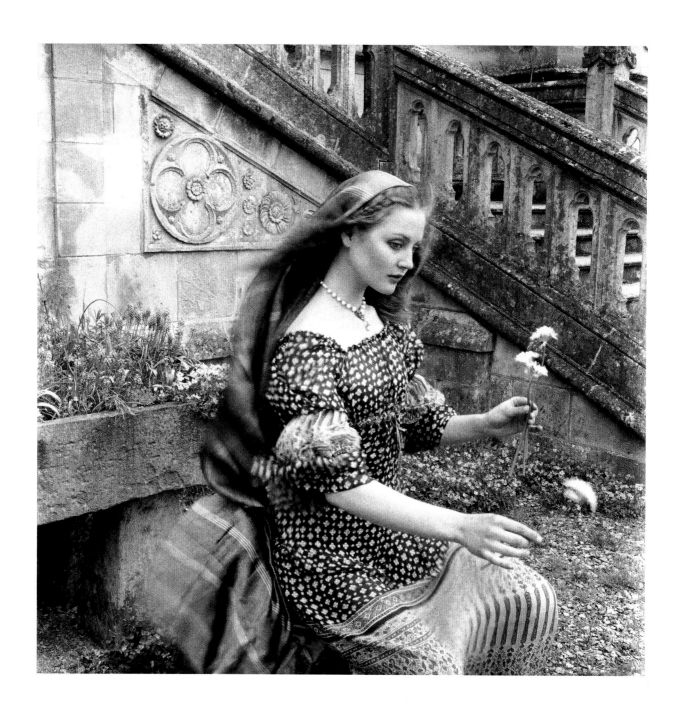

Ingrid Boulting wearing dresses from
(left) Suliman at Bond Street Fashion
Market and (right) Ossie Clark with
a Celia Birtwell print. Photographed
at Lacock Abbey, former home of the
nineteenth-century photographic
pioneer William Henry Fox Talbot.
British *Vogue* magazine, July 1970.

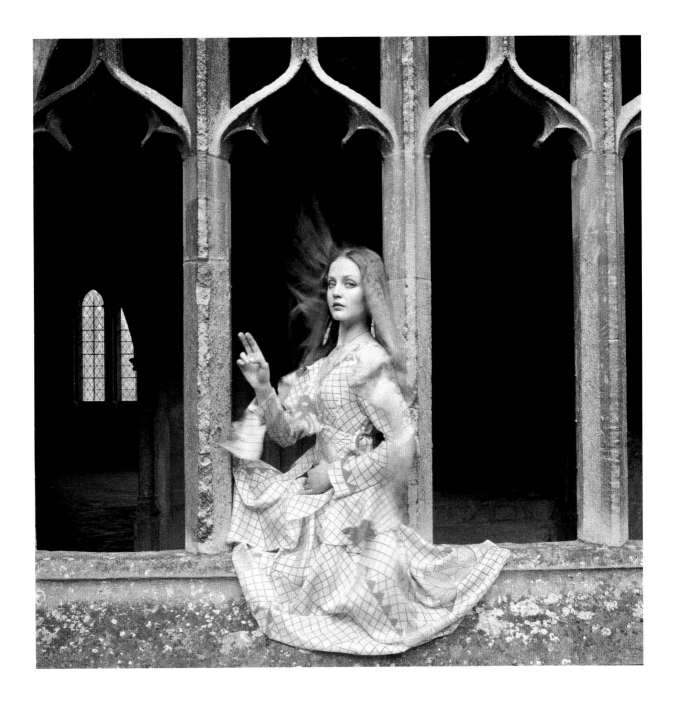

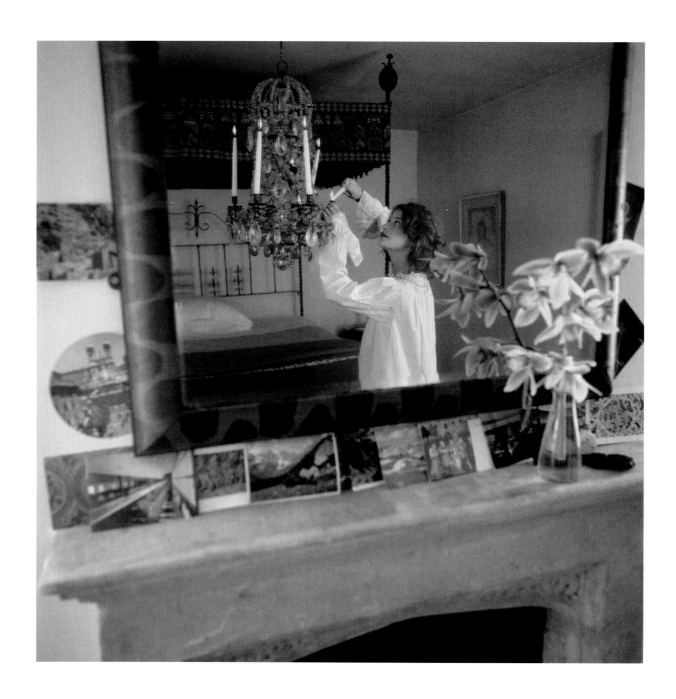

Above: Nicola "Nicky" Samuel Waymouth lighting the candles of her Chelsea bedroom. Among the decor are Calanthe orchids and a seventeenth-century Italian bed with a cover from Naxos and curtains woven in Morocco. British *Vogue*, December 1972.

Opposite: Nicola "Nicky" Samuel Waymouth at home in Chelsea wearing a tulip print chiffon dress by Ossie Clark for British *Vogue*, December 1972. Her home was originally built as a studio for Augustus John just before the First World War.

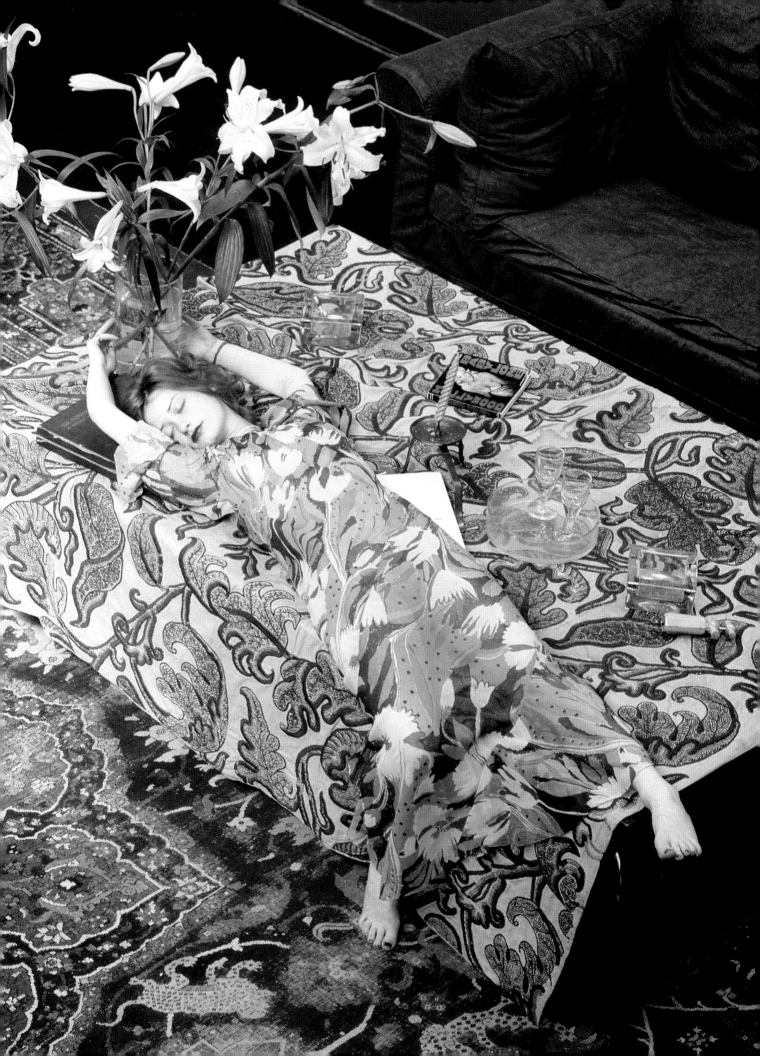

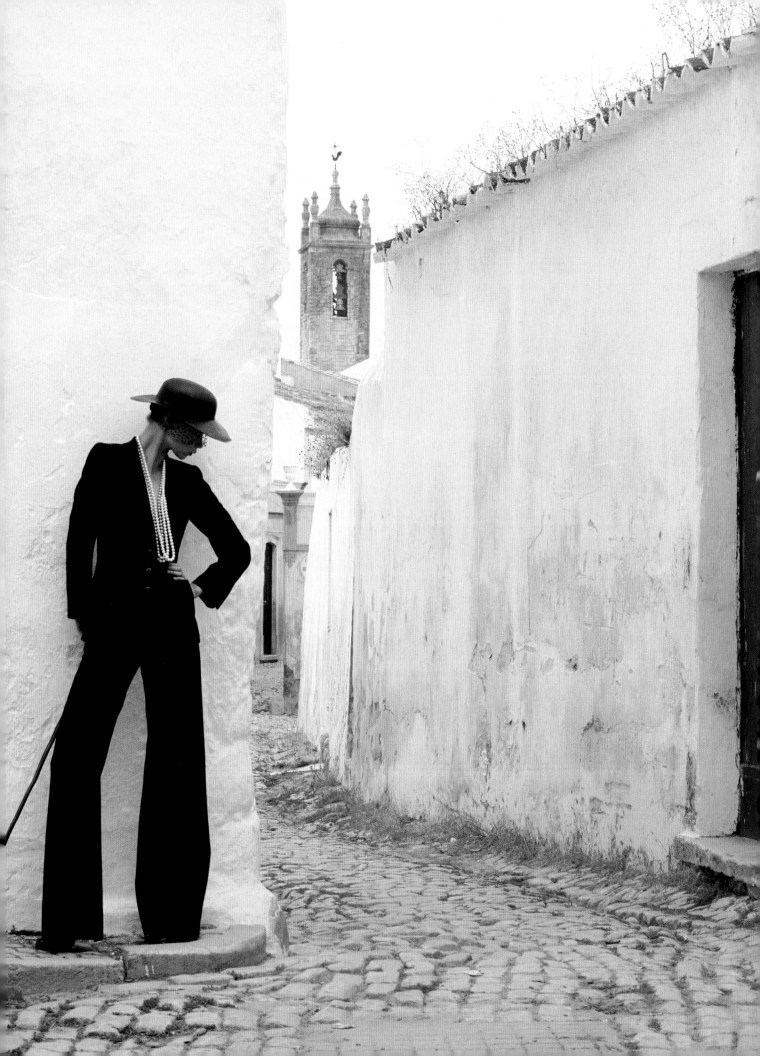

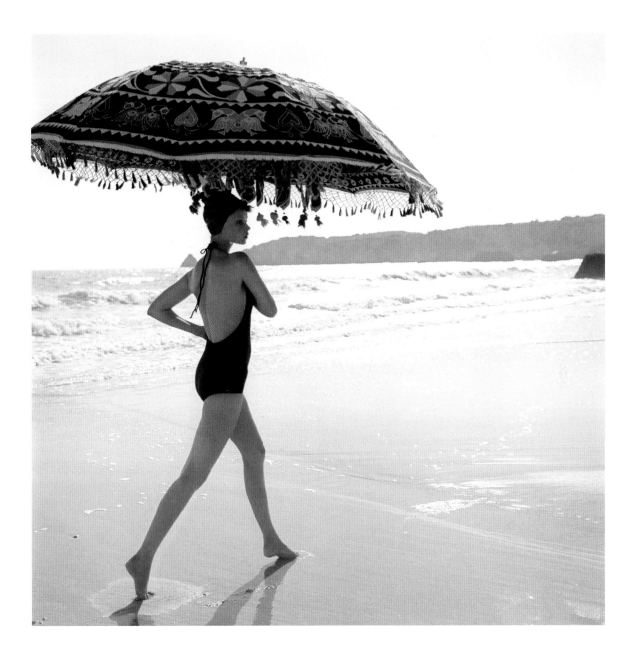

Opposite: Mouche (the nickname of Swedish-born model Agneta Bylander) in Loulé, Portugal wearing an outfit by Saint Laurent with a straw hat from Herbert Johnson. British *Vogue* magazine, January 1973.

Above: Mouche at Praia do Vau, Portugal wearing a Nina Ricci swimsuit. British *Vogue* magazine, January 1973.

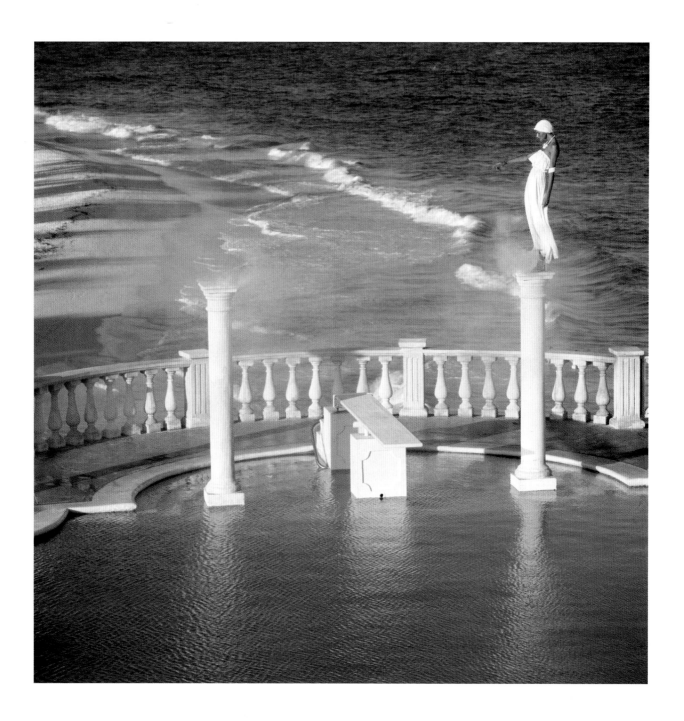

Above: Apollonia van Ravenstein wearing an ivory Banlon dress by Jane Cattlin, standing atop a column at the Crane Beach Hotel in Barbados. British *Vogue*, July 1973.

Opposite: Apollonia van Ravenstein at the Crane Beach Hotel in Barbados wearing a Jane Cattlin swimsuit with a Charles Batten hat, chiffon scarf from Liberty and Saint Laurent Rive Gauche sandals. British *Vogue*, July 1973.

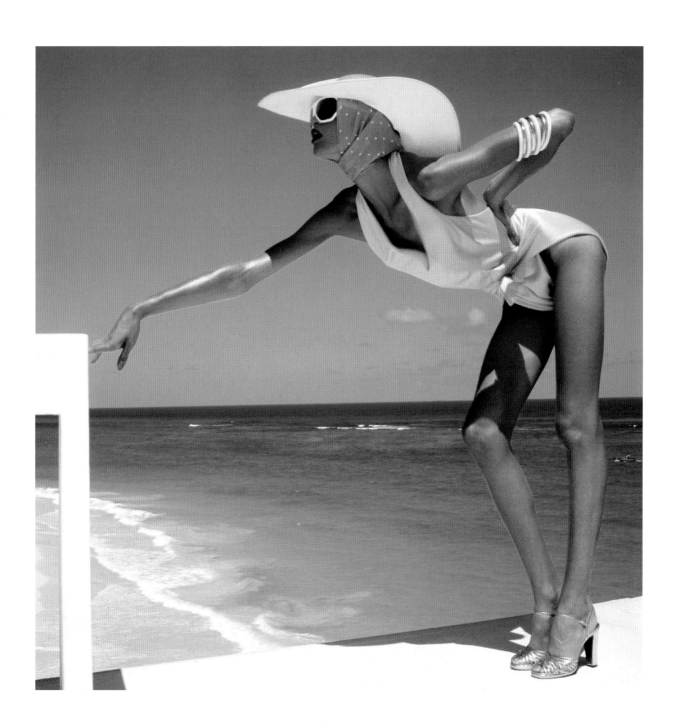

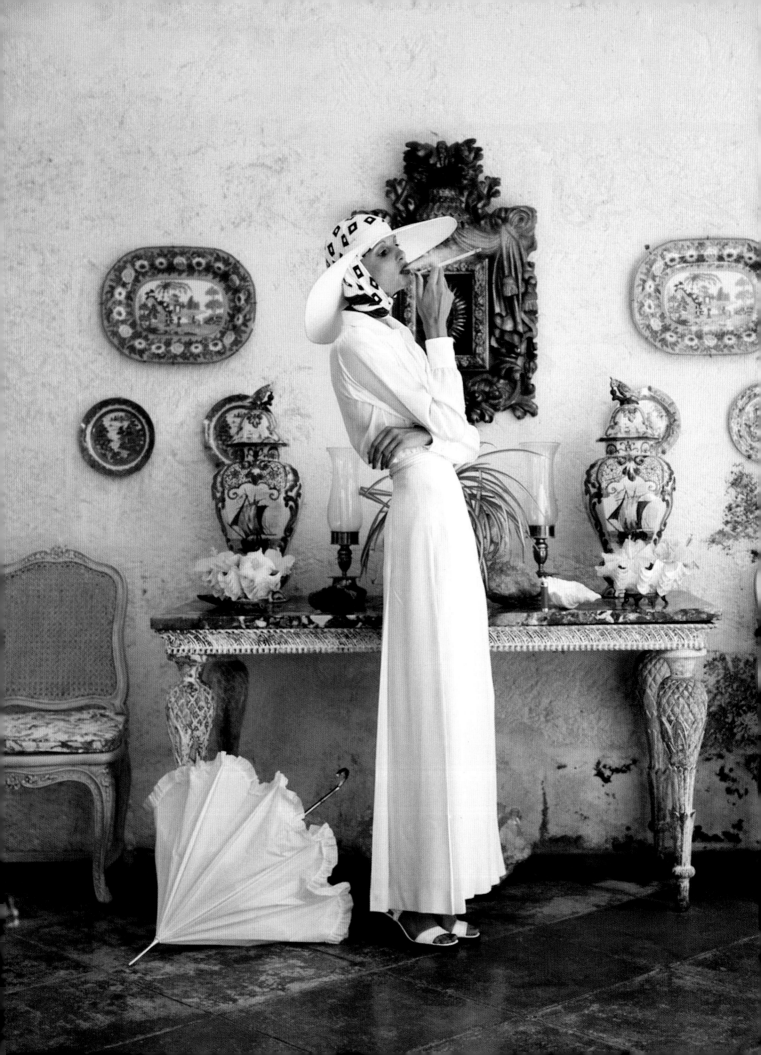

Apollonia van Ravenstein at
Oliver Messel's home in Barbados,
wearing an outfit from Saint
Laurent Rive Gauche with a Charles
Batten hat. British *Vogue*, July 1973.

Eva Malmström photographed for the
cover of British *Vogue*, Late April 1974,
in the Parisian apartment of M Alain
Lesieutre. Make-up and fragrance by
Guerlain with Tricosa accessories.

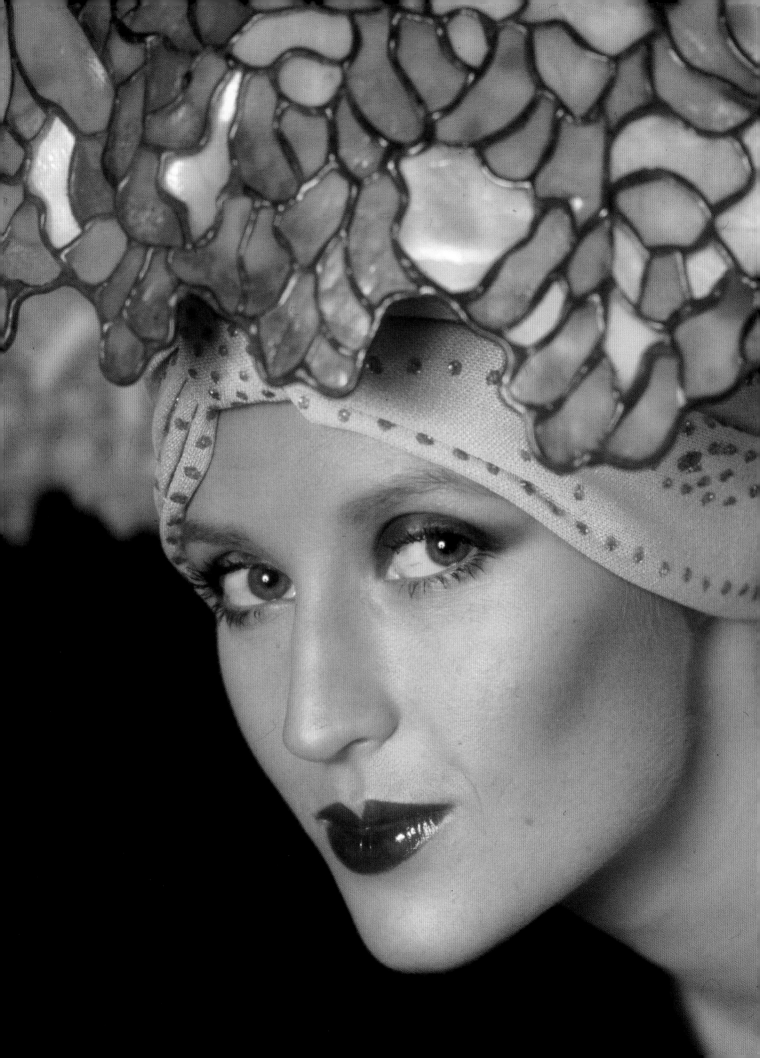

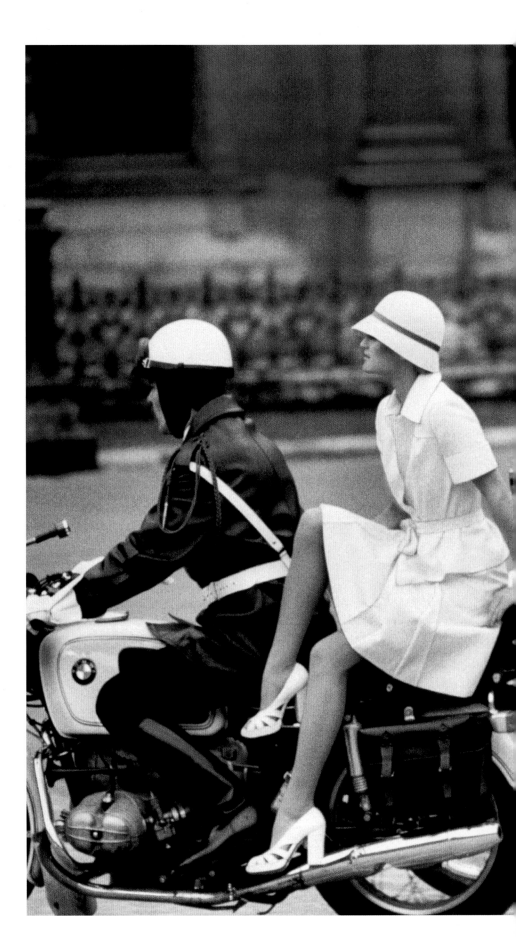

Eva Malmström and Christiana
Steidten in Paris wearing fashion
by Daniel Hechter, Jean-Louis
Scherrer, Christian Dior and
Dorothée Bis. British *Vogue*,
Late April 1974.

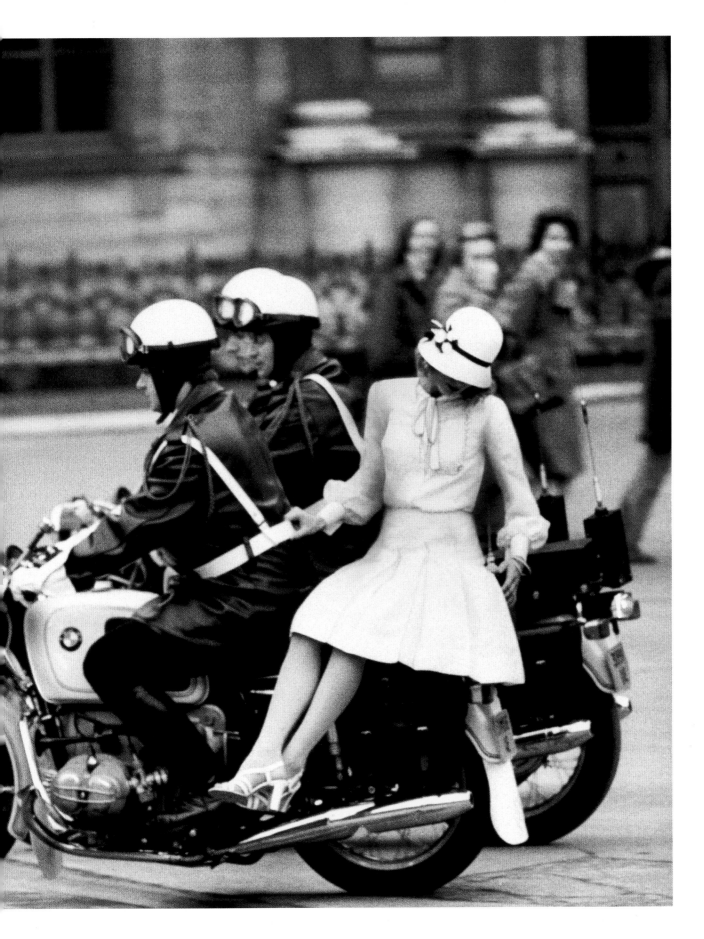

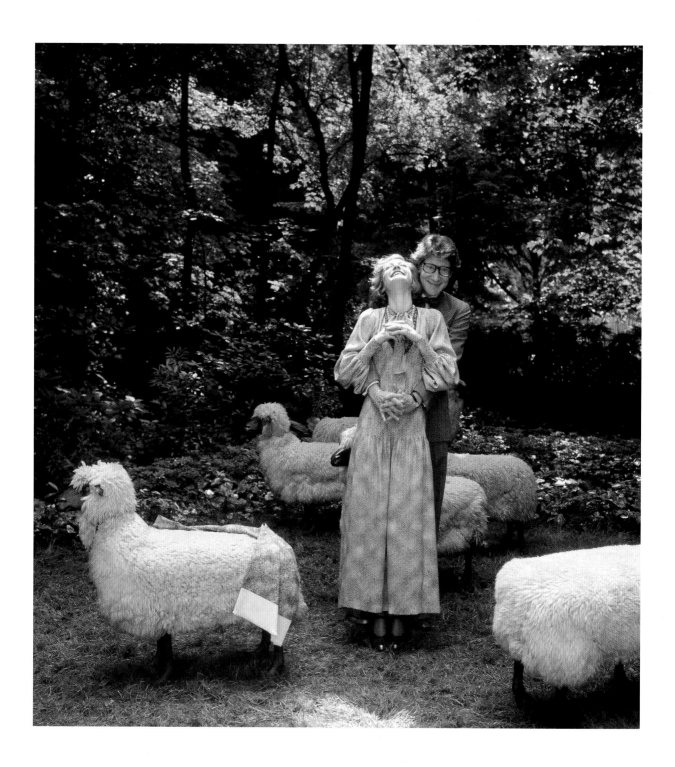

Above: French fashion designer Yves Saint Laurent and his muse Loulou de La Falaise photographed in his Parisian garden with sheep sculptures. British *Vogue*, 1 September 1974.

Opposite: French fashion designer Hubert de Givenchy and socialite Perla de Lucena at his apartment in Paris's 7th arrondissement. British *Vogue*, 1 September 1974.

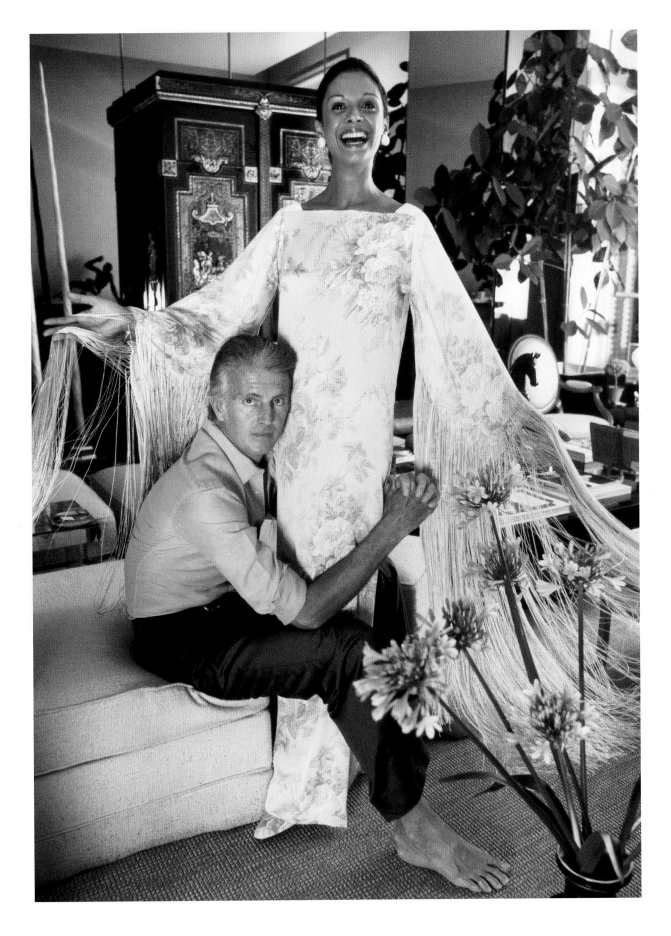

Opposite: Clio Goldsmith photographed in Tobago wearing Max Factor make-up for the cover of British *Vogue*, 15 April 1975.

Above: Clio Goldsmith in Tobago wearing fashion by Berlei with Adrien Mann jewellery. British *Vogue*, 15 April 1975.

Jerry Hall

Cover of British *Vogue*, May 1975

Jerry Hall said, "Norman Parkinson was an old-style gentleman photographer and I adored him. In one of our shoots, he had one of those old-fashioned plate cameras in which the shutter is held open for a few minutes while it absorbs the light. In that way, it records a huge amount of movement. I worked with him many times, but one of my favourite shoots was the one we did in Jamaica with Antonio Lopez and the stylist Grace Coddington, for English *Vogue*."

The 1975 Jamaica shoot was the first of many times Norman Parkinson worked with Jerry Hall and marked her first cover image for British *Vogue*. Parkinson's glamorous shots of Hall catapulted her to fame, also garnering her the attention of future lovers Bryan Ferry and Mick Jagger.

Jerry Hall in Jamaica wearing make-up by Alexandra de Markoff with a swimsuit by Wiki and Britmarine bathing cap. Cover of British *Vogue* magazine, May 1975.

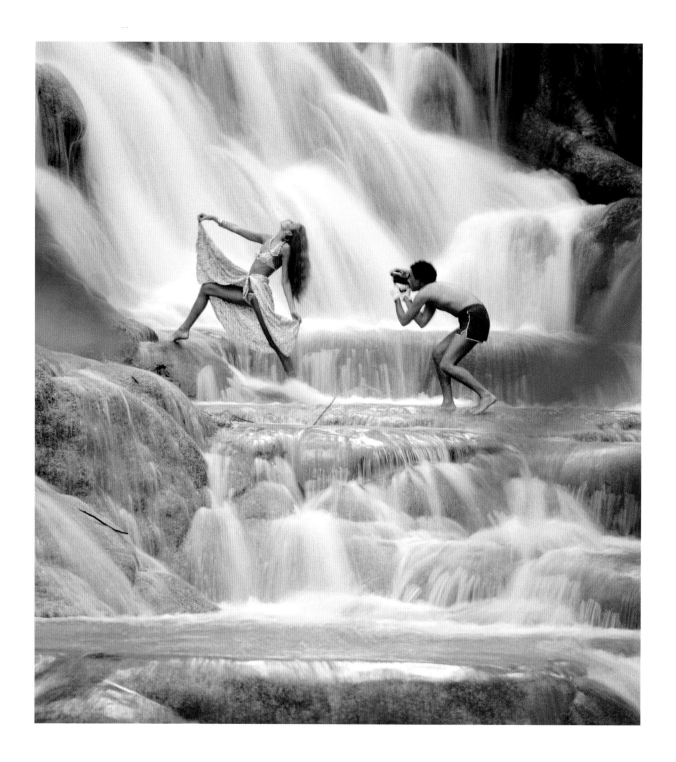

Above: Fashion illustrator Antonio Lopez filming Jerry Hall at Dunn's River Falls in Ocho Rios, Jamaica. Hall wears a bikini from Electric Fittings with Saint Laurent Rive Gauche jewels. British *Vogue* magazine, May 1975.

Opposite: Fashion illustrator Antonio Lopez filming American model Jerry Hall at Jamaica Inn, Ocho Rios, Jamaica. Hall wears a bikini from Pascal with Manolo Blahnik stiletto heels and Saint Laurent Rive Gauche jewels. British *Vogue*, May 1975.

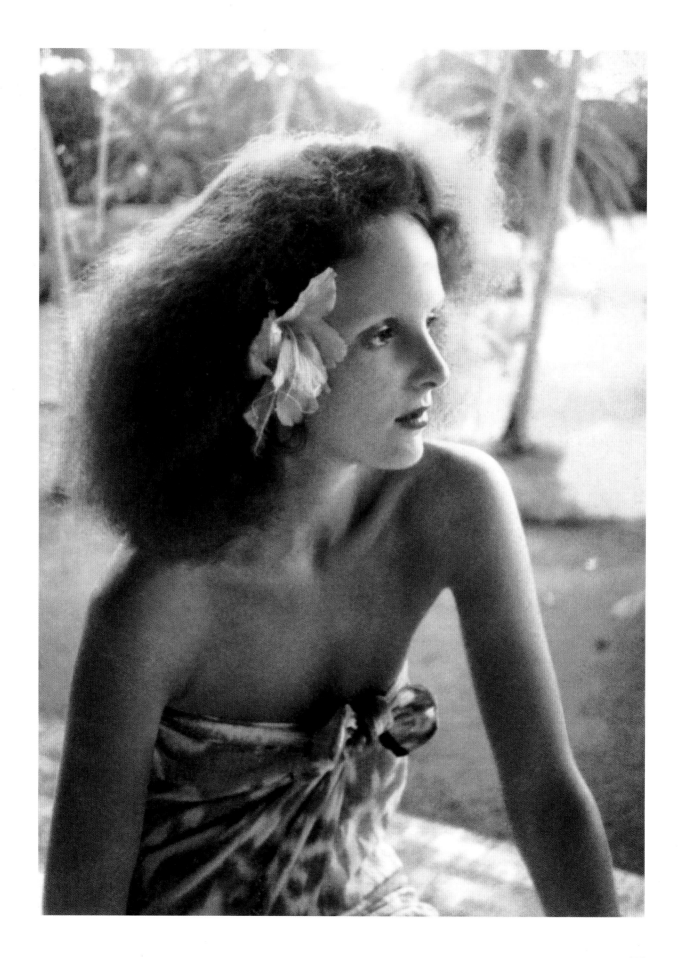

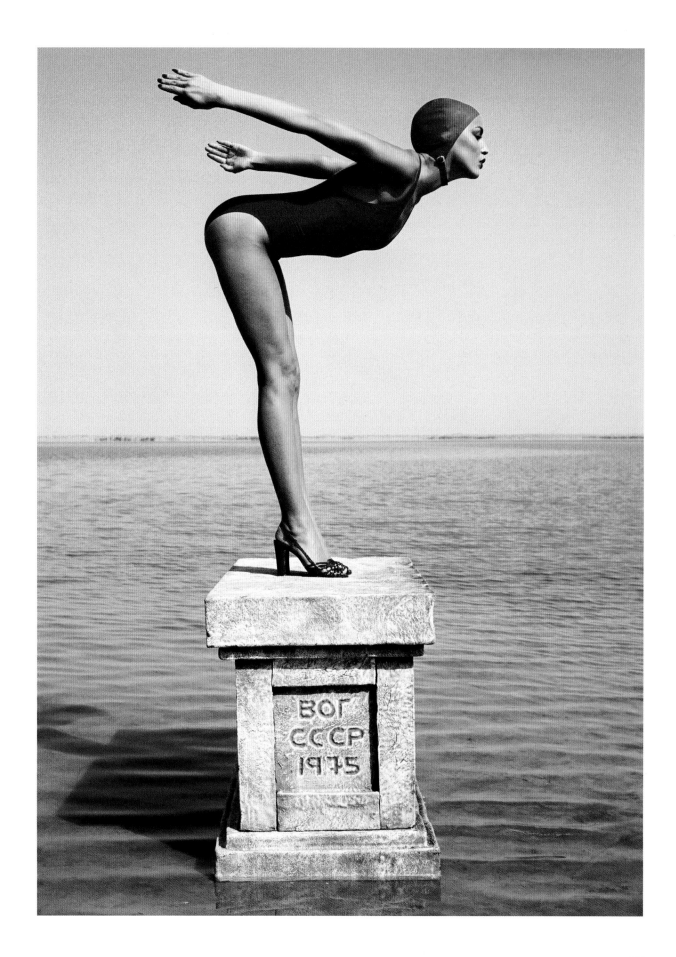

ВОГ
СССР
1975



Твой вкла[д]
в девяту[ю]
пятилет[ку]

Above: Jerry Hall poses next to a Soviet monument at the Exhibition of Achievements of National Economy in Moscow. Hall wears a shirt and matching skirt by Jap with boots from Emperor of Wyoming. British *Vogue* magazine, January 1976.

Opposite: Jerry Hall at the Hindu fire temple at Baku, Azerbaijan. Hall wears a dress by Yuki with Lucienne earrings from Saint Laurent Rive Gauche and sandals by Manolo Blahnik. British *Vogue* magazine, January 1976.

Iman

British *Vogue*, May 1976

"Iman Abdul Majid is the world's most beautiful black woman," declared Norman Parkinson in 1983. He continued, "Iman was eighteen when she was first presented to my camera and has continued to enrich it from time to time since then." The year 1976 marked their first sitting together near Parkinson's home in Tobago for British *Vogue*, a destination Iman returned to in 1989 for an iconic *Town & Country* magazine shoot.

The two became great friends, and during Iman's 10-year marriage to basketball player Spencer Haywood, Parkinson took a notable portrait of them together. He photographed her later husband David Bowie in 1982, ten years before Iman and Bowie met and wed. Parkinson would later create a very notable series of photographs for French *Vogue* of Iman with Jerry Hall in Paris for French *Vogue*, using an iconic image of them together as the cover for his autobiography.

Iman has talked fondly of her partnership with Parkinson, saying, "Photography is a collaborative process – and Norman Parkinson was like Fred Astaire.... Norman's most memorable images are marked by the most extraordinary sense of charm and knowing – you can see it in the eyes of the people he immortalised in his photos."

Iman at King Peter's Bay, Tobago wearing a cheesecloth dress by Lily at Browns with Saint Laurent Rive Gauche earrings. British *Vogue*, May 1976.

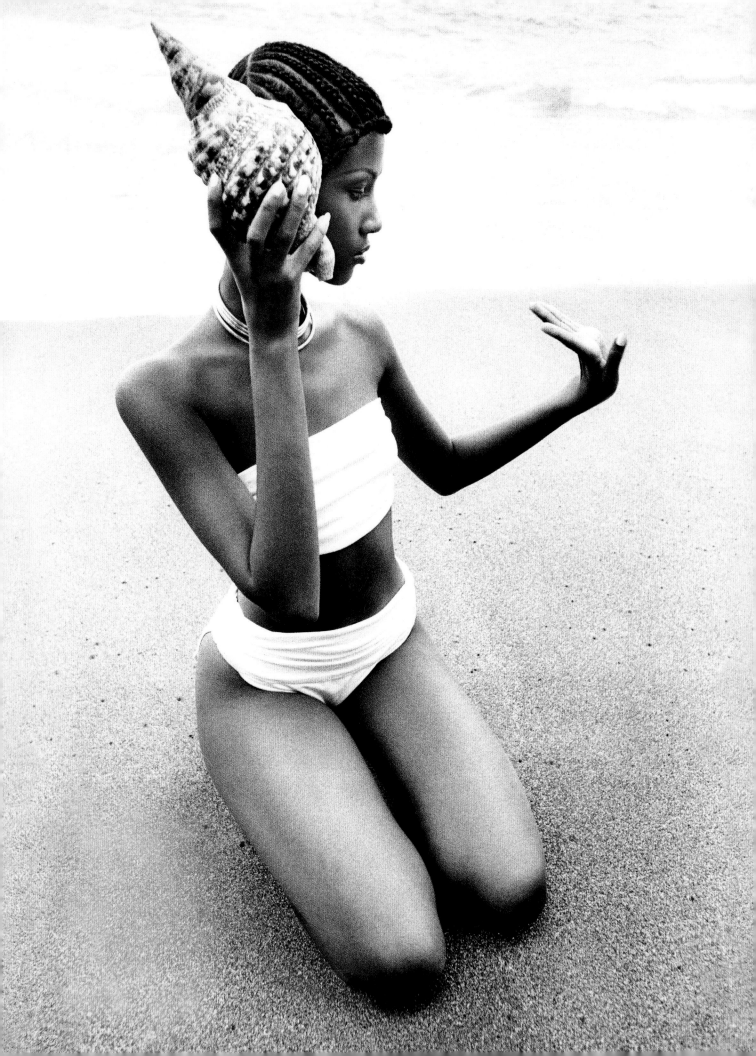

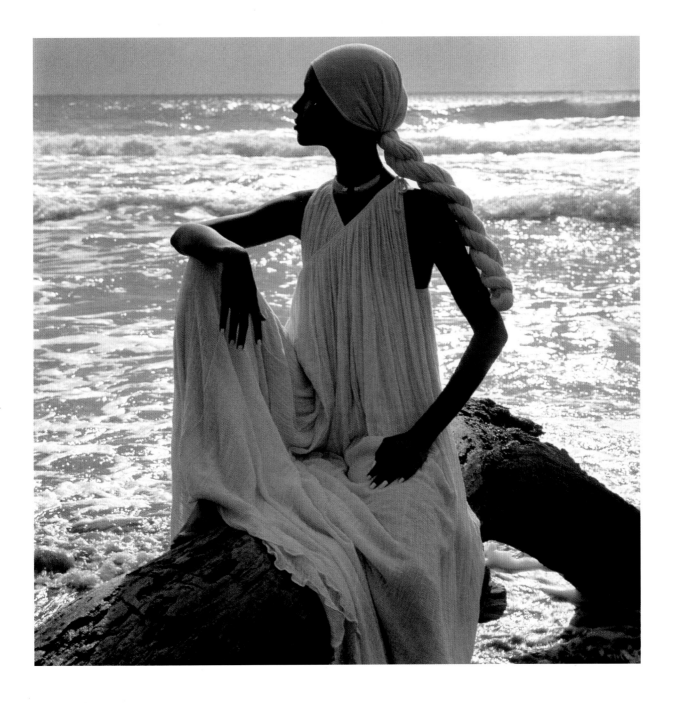

Opposite: Iman at King Peter's Bay, Tobago wearing a Jane Cattlin bikini. British *Vogue*, May 1976.
Above: Iman at King Peter's Bay, Tobago wearing a Mexicana dress made from Liberty fabric. British *Vogue*, May 1976.

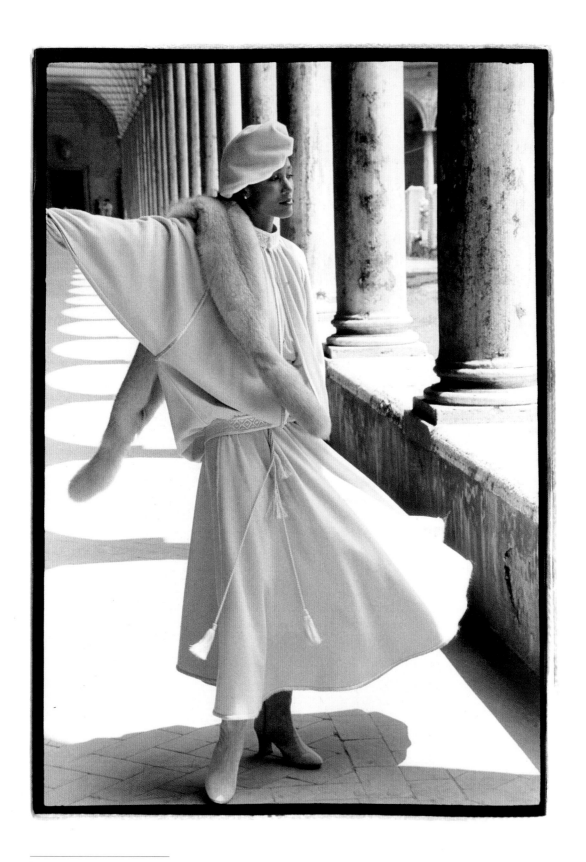

Beverly Johnson photographed in
Italy wearing fashion by Roberto
Capucci and Rafaello for Italian
Vogue, 1977.

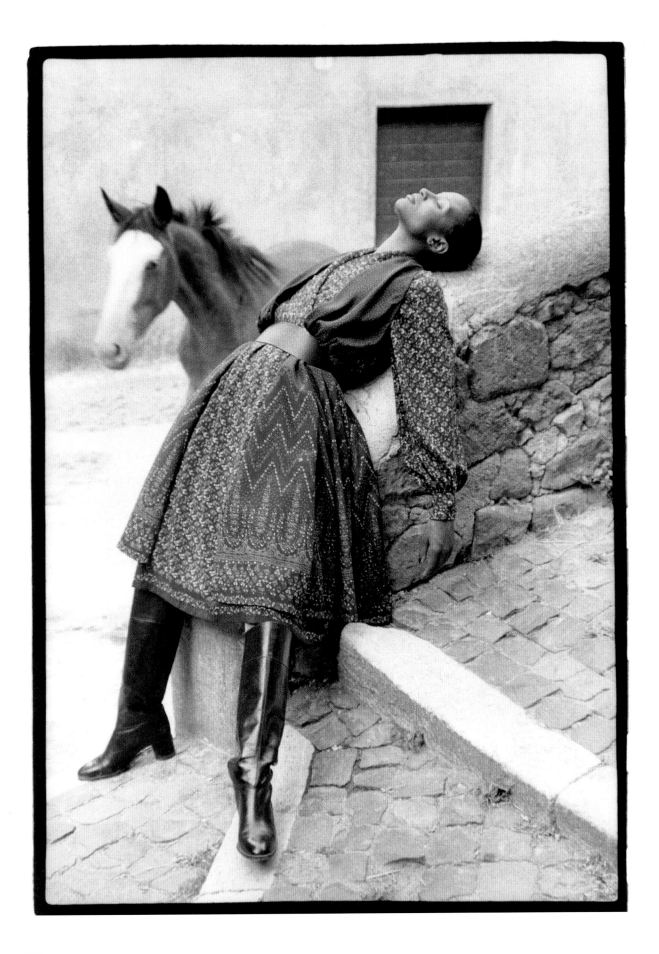

Carmen Dell'Orefice wearing
a velour dress by Hurel and
asymmetric skirt by Carlotto.
French *Vogue*, September 1980.

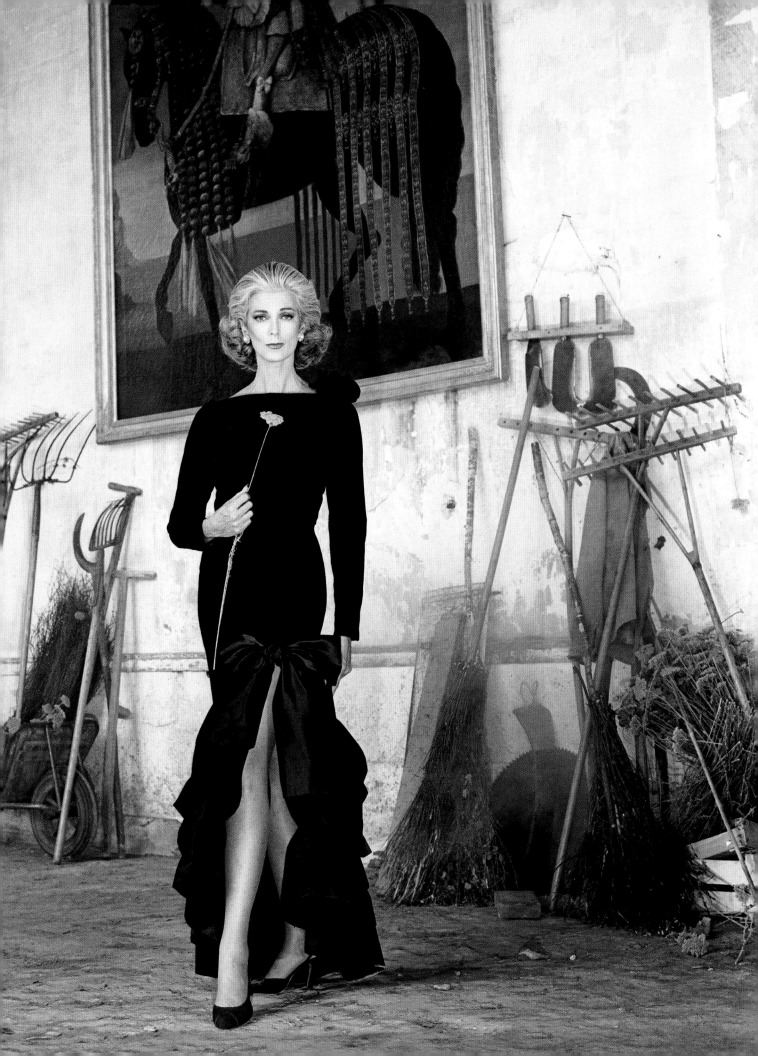

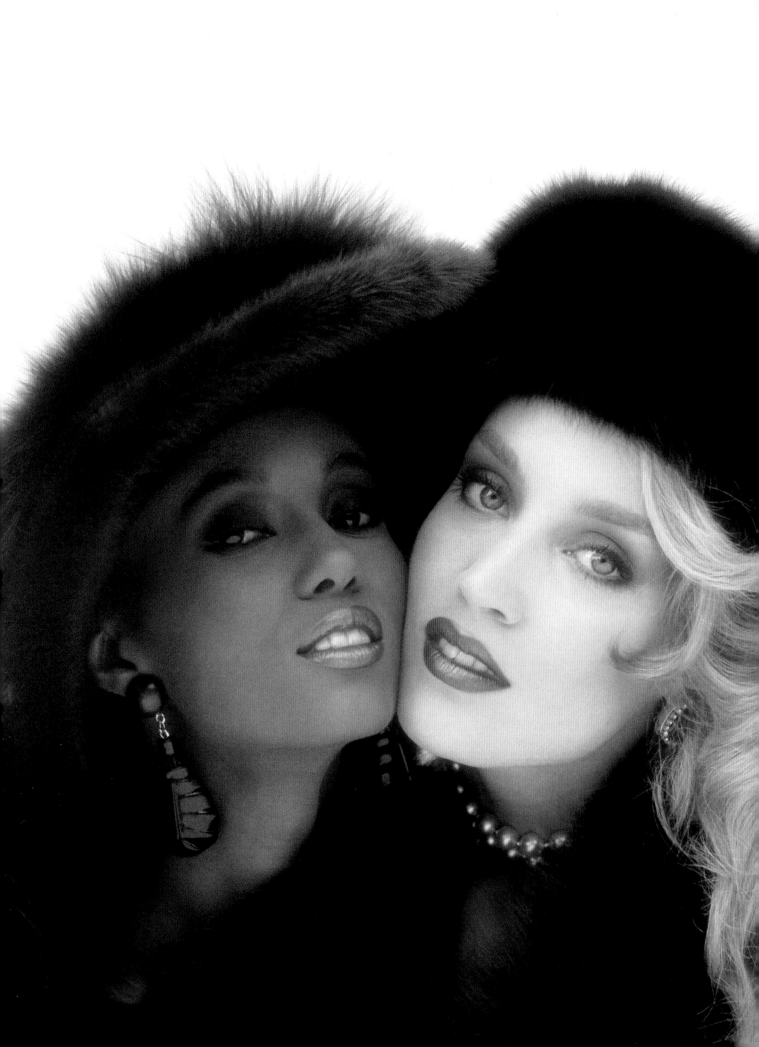

The final years of Parkinson's career consisted mainly of the new collaboration with Hearst's flagship *Town & Country* magazine, under the editorship of Frank Zachary and special features editor Nancy Tuck Gardiner. A decade of more exciting photographs were captured, with the occasional publication in early 1980s French *Vogue*. His 1980 photograph of Carmen Dell'Orefice was taken 31 years after they first met, heralding the return of this early superstar. In 1981 Parkinson was awarded the Royal Photographic Society's Progress Medal and later that decade the Lifetime Achievement Award of the American Society of Magazine Photographers.

Most prestigiously, Parkinson was awarded a CBE for his services to photography and honoured with a retrospective at the National Portrait Gallery, featuring 240 photographs, in 1981.

Although Parkinson left British *Vogue* in 1978 on his signing to *Town & Country*, he did continue to work intermittently for French and Italian *Vogue* in the 1980s, including a 1988 session in Tobago.

Parkinson died aged 76 from a brain haemorrhage on 15 February 1990 while shooting in a remote location in Malaysia, from where he was flown to a hospital in Singapore. Since then, he has been honoured with multiple global exhibitions and photo books.

Iman wearing a Louis Féraud hat and Jerry Hall wearing a Givenchy hat. French *Vogue*, September 1982.

Terence Pepper is the former Curator of Photographs for the National Portrait Gallery and lead curator of the 1981 exhibition 'Norman Parkinson: 50 Years of Portraits and Fashion', among many other photography exhibitions. He was awarded an OBE in 2002 for services to art and photography and the Outstanding Service to Photography Award in 2014.

Published in 2024 by Welbeck

An imprint of Welbeck Non-Fiction Limited, part of Welbeck Publishing Group.

Offices in: London - 20 Mortimer Street, London W1T 3JW & Sydney - Level 17, 207 Kent St, Sydney NSW 2000 Australia

www.welbeckpublishing.com

A CIP catalogue record for this book is available from the British Library

ISBN: 978-1-80279-793-0

Publisher: Joe Cottington
Design: Russell Knowles
Production: Rachel Burgess
Production for Iconic Images: Blake Lewis and Adam Powell

Printed in China

10 9 8 7 6 5 4 3 2 1